Comedy for Animators

While comedy writers are responsible for creating clever scripts, comedic animators have a much more complicated problem to solve: **What makes a physical character funny**? *Comedy for Animators* breaks down the answer by exploring the techniques of those who have used their bodies to make others laugh. Drawing from traditions such as commedia dell'arte, pantomime, vaudeville, the circus, and silent and modern film, animators will learn not only to create funny characters, but also how to execute gags, create a comic climate, and use environment as a character. Whether you're creating a comic villain or a bumbling sidekick, this is the one and only guide you need to get your audience laughing!

- Explanation of comedic archetypes and devices will both inspire and inform your creative choices.
- Exploration of various modes of storytelling allows you to give the right context for your story and characters.
- Tips for creating worlds, scenarios, and casts for your characters to flourish in.
- Companion website includes example videos and further resources to expand your skillset—check it out at www.comedyforanimators.com!

Jonathan Lyons delivers simple, fun, illustrated lessons that teach readers to apply the principles of history's greatest physical comedians to their animated characters. This isn't stand-up comedy—it's the falling down and jumping around sort!

Jonathan Lyons earned his BFA and created an award winning student film at New York University, where he studied with noted animator and author John Canemaker. After moving to California he earned his living in traditional animation, before transitioning to computer graphics and becoming animation supervisor for a dozen Pillsbury Doughboy commercials. While working at Industrial Light & Magic he earned two Clio Awards for commercials and went on to work on the first four *Pirates of the Caribbean* films. From the workshop for *Pee-Wee's Playhouse* to teaching animation at the university level to animating on Seth MacFarlane's feature film *Ted*, Jonathan has been employed in animation for over 25 years. During those years he also studied the work of great physical comedians simply for the love of the art. He applied the principles to his Floyd the Android character in two short films that have been screened in 50 film festivals around the world, and won a handful of awards. He is happy to share with you what he has learned from watching the classic comedians, and reading about the thousand year history of character comedy.

Comedy for Animators

Jonathan Lyons

CRC Press
Taylor & Francis Group
Boca Raton London New York

CRC Press is an imprint of the
Taylor & Francis Group, an **informa** business

A FOCAL PRESS BOOK

CRC Press
Taylor & Francis Group
6000 Broken Sound Parkway NW, Suite 300
Boca Raton, FL 33487-2742

CRC Press is an imprint of the Taylor & Francis Group, an informa business

Library of Congress Cataloging-in-Publication Data
Lyons, Jonathan (Jonathan C.)
 Comedy for animators / Jonathan Lyons.
 pages cm
 Includes bibliographical references.
 1. Animated films—Authorship. 2. Comedy films—Authorship. 3. Cartoon characters. I. Title.
 NC1765.L96 2015
 741.5'8—dc23
 2015016823

ISBN: 978-1-138-77723-1 (hbk)
ISBN: 978-1-138-77718-7 (pbk)
ISBN: 978-1-315-77281-3 (ebk)

Typeset in Myriad Pro
by Apex CoVantage, LLC

Visit the Taylor & Francis Web site at http://www.taylorandfrancis.com and the CRC Press Web site at http://www.crcpress.com

To my wife Wendy.

She took a key lime pie to the face, and paid me back with a spritz from a seltzer bottle.

Contents

Foreword

"Dying is easy. Comedy is hard." The actor who adlibbed that aphorism on his deathbed (it is attributed to two Edmunds of different eras: Kean and Gwenn), spoke the truth. However, Jonathan Lyons' entertaining analysis of cinematic laugh-makers, both live-action and animation, is easy and informative.

A professional animator experienced in both hand-drawn and CG animation, and a longtime *aficionado* and student of physical comedy and comedians, Lyons knows well whereof he speaks. His book offers a cogent and knowledgeable guide to both "presentational" comedians and animators who create characters who make with the funny.

A succinct history of the origins of comedy opens the discussion, including analysis of ancient Greek satyr plays, medieval morality plays, commedia dell'arte, vaudeville, and on to the silent movies of Chaplin, Keaton, Lloyd, Laurel and Hardy, et al.

The book explores human behaviors and empathy, awareness of and playing to an audience, as exemplified by Atkinson, Cleese, Seinfeld, Tati, Chan, the Three Stooges, among others, as well as their animated counterparts, e.g., the Simpsons, Bugs Bunny, Wile E. Coyote, and the wide world of toon laugh-makers.

"All the comedians of my day," Harold Lloyd once said, "had to be students of comedy. You studied comedy. It just didn't happen, believe me." Lyon's informative, articulate book offers a solid grounding in comedy foundations and principles that once understood will undoubtedly inspire a new generation of animators.

John Canemaker
Oscar-winning animation director, author of 12 books
on animation history, professor/head of the animation
program at NYU Tisch School of the Arts.
27 March 2015

Acknowledgments

First, I must thank two guys named John. In 1989 I picked up John Towsen's book *Clowns* in a library, and his descriptions of the history of physical comedy opened my eyes to the connections with animated characters. It was the beginning of this journey, and I am glad to have him as a personal friend. I was also very fortunate to have had animator and animation historian John Canemaker as my professor at New York University. In the years since I earned my degree he has continued to be an inspiration and a mentor.

At Focal Press I must thank Lauren Mattos who contacted me and initiated the entire project. She can't imagine how important this has been to me. Haley Swan took over for Lauren, and did all the hard work involved in shepherding a first-time author through the process. I really hope she is pleased with the results. I would also like to thank Sean Connelly, Lisa Blackwell, Anna Valutkevich and Abigail Stanley.

Thanks to Ben Mitchell for his feedback on the project. In a book that emphasizes the importance of audience feedback for performers, it would be ridiculous to have ignored him. Appreciation also goes to my sister Lois Rogers for her comments on my writing, and general encouragement.

It is now easier than ever to locate public domain images via the World Wide Web, and I am grateful to all those people who have contributed items for everyone to learn from. We are all fortunate to have non-profit sites such as Wikipedia.org, and Archive.org to maintain these collections. In researching this book I visited more web sites than I could possibly remember or call out, but I will point to Tvtropes.org as being particularly useful.

Thanks to all the funny people whose work has made life a little easier.

Thanks to my kids for putting up with my occasional grumpiness and absence due to this project. I am better for it now. Ultimately I must thank my wife Wendy. She is the best thing that ever happened to me.

CHAPTER 1

Introduction

Laughter is fundamental to human existence. Babies begin to laugh before they can talk, so it's safe to assume humans would make each other laugh before we had formal language as well. I imagine that back in prehistoric times, a caveman dropped a rock on his foot and hopped around in pain, and another caveman laughed at him. Later on in the evening, gathered around the fire, the caveman who laughed re-enacted the scene for the others who weren't there, and people laughed with him. Each time it was re-enacted it probably got amplified, with ever more funny faces and ridiculous howling. Every night the others would urge him to do that rock-dropping-on-the-foot business again. With a little improvement each time, he could probably get several shows out of it before people had seen it enough. Then, he had to either find someone new to make fun of, or make something up.

That could have been the beginning of the long history of physical comedy. Physical comedy is a distinct art form, different from verbal and written comedy. I wrote this book because I am fascinated by anyone who can make me laugh without words. For 25 years I have studied the art and history of visual comedy. The animated cartoon is one branch of the whole tree of physical comedy. When studying any art form, it's always important to know the history of what has been done before. If you want to make funny cartoons, you can learn from the successes and failures of the past. All cultures, Eastern and Western, throughout time, have had their comic characters. In their wonderful book *Too Funny for Words,* Frank Thomas and Ollie Johnston had this to say:

> Our ancient history is filled with accounts of the magical spell woven by storytellers and troubadours, but laughter was found more often in the artistry of various types of clowns and, particularly, mimes.[1]

Today, when we hear the word **mime**, we think of a silent actor in white face pretending he is inside an invisible box, or walking into the wind. At its root, the word mime simply means **to imitate**, just as the previously mentioned caveman imitated his less fortunate friend. The words mime and **pantomime** have had various uses throughout the centuries. For instance, an ancient Greek pantomimist acted out all the parts in a play by himself, accompanied by a chorus and music. In England, in the early eighteenth century, a popular form of musical comedy was eventually called pantomime. We will look at the history of the panto in a later chapter.

What Thomas and Johnston were emphasizing was the physicality of the performers. Animators are in the business of making characters move so that the audience can understand what they are thinking or feeling, even if they are not talking. Actors in large theaters have always had to act "big" to reach the furthest rows. We can also call this pantomime acting, regardless of whether the character speaks or not. To create this sort of highly physical performance, beginning animators must learn the principles of animation. By knowing how to stage an actor, carefully time an action, or exaggerate small movements, communicate better to the viewer. There are many great books and resources that teach these principles, and that's where animators must begin. This book is intended as a sort of "next step" in the process. Once someone understands the basics of physical acting, or pantomime, or the principles of animation, the challenge remains of what to do with them. Animation is capable of delivering any sort of story, but it found its greatest success with characters who could make people laugh. Just as silent film comedians are still admired for their movies, some of animation's greatest success came in the early years. How did the golden age of animation happen?

The pioneers of animation didn't have instruction books, schools or online classes. They were figuring it out as they went. When looking for ways to entertain people with funny stories, they took their inspiration from what they saw on vaudeville stages and in silent film comedies. Those were the popular entertainments of the day, and to be successful, you gave people more of what worked. Frank Thomas and Ollie Johnston, in their book *Too Funny For Words!,* wrote about Walt Disney:

> Whenever a famous vaudeville act would come to town, Walt bought tickets for his top men to be sure that they would see these fine performers, and remember them.[2]

Vaudevillians worked extremely hard to please the audience. They had a daily, interactive relationship with each other. Every showman on stage reached out to get as much attention as he or she could. When Charlie Chaplin left the stage to work in films, he brought that thinking with him. In his second appearance on film, he debuted the tramp character that would make him famous. The movie, directed by Henry Lehrman, was called *Kid Auto Races at Venice* (Keystone Film Company, 1914), and the camera is set up documentary style, filming the crowd watching the soap box style races. The oddly dressed Chaplin repeatedly steps into the frame, stares into the camera and tries to get our attention. He was saying "Look at me." This impertinent behavior captured the attention of the public. Only a comedian dares to look into the camera, and then only the star.

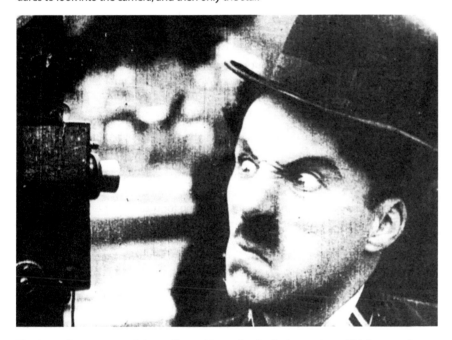

Figure 1.2 Charlie Chaplin, *Kid Auto Races at Venice*, 1914

Courtesy Everett Collection.

The comedian is aware of the audience. He, or she, is playing to them. This is a very important concept in this book. Modern theater can be divided into two general forms, **representational** and **presentational**. The primary way to distinguish them is by how they relate to the audience. Representational theater creates an imaginary **fourth wall** that the audience can look through and see a representation of a story. Presentational theater removes that wall, and allows the performers to be conscious of the audience watching them. They are presenting a show. The caveman is playing to the tribe, trying to make them laugh.

In representational theater, the story is essentially carved in stone. It is the creation of a writer, who has sealed the diorama for all to enjoy. The actors can bring different forms of energy to the part, but they are still restricted by the text. Great stories can live for hundreds of years, and be performed by many, many different casts. The actors can come and go, but the story lives on. There are, of course, comic versions of representational stories. One example would be the **well made play**. The subjects of these plays are the upper class, where one character tries to initiate a scheme, or keep a secret. Problems arise, and as the play progresses, the intertwining intrigues create what appears to be an

inescapable web. Then, in the final act, the writer reveals his skill by his ability to extract the hero from doom, get someone married, and tie up all the loose plot points. In high comedy, verbal wit is demonstrated far more than physical skill.

In short, representational theater is controlled by writers, while presentational theater is created by performers. You could read the script of a dramatic play, and enjoy the story. But reading a Laurel and Hardy script would be a waste of time. In vaudeville, each act was responsible for its own portion of the program. Nobody told them what to do. They were their own writers and directors. Part of the excitement was that anything could happen. All of them went on stage to demonstrate their virtuosity in some art form. They were there to entertain, and to amaze. It is in presentational theater that we can find the most energetic characters to study. Both forms of storytelling are employed in animation. But the work of the animator is different in each. In representational stories, the animator must follow the text and play his or her part in the story. In presentational work, the animator can sometimes make all the decisions about what the characters do, and is far more responsible for their success. It is a different expectation. Where animators on a big studio feature would do well to study traditional acting, the animator looking to create a funny cartoon character should continue reading this book. In 1906, *Variety* critic Acton Davis wrote:

> It is his [the vaudevillian's] business to do and to do quickly everything which an actor on the regular stage is taught and schooled to avoid.[3]

Presentational comedians do not create stories. They create characters. With some exceptions, they generally create one character, which they develop for their entire careers. Or, they spend their careers searching for the right one. Once they have the character, they let the character create the story. The actor and the character become fused. He, or she, cannot be replaced by an imitation. The Marx Brothers only play themselves. Only Jim Carrey can be Ace Ventura. Character driven comedy is a different art than the plot driven comedy of representational theater.

In the golden age of cartoons, writers only helped create the basic outline of the story, and perhaps wrote dialog. The artists worked together to develop characters who could carry a whole story on the thinnest of plot ideas. Some studios, such as Fleischer's in New York, created some Popeye and Betty Boop cartoons on the fly. Each animator was given near total control over what happened within his own shot. It resulted in inconsistent quality, but also had a quirky, unpredictable charm. That is very much a vaudeville style of working.

According to Chaplin, the Tramp came into being when he was told to grab a costume from the wardrobe. He hastily pulled together the oversized pants, undersized jacket, bowler hat, flexible cane and the little mustache he preferred. As Chaplin tells it:

> I had no idea of the character. But the moment I was dressed, the clothes and the make up made me feel the person he was. I began to know him, and by the time I walked onto the stage he was fully born.[4]

Audiences responded instantly. Within a few years Chaplin would be an international sensation. And he achieved it all without words.

No stand-up comic has ever achieved such fame. The stand-up comic tells jokes, has minimal movement, and talks in one language. Jokes often depend on some shared understanding of current events, fashions, popular expressions, or humorous dialects.

Verbal comedy tends to age, so a book of jokes from 1916 would probably be completely unfunny today. Physical comedians work the realm of the human body, essentially unchanged for thousands of years. This is why audiences didn't need to understand the titles to enjoy Chaplin, and this is why he was the first international superstar. The stories were little man vs. big world, and everybody could relate to that. Cartoon characters who can communicate without words have also been widely accepted and beloved.

The rewards of success are deeply gratifying. Making an audience laugh is a validation that only a comedian can experience. There is another potential benefit too: money. The history of comedy is not just the history of an art, it is very much the history of a business. A musician can enjoy playing his own instrument, a painter can decorate her own walls, a dancer can simply love to move. A comedian needs an audience. If a comedian slips on a banana peel in the forest, and nobody is there to see him, it is not funny. In studying the comedians of the past, I routinely learned about their financial successes and failures. People can discuss art to no end, critiquing and reviewing, appreciating and dismissing. Comedy is easily judged by the reaction you get. It requires finding and holding an audience. Hundreds of years ago, if you were putting on a show in the street, and you didn't make people laugh, you would go hungry that night. Make them laugh, and have more come the next day, and you can feed your family.

So where does one learn the principles of successful comedy? Historically, in the world of live theater, you were taught one on one. Children were born into theatrical families and were immersed in the life. Others joined the show and worked all the behind the scenes jobs, while practicing on their own time and hoping for a chance. To work in vaudeville, you would watch the acts and try to develop something similar, but better. Some will say that you can't teach people to be funny. You either have it or you don't. I do not agree, and neither did silent film great Harold Lloyd. He built his fame with simple hard work. He said:

> Look, all the comedians of my day had to be students of comedy. You studied comedy, it just didn't happen, believe me.[5]

Actors are still studying it. Today, around the world, there are small programs that teach physical comedy. Students begin with the same basic exercises; taking age-old challenges and stepping up to see what they can do with them. Students will devise new characters and each character will have a fresh way of dealing with a situation. History will show that, in physical comedy, the same concepts are regularly reused, and renewed, by generations of comedians. Rowan Atkinson, the actor responsible for Mr. Bean, has this to say:

> In visual comedy we see the same ideas crop up again and again. The wit of the comedian often lies in creating new variations of old ideas. He can do this because the success of any comic idea depends not just on the skill with which it is executed, but more importantly on the attitude with which it is performed. New attitude—new joke.[6]

Yes, old ideas get reused again and again. Do not feel you have to create something that is absolutely original. Many artists have painted bowls of fruit, but each is different. Some are more interesting than others. In slapstick, it's all been done before. Many

famous comedians recycled their earlier ideas into fresh situations. You just need to apply it to characters and situations that your audience will appreciate. The first step then, is to build a library of material to draw from. Frank Tashlin directed numerous cartoons at Warner Brothers, then left to work in live action. He was a gag writer for the Marx Brothers and Lucille Ball, a screenwriter for Bob Hope and Red Skelton, and a director of several movies featuring Jerry Lewis. In the book *Tex Avery: King of Cartoons*, Joe Adamson interviews Tex Avery. Avery says:

> Frank Tashlin was working for Schlesinger then, too. We called him Tish-Tash. He had a cartoon strip, and he fooled around. He would see cartoons and he would go to the old slapstick movies with a little flashlight and a little black notebook, and he would note down every Charlie Chaplin and every Laurel and Hardy gag he saw. We used to kid him about his little black book, because he was always looking in it for a joke. Well, the laugh was on us. He went much further in this gag business than we ever did.[7]

The image of Frank Tashlin scribbling in a notebook in the dark makes it sound like work. I imagine the notes went down in between the laughter. Of all the things in the world you can study, I can assure you that comedy is the most fun. It will be time well spent, and if you learn to recognize what you are looking at, your own work will improve. If you are a student who wants to build a great demo reel, you could hardly do anything more impressive than create a genuinely funny character. You might be an independent artist who wants to own a popular character, which can be a valuable piece of intellectual property. Maybe you are a professional who wants to take total ownership of a piece of work. Writers of animation can certainly learn some new approaches. Any of you should find inspiration here.

Notes

[1] Thomas, Frank and Ollie Johnston. *Too funny for words!* (New York: Abbeville Press, 1987), p. 49.

[2] Ibid., p. 15.

[3] Jenkins, H. *What made pistachio nuts* (New York: Columbia University Press, 1992), p. 62.

[4] Chaplin, Charles. *My autobiography* (New York: Simon and Schuster, 1964), p. 144.

[5] Maccann, Richard Dyer. *The silent comedians* (Metuchen, NJ: The Scarecrow Press, 1993), p. 215.

[6] Atkinson, Rowan, David Hinton and Robin Driscoll, "Visual Comedy." *Funny Business.* 22 November 1992.

[7] Adamson, Joe. *Tex Avery: King of cartoons* (New York: Popular Library, 1975), p. 164.

CHAPTER 2

The Dirt Floor

The Ancient Greeks

Figure 2.1 Thalia, the Greek muse of comedy

Ancient Greek history is not the first place one would think to look for comedy, but that is where Western theater began. In fact, it was the merry-makers who came first. Centuries before Aeschylus, "The father of tragedy," began writing his plays, traveling troupes of minstrels, jugglers, acrobats, and mimes were putting on shows. The Greeks held celebrations for Dionysus, the god of winemaking, and of ritual madness and ecstasy. The festivals, called **Dionysia**, began in the rural areas and were held in the months around the winter solstice. It was certainly a time for drinking and the performances were historically lustful, with earthy characters sporting cartoonishly large phalli, as well as hugely padded buttocks and bellies. Distorting the human image for humorous effect has origins long pre-dating comic strips and print media.

They began the tradition of using character **types** for creating comedy. Types are sometimes called **stock characters**, and they provided a common foundation for the actor to build on. Stock characters also allow the audience to quickly recognize and understand them. These ancient comedies had three basic types; the **eiron**, the **alazon**, and the **bomolochus**. These three archetypes are the foundation of many characters to come. The connection between the eiron and alazon is one of the most fundamental comic relationships there is.

Figure 2.2 Statue of Greek eiron

Photo by Marie-Lan Nguyen.

The eiron was a clever character who pretended to be less intelligent then he was. It is trickery. These characters were of low social status, commonly slaves. It was unthinkable for a slave to be smarter than his master, and so he could not behave that way. Because the slave acts dumb, the master never suspects that he is hatching a cunning plan. Eiron, is the root of the word **irony**. It is ironic that the slave knows more than the master. Don't let the role of slave mislead you. The eiron is any character who appears to be weak, vulnerable, or stupid. For example, Tex Avery's Droopy is a very small dog with tired eyes. He walks with little steps and speaks in a slow drawl. All that is merely a façade to set up his opponent to be surprised at Droopy's astonishing abilities. The eiron played his game against the alazon.

The alazon was any character who had a high opinion of himself, or pretended to be more than he was. Clearly, he is the opposite of the eiron. Classically, the alazon was the master to the slave, and of course he always believed himself to be correct. That overconfidence was his undoing. It is up to the eiron to fool the alazon. The alazon usually came in two forms; the **controlling father figure** (senex iratus) and the **braggart soldier** (miles gloriosus). These two characters will be discussed further in Chapter 5. For our purposes we can apply the title alazon to any overconfident character. In animation this might be the villain. It might be someone who is physically powerful, or simply in a bad mood. Droopy Dog was pitted against the much larger wolf. Based on their visual appearance and energy levels, the wolf has a huge advantage, but things never went his way. Bugs Bunny routinely had to defend himself against the perpetually angry and heavily armed Yosemite Sam. Tweety Bird was as vulnerable a character as you could find, and he was pursued by his natural nemesis, the cat Sylvestor.

The third common character, the bomolochus, was the buffoon. This character is vulgar and ridiculous, but amusing. He is truly ignorant, unlike the sneaky eiron. A purely stupid character always has lots of comic potential. He breaks the rules of society because he doesn't know any better, and that is why he can get away with it. His stupidity allowed him to be manipulated by the first two characters, the eiron and the alazon. He could help the eiron and hinder the alazon. A third character widens the selection of potential storylines. Audiences enjoy the buffoon for two reasons. First, they feel superior to him. Second, they envy him. He isn't as inhibited and constrained as they are. His honesty is freedom.

From these three basic archetypes have risen an uncountable number of characters. Playing on cleverness, deception, self-deception, foolishness, and bad social skills, they represent simple human characteristics that we can never outgrow.

In time, the writers arrived and began creating plays to be performed for the summer theater festivals. This is when the sad stories became so important. The symbol for theater is the two masks, one laughing and one crying. The crying mask represents **Melpomene**, the Greek muse of tragedy, and the laughing mask is **Thalia**, the muse of comedy. Theater was now balanced.

These festivals were competitions, and writers of tragedies had to submit four plays, one of which was humorous. After a trio of tragedies, the audience was treated to some comic relief in the form of a play that made fun of the first three. Called a **satyr** play, it is the root of the word **satire**. "Always leave them laughing" is one of the best mottos in show business.

Medieval Comedy

During the medieval era, times were difficult, to say the least. Life was short and full of hunger, war, crime, and disease. To get a moment's relief, they enjoyed whatever entertainment could be found. But churches in the medieval era had strict guidelines for what themes were appropriate for literature and theater. Religious institutions are often suspicious of popular culture. Putting on a show usually required permission from local authorities, and the best way to get permission was to have a religious theme to the work. Most interesting to animators would be the **miracle plays**.

Figure 2.3 "The demons were generally funny." Mystery or miracle play, where biblical stories and subjects were acted out for the benefit of the largely illiterate populace during the European Middle Ages

Picture courtesy Mary Evans Picture Library.

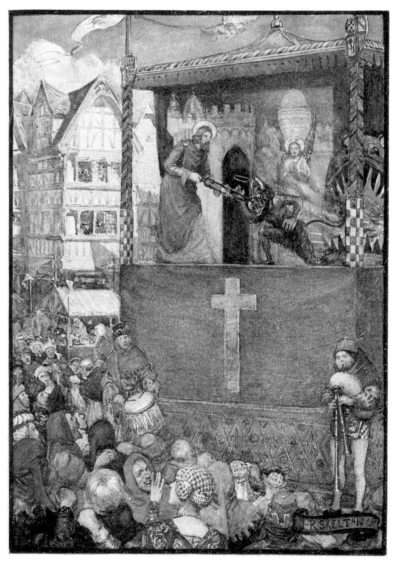

THE DEMONS WERE GENERALLY FUNNY.

When an animated character faces a moral dilemma there is a common trope used to bring it to life. That is of having an angel on one shoulder, and the devil on the other, each presenting his case to the character. Miracle plays used the same concept to impart moral lessons to the people. The protagonist would be a representation of the common people. He would encounter a variety of characters who represented moral values of good, and others who were temptations to evil. Virtuous characters with names like Fellowship, Knowledge, and Good Deeds gave serious speeches about proper behavior. Action and comedy were handled by the one named **Vice**. Dressed in the jester's cap and bells, he represented the seven deadly sins; Avarice, Gluttony, Lust, Pride, Wrath, Sloth, and Envy. Seven fine starting places for a laughable character. One of the best tools of storytelling is to take a concept, such as a human trait, give it legs and a mouth and make it walk and talk. Ultimately, Vice would howl with exaggerated terror as he was lifted up by the devil and carried off into the "hell mouth," a huge sculpted maw of a demon with fangs and smoky breath. Hell was always placed on stage left (the right side of the stage to the audience). The good characters always entered from the other side, stage right. This was the origin of the common practice of good guys moving from left to right, and the villains moving from right to left in opposition.

It is also in the Middle Ages when we see one of the earliest known examples of using comedy to sell things. **Mountebanks** were traveling salesmen who peddled medicines to the gullible peasants. To gather a crowd, the mountebank would set up a temporary stage, a sort of bench. Mountebank means to "mount the bench." First up was his zany partner, a clown to caper and joke. Humor would put the customers into a good mood, making them more agreeable. Once he had assembled enough rubes, the mountebank would take over with his pitch that extolled the wonders of his potion or pills. The zany is comparable to the modern advertising character, such as Tony the Tiger, Captain Crunch, or the Pillsbury Doughboy. Characters who behave in comical ways to get attention and create a positive association for the product

Commedia Dell'Arte

Beginning in sixteenth-century Italy, the commedia dell'arte was a popular form of open-air entertainment. The stories used some of the archetypes found in Greek theater. There were clever servants (the eiron), who came to the aid of the young romantic couples, and who work in opposition to the elders (the alazon). Each actor played the same part every time, only the situations were changed. Same characters— different stories. They used a production method that is very similar to the way early slapstick comedy and cartoons are produced. The actors did not have a set script. Instead they worked from a rough **outline** that provided key plot points to hit. These were routine stories of love, jealousy, pride, and greed but filled out with substantial helpings of comic material. Just as cartoons start with simple outlines, and the story artists fill in the action with funny ideas, the actors in commedia could fill in the rest with comic business chosen almost at random. These gags and routines were called **lazzi**. They appeared to be improvised, but were actually well rehearsed. Lazzi routines

Figure 2.4 Commedia illustration by James Callot

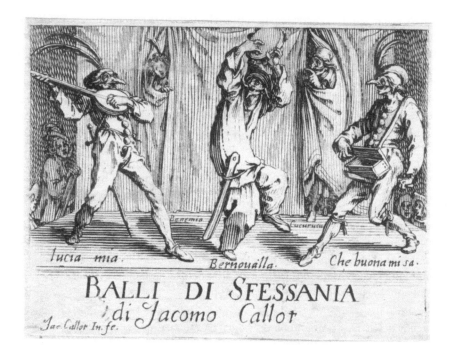

were rarely documented, as they were considered a sort of trade secret within the acting companies. In his book *Lazzi: The comic routines of the commedia dell'arte*, Mel Gordon presents as much as is known on the topic. He divides the routines into 12 categories, and these categories can be described with modern equivalents. Keep in mind this is based on one particular style of theater, and it is by no means the ultimate list of all possible kinds of comedy gags. It does provide one perspective on the possible varieties of physical comedy.

- **Acrobatic and mimic lazzi.** Live actors must put a great deal of work into perfecting acrobatic skills, and it pays off on the stage. Virtuoso performances such as these are a separate challenge for animation, so I will focus on the "mimic" aspect of this category. Mimic comedy is any actor pretending to be someone, or something, else. The actor on stage creates a comical caricature, often to fool somebody. For further examples, see mimicry in Chapter 9: "Gags and Comic Events."

- **Comic violence/sadistic behavior.** Gordon points out that the commedia was "set in a world of masters and servants,"[1] and it made fun of the cruel behavior that could be found there. Comic violence is certainly well known in animation. Characters who commit violence are not always doing it in anger. Whenever Bugs Bunny tricks Elmer Fudd into shooting Daffy Duck, he seems to be taking a little perverse pleasure in making it happen.

Figure 2.5 Commedia illustration by James Callot

- **Food lazzi**. The zany characters, called zanni in commedia, were poor folk, and routinely hungry. The pursuit of food was something to which the audience could relate. Maybe one of the most common food lazzi found in cartoons involves a starving person looking at another character, and visualizing them as some sort of tasty dish. In animation, it is possible for the characters to *be* the food. On a few occasions, Bugs Bunny found himself sitting in pot or a pan being prepared as a meal.

- **Illogical lazzi**. This is where characters are doubly stupid. Gordon writes: "Frequently, the comedy works because the offending character … not only thinks he has fooled the others, but suddenly convinces himself of his illogic."[2] That reminds me of when Wile E. Coyote paints a picture of a tunnel on the side of a wall, and waits for the Road Runner to smash into it. When the Road Runner actually enters the tunnel, Coyote believes what he sees. When he tries it, he flattens himself against the rock.

- **Stage properties as lazzi**. Commedia companies created special trick props to use in their routines. I include an entire chapter on the use of props in comedy (see Chapter 10 "Props").

- **Sexual/scatological lazzi**. In post-medieval Europe, humor was far more vulgar than it is today. Much of it would be considered obscene by modern standards. Still, when Tex Avery's wolf goes into gyrations at seeing a pretty dancer we could categorize that as sexual lazzi. Today scatological humor is commonly delivered in the form of fart jokes.

Figure 2.6 Commedia illustration by James Callot

Cap. Cardoni. *Maramao.*

- **Social-class rebellion lazzi**. Similar to the comic violence lazzi, this comedy is based on the disparity between the rich and the poor. It often involved some role reversal, where the master gets put into the servant position. Bugs Bunny would often go to war against an important person such as an opera singer, or a Texas oil millionaire. He would trick the important character into doing foolish things.

- **Stage/life duality lazzi**. This was any time an actor broke out of the illusion of a story, usually to make fun of the show itself. Many times, cartoon characters will speak to the audience, or hold up a sign that comments on what is happening. The most extreme example is Chuck Jones' *Duck Amuck* (Warner Brothers, 1953), which had Bugs Bunny controlling all the events in Daffy's world.

- **Stupidity/inappropriate behavior**. This is when characters are ignorant of the basic rules of human interaction. It's about being terribly inconsiderate. In the Warner Brothers short *A Pest in the House* (1947), directed by Chuck Jones, Daffy Duck plays the bellhop at a hotel. A guest checks in who is very tired, and needs peace and quiet to rest. Daffy repeatedly, and loudly, declares how quiet he will be. From then on, Daffy does everything in a very noisy way, all the while saying he's trying to keep things quiet.

- **Transformation lazzi**. This lazzi makes fun of how people's thoughts can transform quickly. Gordon writes: "Greed, fear, anger, envy, recognition, all produce an instantaneous transformation in commedia characters." [3] In the Chuck Jones short *Ali Baba Bunny* (Warner Brothers, 1947), Bugs and Daffy tunnel into Ali Baba's treasure cave. Like Scrooge McDuck, Daffy goes crazy over the gold, diving in and swimming through it as though it were water. In this category, Gordon describes "lazzi of Nightfall" which includes actors on stage pretending to be stumbling around in the dark, being confused about what is going on. This reminds me of scenes in cartoons when everything is black, and all that can be seen are the characters eyes. The comedy is carried by the sound effects, dialog, and the shape of the white eyes on the black background.

- **Trickery lazzi**. There are very many tricks played in cartoons. To describe this I am going to choose one that I call the "lazzi of the dance." This is any time Bugs Bunny starts playing music, and his antagonist feels compelled to dance to it, making the antagonist look foolish.

- **Wordplay lazzi**. Wordplay is the realm of the writer, but there is an example that should be familiar to cartoon lovers. This is any time two characters are in a simple ping pong argument, and one switches sides. The other is accustomed to giving the contradictory answer, so he switches too. For example, Daffy Duck is wearing a rabbit costume and Bugs Bunny is dressed as a duck. The argument goes "Rabbit season!" "Duck season!" "Rabbit season!" "Duck season!" Then Bugs switches to "Duck season" and Daffy replies "Rabbit season!" He is then instantly shot by Elmer Fudd.

Where commedia actors strived to memorize and perfect popular lazzi, animators need to simply understand their use, and innovate on the basic ideas. Familiarity will help connect the audience to the humor. There are endless possibilities to create new lazzi for any form of comedy.

In the mid-1700s the commedia dell'arte was very popular with the people but a certain comedy playwright named Carlo Goldoni had new ideas. In the book *The World of Harlequin*, Allardyce Nicoll writes:

> Basically, Goldoni was concerned with bringing character, social criticism, and moral purpose to the stage, and for achievement of this objective he required a realistic framework.[4]

His actors could no longer wear masks or improvise or directly address the audience. They had to adhere to a script carefully crafted to reflect the social values being promoted. Goldoni was the theater's representative of the intellectual movement known as The Age of Reason. Nicoll writes:

> The age of reason and sensibility had no use for the exercise of fantasy, and the actors business came to be the presentation of the real as adapted by the dramatist to inculcate a moral lesson.[5]

Goldoni succeeded, and the commedia dell'arte lost its vitality. A presentational form of theater was taken over by a writer. Carlo Goldoni was Judge Doom to the Toontown of the commedia. By then, however, the commedia had spread far beyond Italy, and had become quite influential in other European countries. The characters were adapted to suit the tastes of other people. The traditions were not completely lost, and there are still schools and teachers preserving the original methods. In the chapter dedicated to character, I dig deeper into describing the important archetypes of the commedia (see Chapter 5 "Essential Characters").

Shakespeare

Fools and clowns were central to Shakespeare's success. His serious reputation belies how much he relied upon these characters to win the audience. While he wrote 12 tragedies, he produced more comedies, 16 in all. Furthermore, the tragedies contain a

significant amount of comic material. He made more use of fools and clowns than any other playwright of his time, and to better effect. Nearly every play has at least a few lines dedicated to the "clown," and some, such as King Lear's Fool, are essential to the story. In the tragedies, the fools tended to appear immediately after the scenes with the most intense violence. They would help lighten up what can be rather heavy and dreary plots. While this might be considered "comic relief" it was actually more than that. Even the small parts for clowns and fools could provide a perspective on the situation that might have eluded a portion of the crowd. Paradoxically, the fools are often the characters most likely to say something witty and, therefore, expound on the meaning of the events. While they may not be absolutely necessary to the story, they developed the entertainment value and were informal narrators. Spectators were accustomed to comedic characters interacting with them. They are a presentational character, inside a representational story, commenting on the action.

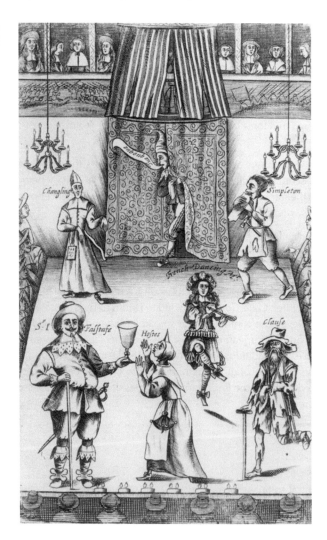

Figure 2.7 Frontispiece to "The Wits," showing various theatrical drolls, including Shakespeare's Falstaff in Restoration theatre in England

It has been widely observed that the Disney animated feature *The Lion King* (1994), directed by Roger Allers and Rob Minkoff, has numerous similarities to Shakespeare's *Hamlet*. Mufasa the king is murdered by his ambitious brother Scar. Mufasa's son Simba banishes himself in despair, but ultimately returns to take back his kingdom. While he is away, he makes friends with a warthog named Pumbaa, and a meerkat named Timon. These two are often likened to Rosencranz and Guildenstern, two comic characters who befriend Hamlet. However, those two are false friends to Hamlet. There is another Shakespeare character who influences a wayward prince, and that is Falstaff, friend to Prince Hal in the two plays of *Henry IV*. Falstaff is a fat and cowardly drunkard, but he lives life to the fullest. In those two plays, prince Hal forsakes his royal duties to hang about with lowlifes, including Falstaff. It is a situation very much like when Simba flees his kingdom to sing "Hakuna Matata" with Timon and Pumbaa. Both Falstaff and Pumbaa help their respective princes avoid responsibility, and destiny. While Pumbaa eventually becomes Simba's ally, Falstaff is rejected by Prince Hal, and left behind. After all, in a tragedy, you can't have the funny character hanging around at the end, slapping the protagonist on the back.

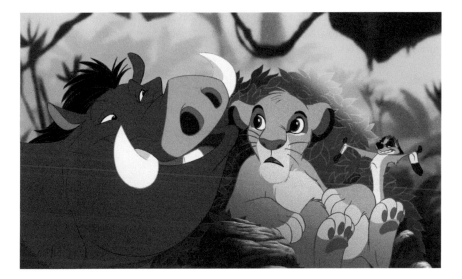

Figure 2.8 *The Lion King*, 1994

© 1994 Disney.

Another animated fool who helped out a friend is Dory, the blue tang in Pixar's *Finding Nemo* (2003), directed by Andrew Stanton and Lee Unkrich. She is paired with Marlin, the clown fish (ironically) who can't forget what happened to Nemo's mother. The flaw that makes Dory look foolish is that she remembers almost nothing. Many of her jokes are based on having forgotten something she learned only moments before. By being with her, his opposite, Martin learns to let go and live for the moment. The take away here is that comical characters can be used for much more than distracting the audience with laughs. And they are not always antagonists trying to irritate another character. Some bring comic relief to the characters *within* the story. Characters like Falstaff and Pumbaa can provide an invaluable vacation for a stressed out

prince. It is a certain kind of fool, who helps the character who is uptight, stressed or overly serious. J. Philip Newell wrote:

> The fool is calling us to be truly ourselves and points out the falseness of what we have become. He is not, however, over and against his hearers. Rather he invites them to discover the fool inside themselves.[6]

These are great characters for long form films. If you get your protagonist into a terrible bind, perhaps the solution can be inspired by the character who seems least qualified to provide it. It is the fool's ability to see things in unusual ways that allows him, or her, to bring a surprisingly clever perspective to the events. Being considered foolish does not necessarily mean you are wrong.

Comedy has the potential to reveal the apparently smart person to be a phony, and the idiot is the only one brave enough to speak the truth. These centuries old forms of theater established so much of what we still use today. We still like seeing the poor and weak being clever, and the rich and powerful making mistakes. We can relate to jealousy causing romantic complications. There are still liars who try to fool others, and we enjoy seeing them exposed and humiliated. Greed and hunger are powerful motivations for stories. These are all topics that speak to our hearts and minds. While the ancient Greeks and Shakespearean clowns may seem archaic, what made them successful is still relevant today. Audiences haven't changed that much.

Notes

[1] Gordon, Mel. *Lazzi: The comic routines of the commedia dell'arte* (New York: Performing Art Journal Publications, 1983), p. 14.

[2] Ibid., p. 25.

[3] Ibid., p. 47.

[4] Nicoll, A. *The world of Harlequin* (Cambridge: Cambridge University Press, 1963), p. 205.

[5] Ibid., p. 216.

[6] Newell, J. Philip. *Shakespeare and the human mystery* (New York: Paulist Press, 2003), p. 117.

CHAPTER 3

Palatial Theaters

GATHERING FOR THE PANTOMIME; A DREAM OF CHANCINANCIA.—DRAWN BY ALFRED CROWQUILL.

Figure 3.1 Illustration of Pantomime by Alfred Henry Forrester, aka Alfred Crowquill

The previous chapter described the world of itinerant actors, small troupes, and local theaters. After the Elizabethan period, restrictions on performances slowly lifted, allowing it to become more viable as a business. Theater producers built larger venues to put on growing shows. Rather than struggle on their own, individual artists and teams could be hired to be part of a larger program of variety. Talented actors could find large audiences, international fame, and financial success.

English Pantomime

The Italian commedia dell'arte traveled the continent, through France, and by the end of the sixteenth century entered into England. As the Italians spoke only their own language, their performances became more dependent on song, dance, and mimed acting. In England, the Italians had a short run, but a variation of their theater arrived in the early eighteenth century. Troupes of French actors adapted the commedia and put on shows they called "Italian Night Scenes." These comedies featured the same basic characters as the Italians. These were highly physical performances using mime and acrobatics. The settings were anglicized as well, with London now replacing Italy. Although considered vulgar, the shows were quite popular, and English companies soon took up production themselves. The clever Italian servant Arlecchino was transformed into Harlequin, and became the romantic lead. He and Columbine were lovers on the run from her father, Pantaloon, and his silly and untrustworthy servants.

In 1717, John Rich produced a series of pantomimes called Harlequin Sorcerer, which mixed classic fairy tales with the comic action of Harlequin and Columbine. These productions would add components that we would recognize in animated films today. First, Rich introduced a magical element with Harlequin's slapstick doing double duty as both comical weapon, and magic wand. With his wand, he was able to transform not only scenery, but characters. In 1871, a production of *Robinson Crusoe* as a panto introduced a major development: the transformation scene. As the story from the first act wound down, the characters were magically revealed to be the personalities of the Harlequinade. This was followed by another staple of action and comedy in films, the chase. John Towsen describes it:

> In those days, pantomimes were divided into two parts, the opening – a fairy tale in dance, dialogue and song—and the madcap harlequinade. The two halves were linked by a transformation scene in which a benevolent agent such as Mother Goose, or a Fairy Queen miraculously change the characters of the opening into such stock types as Harlequin, Columbine, Pantaloon, and Clown. The plot shared by both parts usually centered around the romance of two young lovers . . . The inevitable result was a long chase scene with Pantaloon and his not so loyal servant, Clown, in hot pursuit of Harlequin and Columbine. It was as if a performance of Cinderella suddenly turned into a Keystone Cops comedy.[1]

The transformation scene included spectacular changes in stage scenery, with the setting of the first story metamorphosing into the fantasy world of Harlequin before the eyes of the audience. Once the transformation was complete, Clown would shout

out "Here we are again!" and the audience was primed for the fun. Creating massive trick effects became one way the theaters brought in audiences, just as movie studios plan spectacular set pieces for their summer blockbusters. Extensive machinery and trap doors allowed actors to leap into and out of the set almost instantly. The chase scene was an exciting finale that sent the audience out with a smile. It is not unlike many animated films that includes a chase scene somewhere in the second half of the film. These chases build up the energy towards the climactic confrontation. In Blue Sky's *Robots* (2005), directed by Chris Wedge, Rodney saves his hero Bigweld from being taken away for scrap, that leads to a wild and dangerous chase through Robot City. In Pixar's *The Incredibles* (2004), directed by Brad Bird, the Incredible family returns to Metroville by dropping from the sky in a recreational vehicle, and careening through the streets. All the while the mom and dad are arguing like a normal family. In Sony's *Surf's Up* (2007), directed by Ash Brannon and Chris Buck, the young penguin Cody is surfing in the championship against his nemesis Tank, that leads to a run through the treacherous "bone yard."

Animated films have transformation scenes as well, but they tend to occur just after the climax. In *Beauty and the Beast* (Disney, 1991), directed by Gary Trousdale and Kirk Wise, Belle finally tells the Beast she loves him. That breaks the spell and the enchanted inhabitants of the beast's castle are restored and the castle returns to its former glory. Sometimes the environment seemingly responds to the narrative, such as in *The Lion King* (Disney, 1994). Once Simba is restored to power, the rain returns and the land reawakens as though it were spring in fast forward.

As Harlequin became the lead, a new character had to take over the job of getting the laughs. This now fell to Pantaloon's servant Clown. And one clown in particular, Joseph Grimaldi, rose to set the standard for all clowning to come. While his name is Italian, he was an Englishman born in London in 1778. He would become the most celebrated actor in all of pantomime. Though he never appeared in a circus, all future clowns would be nicknamed Joey in his honor.

Figure 3.2 Joseph Grimaldi, the greatest pantomime clown

Grimaldi's Clown practiced the art of mischief making, which is also known as knavery. In his case it often expressed itself in petty theft. As comedy is often about poor people, being hungry is a common theme for the characters. To feed his enormous appetite, he used cleverness and quick hands to grab pies, large pieces of meat, and strings of sausages that would easily disappear into his secret and voluminous pockets. Grimaldi was an expert swordsman, dancer, and acrobat. To underscore the value of exaggeration in cartooning, Lowell Swortzell describes Grimaldi's highly animated face:

> Joe's essential comic gift was the uncanny mobility and expressiveness of his face and body . . . Joe's glances, winces, and scowls instantly projected his volatile emotions to the farthest reaches of the gallery. His nose seemed almost to roam at will across his face. His busy tongue darted out irrepressibly, slyly punctuating a joke, or signaling heartfelt but inexpressible feeling. His jaw, a contemporary recalled, had the power to lower his chin an alarming distance down his waistcoat, taking the ears along with it. His famous grin was said to travel across his plump face from ear to ear, then, just as suddenly, to retreat into a frown or grimace.[2]

Figure 3.3 Illustration of gags by pantomime clown. Including blowing up a policeman, reassembling his parts, and bringing him back to life.

Artist: Phil May

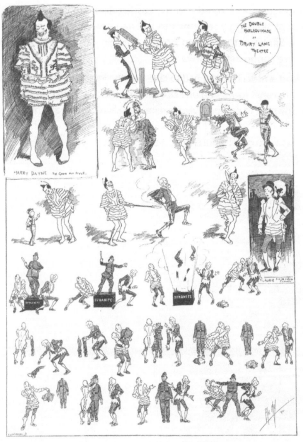

English pantos gave us the peculiar character of the **pantomime dame**. This is an older female character who is always played by a male actor. Often it is a large man, who is flamboyantly dressed, wears heavy make-up, and a substantial wig. The contradiction in gender makes for a provocative character, but it is only funny when the audience recognizes the masquerade. If the transformation is too real, it won't be comical. The more energy that is put into being a caricature of a woman, the funnier it is. Males dressed up as females has a long history in film and theater. Milton Berle was successful in vaudeville and television, and he occasionally dressed in drag as Cleopatra or Carmen Miranda. In the stop motion film, *The Boxtrolls* (Laika Entertainment, 2014), directed by Anthony Stacchi and Graham Annable, the character named Madame Frou Frou takes to a small stage in a very tight dress, a big red hair-do and excessive make-up. She does a slinky cabaret style dance to describe how terrible the Boxtrolls are. But there is still something suspiciously masculine about her, and it turns out she is actually Archibald Snatcher, the male villain in the story.

If there is one form of live show that most resembles the traditional animated fairy tale, it is the modern English pantomime. It is now performed across Britain during the Christmas holidays. While highly traditional, it has been able to remain relevant by including humor based on current events and personalities. Every year each of the major production companies selects from the shortlist of standard tales, such as *Cinderella*, *Aladdin*, *Dick Whittington*, and *Snow White*. Pantomime was, and still is, entertainment on a large scale. For a less glamorous evening out, crowds in the nineteenth century might find some food, drink and fun at the music hall.

English Music Hall

English music hall began in the mid nineteenth century, and thrived into the early twentieth century. Music hall was a series of short acts, working fast to create an evening's entertainment. Along with the music there were numerous specialty acts, such as jugglers, trapeze artists, animal acts, strongmen and strongwomen, mimes and impressionists, fire eaters, ventriloquists, and magicians, including the great Harry Houdini. It was a demanding business to be in. Below is a quote by Chaplin biographer David Robinson, which I like because it is also a great prescription on how to set the pace and structure of a short cartoon.

> A music hall act had to seize and hold its audience and to make its mark within a limited time—between six and sixteen minutes. The audience was not indulgent, and the competition was relentless. The performer in the music hall could not rely on a sympathetic context or build up: Sarah Bernhardt might find herself following Lockhart's Elephants on the bill. So every performer had to learn the secrets of attack and structure, the need to give the act a *crescendo*—a beginning, a middle, and smashing exit to grab the applause.[3]

From that quote it should be obvious it is essential to make an impression on the audience. A simple way to immediately identify yourself is to have an unusual appearance. One music hall act that could easily be called a human cartoon was Little Tich. Born Harry Relph, he would only grow to be four and a half feet tall. Though he was a talented visual artist, he leveraged his small stature in becoming

a music hall dancer, comedian and actor He created a number of female characters including "Miss Turpentine" who was an eccentric ballerina in an oversized tutu. His most successful act was his big-boot dance. Wearing boots that were 27 inches long, he was able to do a number of entertaining stunts with the oversized shoes. Fortunately, this dance was preserved on film by Clément-Maurice.

Figure 3.4 Little Tich performing his big boot dance

One of the most successful impresarios of English music hall was Fred Karno. That was the stage name of Frederick John Westcott. Starting as an acrobat in the circus and music halls, he eventually started producing short comedic sketches with slapstick comedy and no dialog. Early on, the music halls were licensed only for music and singing. Dialog was prohibited, so pantomime comedy became the method to get laughter without telling jokes. As successes built, he became a creative promoter, and bought a row of buildings for developing shows and talent, and he called it "Fred's Fun Factory." It may or may not be true, but he is credited with having invented the cream pie in the face gag. (Blackberry pie for blondes, and lemon meringue for brunettes.) He called his crew "Fred Karno's Army" and the phrase became synonymous with any chaotic group. The most successful of his shows was titled *Mummingbirds* and it featured Charles Chaplin as a drunken audience member interfering with the actors on stage.

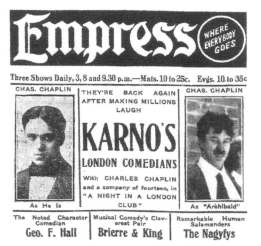

Figure 3.5 Print advertisement for Karno production featuring Charlie Chaplin

Chaplin was the most successful performer to pass through Karno's Army, but there were many others who trained there before moving on to fine careers afterwards. Alongside Chaplin was Arthur Jefferson, later to take on the stage name Stan Laurel. Chaplin kept quiet about what he learned from Karno, but Stan Laurel left a few quotes about him. This one has to do with putting a little bit of sentimentality into the act.

> Wistful. I don't think I even knew what in the hell wistful meant at the time. But I gradually got at least part of the idea when Karno used to say it to some of the old-timers in the troupe. I don't remember if he was the one who originated the idea of putting a little bit of sentiment right in the midst of a funny music hall turn, but I know he did it all the time . . . It was a bit touching. Karno encouraged that sort of thing. "Wistful" for him I think meant putting in that serious touch once in a while . . . You would have to look sorry, really sorry, for a few seconds . . . Karno would say "Wistful, please, wistful." It was only a bit of a look, but somehow it made the whole thing funnier. The audience didn't expect that serious look. Karno really knew how to sharpen comedy in a way.[4]

There is something called **pathos** which means "a quality that provokes pity or sadness." One of the reasons Chaplin's films are so highly regarded now, is because he included room for a little pathos. Charlie's tramp has a vulnerable quality that makes him feel very real. If he were purely a fun loving trickster, his appeal might not have been as great. The same quality was applied to the little robot in Pixar's *Wall-E* (2008), directed by Andrew Stanton. He absolutely has a wistful moment when he is watching the old video of the romantic musical, and he wonders what it would be like to hold someone else's hand. I would say that Wile E. Coyote's sad look before falling off the cliff qualifies as pathos. In Bugs Bunny cartoons, Bugs sometimes fools Elmer Fudd into thinking he has killed him, and Elmer suddenly has great remorse for his actions. Comedy has room for all emotions, including sadness, it just needs to be played in the right way at the right time.

In addition to being occasionally wistful, Stan Laurel learned something else from Karno: to see the possibilities in letting the audience know what is coming, to build their expectations. Tony Staveacre writes about Karno:

> He'd learned something about the nature of laughter. You could draw out a laugh, double it, extend it ad infinitum, if you added the element of suspense. Now instead of simply being the observer of a ludicrous accident, the audience becomes a conspirator with the onstage villain, who is planning to do his victim some mischief. The audience can see it coming and they enjoyed the power it gives them.[5]

Stan Laurel used that in many of his Laurel and Hardy films. He shows the audience the situation that is developing, and allows the anticipation of the inevitable consequences. Suspense is a great way to engage an audience, and it works in comedy just was well. In Nick Park's *Wallace and Gromit: Curse of the Were-Rabbit* (Aardman Animations, 2005), there is an extended sequence where Gromit realizes that Wallace is the were-rabbit, and he is racing to get home before the transformation begins. Gromit knows it is going to happen, so every delay makes him more and more anxious, and it builds up the anticipation in the audience as well. When Wile E. Coyote is setting up one of his traps, the audience knows it won't work well, and they are just waiting for the inevitable backfire.

Music hall was lively entertainment for the working man. As the cities grew in the industrial age, the people needed places to have fun. It was very much the same in the United States, with the worlds of circus and vaudeville.

Circus

There is no performer with more freedom than the clown. Anything goes, as long as it makes people laugh. When a clown creates his act he has no limitations. The world is as open to him as it is for animator sitting down to draw a storyboard. A great many clowns have indicated cartoons as being one of their inspirations. According to Earl Shipley, a clown with the Ringling Brothers, Barnum and Bailey circus during the 1920s:

> The work is much like cartooning, with the exception that the artist in the circus is his own picture.[6]

Originally the circus was a show of horses running around in a ring with riders performing stunts. A clown would pose as a drunken audience member and demand to ride one of the horses. The "drunk" would not only manage to stay on the horse, but would "accidentally" perform amazing stunts. This is again an example of a character who poses as being inept, yet has surprising abilities. Stunts on horseback are dangerous and that engages the audience even more. He must be able to be both a convincing actor, when playing the drunk, and a skilled acrobat.

In the days of the one ring circus, clowns could easily employ verbal humor, sometimes being little more than stand-up comics. But as competition among circuses increased, a second ring was added, and then a third, as promoters learned audiences gravitated to the more spectacular show. As the circus grew, clowns became relatively smaller. To be visible to the huge audiences, they had to act in a broad manner, dispensing with subtlety of character. They also had to move fast to maintain the energy of the show. At their low point, they were sometimes reduced to running out and doing some quick pratfalls to fill time while the equipment was being changed.

Clowns have undergone a renaissance along with the circus. It began when the Ringling Brothers, Barnum and Bailey (RBB&B) circus realized they needed to start training new clowns. RBB&B ran a Clown College from 1968 to 1996 and trained over 1400 clowns. It was intended to develop talent to work in the style of the RBB&B shows. But it also gave quite a few people a strong foundation in the art of physical comedy, and they were able to spread out to other performing arts. Well-known graduates of the Clown College include Steven Banks, animation writer for *Sponge Bob Squarepants*, and Steve O, of the MTV show *Jackass*. Bill Irwin graduated in 1974, and went on to be not only a successful clown, but an award winning actor of stage and screen. His stage work has earned him fellowships from The MacArthur Foundation, The Guggenheim Foundation, and The National Endowment for the Arts. And to top it all off, he was Mr. Noodle on Sesame Street. Irwin expressed the drive to get out in front of an audience:

> Most of us wanted to be performers for the most noble—and ignoble—reasons. Rather than waiting around for a part in a play, we created our own stuff. It was a way of getting out of the straitjackets of the times.[7]

Figure 3.6 Actor and clown Bill Irwin

Photo by Carol Rosegg.

Likewise, as an animator, you do not need to sit around waiting for someone to give you a job. Start building a character with whatever tools you know, put it on YouTube, and you're in business. Or, as Milton Berle put it more succinctly:

If opportunity doesn't knock, build a door.[8]

Classically, circus clowns come in three basic varieties: **whiteface**, **auguste**, and **character** clowns. The whiteface and auguste usually form a duo, and understanding their relationship can be very useful in recreating a timeless form of comedy.

As implied, the whiteface clown usually has a face that is painted completely white, with a few dashes of color to uniquely identify them. The whiteface clown wears a fancy costume, and behaves with more dignity than other clowns because he considers himself to be important. He is sure the audience will love him and whatever he does. To those around him, he is an authority figure, and something of a straight man to his fumbling assistant, the auguste.

Auguste clowns will have less white on their faces, and add other colors. They almost always have the large red nose. The auguste is a fool, a simpleton. He has a hard time following orders, and screws up, which irritates the whiteface. Sometimes the auguste can be a prankster, intentionally failing at the job. That might lead to receiving blows from the superior whiteface. Because he is a kind and harmless figure, audiences have sympathy for him. His clothing is often a spectacular mess. Even if it is a fine suit, it is significantly too large for him. The whiteface and the auguste are studies in contrast. The relationship between whiteface and auguste is based on status. One of them is graceful,

attractive, and mannered. The other is not. The relationship is not unlike Dean Martin and Jerry Lewis, or Abbott and Costello. The auguste seems to be only capable of irritating the whiteface, even though he often shows moments of unexpected brilliance.

Figure 3.7 An auguste (on the left) and whiteface (on the right)

Photo courtesy State Library and Archives of Florida.

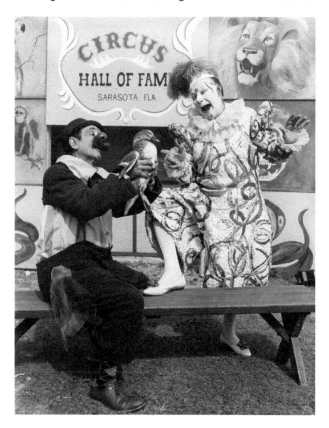

Tex Avery directed a perfect recreation of the whiteface–auguste duo. *Aloha Hooey* was released by Warner Brothers in 1942. Sammy is a white seagull and a fast talking bird with a city accent. He is paired with Cecil Crow, the slow witted country bird. They stow away on a ship headed to Hawaii. After landing, they proceed to compete for the attentions of a cute native chick. The white bird is slick and able to impress the girl with his tricks. When the black bird tries the same tricks, he fumbles it badly, but the girl laughs and finds him appealing. A gorilla comes out of the jungle, wearing a shirt printed with the words "The Villain." When he carries off the chick, it is Cecil Crow who runs to save her. He, of course, wins the rivalry, and gets the chick.

Perhaps the example that most readers will recognize are the two main robots from *Star Wars* (Lucasfilm), directed by George Lucas. C3PO is very much a high status character. He is shiny and gold, speaks with great diction and seems programmed to work in diplomacy. R2D2 is an inarticulate lump, speaking in beeps and clicks. He is low to the ground and looks like a trash can. Ultimately, however, it is R2D2 who solves many of the predicaments in the story. This illustrates how an essential idea can be the source of something that appears to be completely new.

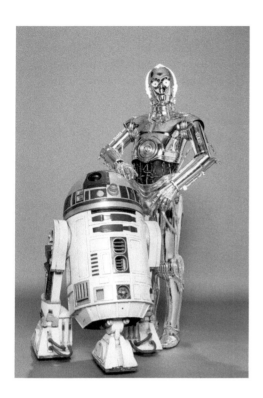

Figure 3.8 *Star Wars: Return of the Jedi*, from left: Kenny Baker, as R2D2, Anthony Daniels, as C-3PO, 2005

An interesting thing happens with these sorts of high status/low status clowns. The low status clown will, over time, rise. Harlequin began as the lowly slave Arlecchino before evolving into the lead of the English pantomime. His comic shoes were filled in by a clown made famous by Grimaldi. When the clown developed into the whiteface, he needed a new fool to be below him. And so the auguste came to be. It seems that the audience has an affinity for the lesser character, especially when that character successfully plays a trick on the boss. In time, he becomes more popular, and takes over. This happened with an auguste named Grock.

Grock worked successfully with a famous whiteface named Antonet, but eventually he became the star attraction and left to work on his own. For a while he was the highest paid entertainer in Europe. Grock spent much of his career developing a single **entree**, which is the term used for a clown's act. His show involved his struggles to play a single instrument, either a piano, or a tiny violin. Everything, from entering the stage with his equipment, to setting up, to simply using a chair, involved considerable difficulty for him. But he never lost his smile, he never got frustrated, he never quit. A reviewer once wrote of him:

> It is apparent that Grock has been burdened with a multitude of inconveniences
> that would break the heart of anyone else. His legs and arms are quite
> irresponsible, and much of the time that he would like to give to his beloved
> music is wasted by his efforts to control his enormous feet, to bring his hands
> into the right position, and to keep his body reasonably straight. All this time he

gazes at the audience with eyes that are full of trust. You feel that he is convinced that this time at least he is spending his evenings with really nice people who, if they see anything odd in him, will know better than to comment about it; who will, moreover, share his delight at surmounting all his innumerable difficulties.[9]

Figure 3.9 Theatre, "Grock" Nerman. Grock 1880–1959, born Charles Adrien Wettach. Swiss clown

Photo courtesy Everett Collection/© Illustrated London News Ltd.

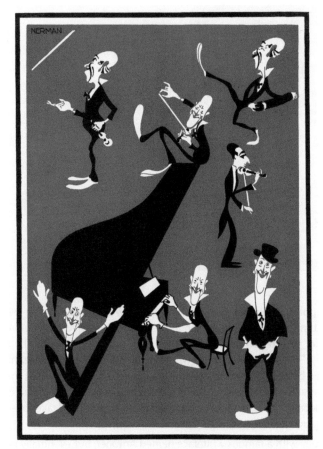

It is that spirit of carrying on that audiences admire. Even while they see his foolishness, they want to see him succeed. He brought out the best in people. Grock sums up his message this way:

> The genius of clowning is transforming the little, everyday annoyances, not only overcoming, but actually transforming them into something strange and terrific . . . it is the power to extract out of nothing and less than nothing: a wig, a stick of grease paint, a child's fiddle, a chair without a seat.[10]

As the auguste can gain the sympathy of the audience, so does the hobo clown. The **hobo**, or tramp, clown is an American creation, and probably the best known example

of a character clown. While young Walt Disney was working at the Kansas City Film Ad Company, somewhere else in town, Emmett Kelly was working as a cartoonist for the Adagram Company which also produced advertisements for movie projection. Emmett sketched out a clown character, that he later made into Weary Willie, the most famous hobo clown ever. At first, the boss clown rejected his tramp clown concept, but, after the depression struck, Americans were more interested in characters who represented struggle. Weary Willie would wander through the circus. He was a forlorn character with a slow style of performance, and the audience carefully followed his movements. His most famous act involved him sweeping up the spotlight into a tiny pool, until it went out.

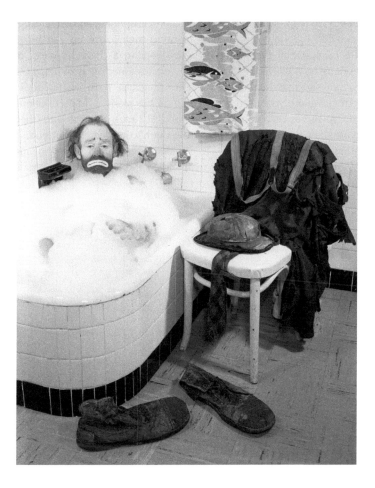

Figure 3.10 Emmett Kelly as Weary Willie

Photo courtesy State Library and Archives of Florida.

Otherwise, character clowns can be any sort of occupation, or type. They could be an old woman, a doctor, or a cook. There was even a little person clown playing a baby in a carriage, years before Baby Herman appeared in *Who Framed Roger Rabbit* (Touchstone Pictures, 1988), directed by Robert Zemeckis. The Roger Rabbit movie contains quite a few nods to classic comedy. Eddie Valiant is the private detective

working the Roger Rabbit case, and a pan across his desk reveals his family history with the circus. Prominently displayed is a picture of a clown with his children, also in clown costume, standing before a Ringling Brothers and Barnum & Bailey sign. The picture is labelled "Eddie & Teddy on the road with dad." Another photo is of Eddie and his brother when they graduated from the police academy. They are wearing red noses and striking funny poses, looking somewhat like Keystone cops. Eddie's training as a clown is what allows him to defeat the weasels at the end of the movie. Laughter is a threat to all villains, but the weasels can literally die from it. In comedy, to "kill" is to make the audience laugh really hard. That is taken to its ultimate end, when Eddie's slapstick routine kills the weasels with laughter and sends their ghosts heavenward.

Though circus clowns can be exquisitely funny at times, this type of clown does not do well outside of it. Because of the scale of a three ring circus, everything about the circus clown must scream for attention, so attempts to bring them close up can prove overwhelming. They are out of their element when working a children's party, or handling a microphone on a television show. Sadly, American media has reduced the clown to a funny suit and make-up, removing all of their true spirit and value. To appreciate modern clowning, you must attend one of the many smaller, boutique circuses. Cirque du Soleil has revolutionized the world of circus. They develop their clowns and integrate them into shows that are so thoroughly designed that attending one is like entering an alternate universe. To supply its numerous traveling and permanent shows, they recruit top talent by maintaining the largest entertainment casting operation in the world.

Vaudeville

Figure 3.11 George Felix & Lydia Barry in "The Vaudeville Craze," 1899

Courtesy of Everett Collection.

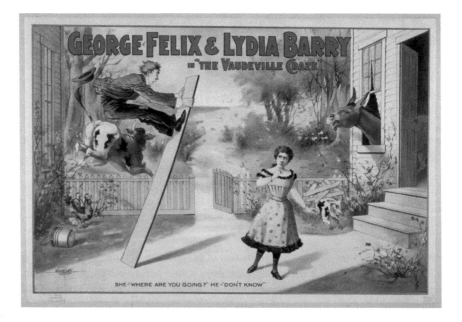

Vaudeville was the great expression of American multiculturalism and the birth of entertainment as an industry. Beginning in New York City, vaudeville brought together the influence of English music hall, circus, minstrel shows, dime museums, Yiddish theater, and burlesque. Burlesque was a series of sketches, intermingled with chorus girls and strippers. It took place in drinking establishments and was obviously aimed at a working-class male audience. The crowd was drunk and the women were not ladies. Working in the theater, of any kind, had long been considered a lowly profession. Actors were always on the fringes of society. Their traveling ways meant they were perpetual strangers in the towns they visited. They swept in and tried to get money for pretending to be someone else. They laughed, drank, and had no commitments. How could they be trusted? The vaudeville historian Trav S.D. points out:

> In the 1940 Disney film *Pinocchio* the title character is waylaid on the way to school by two evil creatures who teach him to sing "heigh diddle dee-dee, the actor's life for me."[11]

Beginning in the 1880s, theater manager and former circus ringmaster, Tony Pastor, understood that large portions of the public were avoiding the negative environment at the shows. That meant business not coming through the doors. He decided to clean up his acts. His theaters began courting favor with the middle class, people who had money to spend. The theaters went "dry" by removing the alcohol. He forbade certain words to be spoken on stage, and women had to wear silk tights instead of showing bare skin. Profits soared, more theaters followed suit, and the vaudeville era began. I am describing this history of the business to emphasize the idea of the **mass market**. In the introduction, I emphasized how comedians need audiences, and can become internationally famous. Creating family friendly entertainment has always had the most potential for the widest possible success.

Eventually, these theater managers became mass marketers of the highest quality entertainment. They developed chains of theaters, with booking networks for the performers. In the time before radio and film, they became the corporations that brought big time shows to people throughout the United States and Canada.

Vaudeville shows were incredibly diverse. They had song and dance, juggling, animal acts, slapstick comedy, stand-up comedy, acrobatics, bird imitators, escape artists, whistlers, hypnotists, cartoonists, trick shooters, yodelers, and pretty much anything else. A book titled *How to enter vaudeville: A complete illustrated course of instruction* was published as a guide to getting started. Many of these artists came into show business by simply going to see the acts, choosing what they thought they could do, going home to practice, then returning to audition for the management. Popular comic strips were also adapted for the stage.

Of all the forms of live theater, none has had more influence on animation than vaudeville. The pioneers of animated film, Walt Disney, Max and Dave Fleischer, Otto Messmer, all grew up watching these shows, and learned virtually everything they knew about comedy there. Dave Fleischer was an usher in a vaudeville theater, where he studied the acts. Winsor McCay appeared on stage, and interacted with his animated Gertie the Dinosaur. As a boy Walt Disney teamed up with his childhood friend Walt Pfeiffer, and they performed comedy sketches as "The Two Walts."

Frank Thomas and Ollie Johnston remember,

> [I]f Walt had not had vaudeville as a model, had not seen these examples, and not been aware of the possibilities, he would have settled for less without ever knowing such potential existed.[12]

In *Steamboat Willie* (Walt Disney Studios, 1928), directed by Walt Disney, there is a gag which may have been inspired by a stage act. In the film, Mickey does his musical number by using animals as instruments. When he finds a group of piglets suckling at a sow, Mickey yanks on their tails to produce squeals that follow the melody. There was a vaudeville act called The Cat Piano. A "musician" would come on stage rolling a long box that was divided into compartments. In each compartment a live cat could be seen. Turning the box around he exhibited the cat's tails (actually false) protruding from the back of the box. With his back to the audience, the cat pianist would sequentially yank the tails and vocally create the various screeches and yowls, and spits the cats were supposedly making, forming them into a known melody.

Thomas and Johnston also write about the planning of the ballet dancing hippos for the Dance of the Hours segment of *Fantasia* (Disney, 1940), directed by Norman Ferguson. In choosing how the sequence should progress, Walt Disney refers to a vaudeville act that was popular in America and Europe:

> Maybe like Frank Britton's Band . . . Frank's all dressed up in evening clothes in front of his dignified looking band. They start out playing good music, when here the cello player—playing away—first his chair slips off the platform, and you think something has actually happened, and the cello stand slips to the floor. From there everything goes wrong, and they end up throwing each other in the orchestra pit – breaking violins over each other's heads. It's very funny—but straight at the beginning.[13]

Something the quote does not mention is that the conductor of the band is so lost in concentration that he continues to perform while his band is destroying itself. His lack of reaction contrasts with the bedlam of the musicians, and is half the comedy. This act must also have been the inspiration for *The Band Concert* (Disney, 1935), directed by Wilfred Jackson. In that film, Mickey Mouse continues to conduct an all animal band despite the arrival of a tornado which lifts and scatters them all over the countryside. When things are going terribly wrong, it is funny when the characters won't stop.

Figure 3.13 Mickey Mouse in his conductors outfit for *The Band Concert*

© 1935 Disney.

Those ballet dancing hippos, by the way, also had a predecessor in Tony Grice, a British music hall clown who was a stout gentleman. One of his most popular acts was his imitation of a ballet dancer.

There was a common knockabout routine called "The Rivals". The skit involved only two men. The scenery was the exterior of a cottage. One man would enter the stage where he would sing a song about visiting his sweetheart. Then he would dance a bit, and go

into the cottage. The second man would enter the stage and sing about his girlfriend and his suspicions of the first man. Then he would go into the cottage. Crashing sounds were heard and one man would come smashing through the door. The other would jump out through the window. Somehow they called a truce and left as friends. Douglas Gilbert in his *American Vaudeville* writes:

> The "rival" song and dance acts are interesting because they were of a pattern, highly stylized, and depended upon the clever lines and the ability of the performers.[14]

Anyone familiar with the history of animation will recognize "The Rivals" as the scenario so commonly used in many Popeye shorts. The very first Popeye cartoon, *Popeye the Sailor* (Fleischer Studios, 1933), directed by Dave Fleischer, introduces Popeye when he's walking on the deck of his ship. He is singing his theme song, and punching things for fun. In between punches, he would dance a little jig. The musical timing of the old Popeye shorts recreates what was certainly the musical accompaniment to the rivals vaudeville sketch. All the early Popeye shorts opened with a musical number, usually with Popeye walking, singing, and dancing a little. Bluto would sometimes have his own musical entrance. I imagine that the Flieschers were looking to present a show that was not unlike what audiences were familiar with.

It is important to understand that vaudeville show folk were business people first, and artists second. There were theaters to fill, and openings for anyone who could do a solid 15 minutes of something interesting. You had to hustle and be aggressive. It was a profession you took up to make a living, not to express your inner feelings. It was competitive and demanding work, but it was better than shoveling coal.

Every moment on stage, the vaudevillian was being judged. For the comedian it was the laughs. For him and everyone else, it was the applause at the end. The performer, and the manager too, had precisely tuned ears to judge the sound of applause. They lived and died by it. By repeating their acts endlessly in front of many audiences, they were able to get instant feedback, and continuously develop the show. This quickly weeded out the poor ideas and reinforced the good ones. Great works do not happen easily. They are developed by exploration and hard work.

> All of vaudeville's great stars started out as something vastly different from the personae that made them famous, only slowly groping their way toward the acts and identities that would define them for all time. The process could take ten, fifteen, twenty years. George Burns, for example, fumbled around for over two decades. He performed with perhaps dozens of failed acts prior to teaming up with Gracie Allen.[15]

So, if your character doesn't blossom immediately, keep working at it.

Vaudeville died a slow death. Radio reduced the desire to go to the theater, and the movies finished it off. Any small studio with a camera could lure a vaudeville act to put itself on film, at which point they could be duplicated, distributed, and forgotten. It was the **dumb acts**, those who had no need for sound, that were the first to go. Vaudeville slowly lost these **novelty acts**, and this is when it started to get the reputation of being tired song and dance routines. When movies arrived, they were shown in the same theaters in between the live sets. Early film projectors needed time to cool down, and that's

when the old acts would come on stage and fill the time. They were called "coolers" for that reason. A child once said to vaudeville star Eddie Cantor:

I was waitin' for you to get done, so I could see Donald Duck.[16]

The lessons from vaudeville are still very relevant. Presentational theater is alive and well on the internet. YouTube could be compared to vaudeville. One could easily arrange a series of YouTube videos to show singing, dancing, juggling, silly animal acts, clumsy people falling down, and of course, animated cartoons. There is not much representational drama on YouTube. The producers are all competing to accumulate views, likes, and comments. Many people work to create YouTube personalities that will draw viewers to subscribe to see more. As vaudeville had producers who selected acts to promote, YouTube has channels which program the best they can find, for which they earn a cut of the advertising revenue. It's show business. Where the audience used to boo people off the stage, they now leave excoriating comments. If the work fails to go over, the creators need to figure out what went wrong, and try again quickly.

Among the uncountable number of animated works on YouTube, there are a few success stories. In 2007, Simon Tofield made a short film about his cat, and put it on YouTube. It was titled *Cat Man Do*, and was the first "Simon's Cat" short. The film was hand drawn in black and white, had no dialog, and was just over one and a half minutes long. It is a very funny film about a cat trying to wake up his owner to get food. Simon's cat uses the natural behavior of a cat, mixed with a certain measure of human cleverness, and no small amount of slapstick comedy. It was a huge success, and led to more and more shorts. Simon's Cat now has over 3 million subscribers, which generates advertising income. Tofield also sells books and merchandise featuring his artwork.

Nearly every artist starts out by trying to recreate the sort of artwork they like. Kids practice drawing by copying the characters they enjoy. Film makers follow the examples of the kind of work they want to do. It's okay to start out emulating the animation of the styles that make you laugh. You just need to put your own ideas into the work and make it feel fresh. You no longer have to travel from town, or rent a stage, or go to an audition. But you still have to compete. The internet is not a shortcut to success. There are many thousands of new videos going up on YouTube every day. If you have a funny animation, you still have to hustle to get attention, just like every performer in history has had to.

Notes

[1] Towsen, J. *Clowns* (New York: Hawthorn, 1976), pp. 140–41.

[2] Swortzell, L. *Here come the clowns* (New York: Viking Press, 1978), pp. 108–09.

[3] Robinson, David. *Chaplin: His life and art* (New York: McGraw Hill, 1985), p. 31.

[4] Weissman, Stephen. *Chaplin: A life* (New York: Arcade Publishing, 2008), p. 173.

[5] Staveacre, Tony. *Slapstick: The illustrated story* (London: Angus & Robertson, 1987), p. 41.

[6] Towsen, op. cit., p. 274.

[7] Trav S.D. *No applause please, just throw money* (New York: Faber and Faber, 2005), p. 281.

[8] Berle, Milton. http://www.cmgww.com/stars/berle/about/quotes.html

[9] Towsen, op.cit., p. 233.

[10] Wattach, Adrien. *Life's a lark* (New York: Benjamin Blom, 1969), pp. 17, 51.

[11] Trav S.D., op. cit., p. 24.

[12] Thomas, Frank and Ollie Johnston. *Too funny for words!* (New York: Abbeville Press, 1987), p. 51.

[13] Ibid., p. 51.

[14] Gilbert, Douglas. *American vaudeville: Its life and times* (New York: Dover, 1968), p. 39.

[15] Trav S.D., op. cit., p. 207.

[16] *American Masters: Vaudeville.* 1997. DVD.

CHAPTER 4

Shadow and Light

In the beginning, there was the **prank**.

When motion pictures first appeared, movie cameras were used simply to record normal events. They showed things such as workers leaving a factory, or a train entering a station. It wasn't long before simple stories were created for film. Since reels of film were extremely short, the story also had to be very short. So, in 1895, Louie Lumière staged a simple prank. His film, originally titled *Le Jardinere*, is now commonly referred to as *L'Arroseur Arrosé,* or in English, *The Sprinkler Sprinkled*. It shows a man using a hose to water a garden. A boy enters the frame and steps on the hose, stopping the water flow. When the gardener looks into the nozzle, the boy releases the pressure and the gardener gets a face full of water. The boy laughs, but is immediately caught and spanked.

This created the first film comedy genre. Prank films became the common way to get laughs from an audience during the earliest days of cinema. It is an extremely simple but infinitely flexible method of creating a moment of tension and release. The audience gets to be "in on the joke" watching the situation being set up. The trap is sprung, forming the climax of the event. Usually, the prankster is caught, and punished, giving closure to the narrative.

Similar stories involved people simply misbehaving and getting their comeuppance. *Mr. Flip* (The Essanay Film Manufacturing Company, 1909), directed by Gilbert M. Anderson, featured Ben Turpin as an incorrigible flirt. He goes to various shops and offices, trying to caress the cheeks of female workers. In each of the events, he gets rebuffed and punished. The seamstress pokes him in the butt with scissors, the customers in the bar spray seltzer in his face, and the switchboard operator can somehow send electric shocks to the telephone he is using. He is established as a character that deserves his treatment.

A comic strip called *Foxy Grandpa* by Carl E. Schultze featured an old man with a pair of rascally grandsons. They would try to play tricks on him but he would always turn the tables on them by using his wits. The strip was developed into a vaudeville character played by Joseph Hart, who went on to play the same part in silent films.

Figure 4.1 Six frames of a prank from *Mr. Flip*, 1909

Figure 4.2 Original comic strip *Foxy Grandpa*, 1904, by Carl E. Schultze

It would be a mistake to think of this as an obsolete style of comedy. Prank films are certainly still a hot commodity on YouTube. It is also a valid way to design an animated narrative. The best example would be the Wile E. Coyote and Road Runner cartoons. Each of the Coyote's schemes is comparable to a prank. He sets up a trap, tries to spring it on the Road Runner, it fails and he gets the worst of it.

Charlie Chaplin

Carefully studying the films of Charlie Chaplin is an invaluable experience for animators. Watch scenes repeatedly in slow motion. Seeing the final product is where you should start. But how was Chaplin able to do what he did? Rather than analyze details from the films, I want to provide an introduction to his thought process and working methods. There is also inspiration in his personal story of transcendence.

Born in London on April 16, 1889, Charles Spencer Chaplin would have an absolutely miserable childhood. He was the son of Hannah and Charles Chaplin Sr., who were both music hall performers. His alcoholic father would abandon him and his half-brother Sydney when Charlie was but two years old. When he was seven years old, his mother Hannah could no longer provide for him, and young Charlie was taken by the authorities to live in a workhouse. When he was a teenager, his mother suffered a psychological breakdown, and Charlie had to take her to an asylum. In her delirium, she blamed him for her situation. He was devastated.

But it didn't break him. He took what life gave him, and learned to make fun out of it.

Charlie's brother Sydney found employment in the music halls, working with Fred Karno. Karno was the most successful theatrical producer of his day. Eventually, Charlie was

Figure 4.3 Charlie Chaplin in *A Night at the Show*, 1915

Courtesy www.doctormacro. com.

brought in as well. Karno was a demanding producer who gave Charlie a first rate education in comedy. His rehearsals were long and Karno required precise timing between everyone in the troupe. This was one of the lessons that Chaplin would carry with him throughout his career.

In 1912, 22-year-old Charlie Chaplin toured the United States with a show called *A Night in an English Music Hall*, where he played the drunk harassing the actors and patrons. His mother had been mistreated by such people, now he ridiculed them and made his living at it. He was earning $40 a week. In 1913, he was seen by Mack Sennett. Sennett sent him an offer to work as an actor in his slapstick comedies, and Chaplin accepted a contract with pay of $150 per week, a lot of money to gamble on someone unproven before the camera. Chaplin assumed it would be a temporary gig that would pay him well and afterwards he would go back to the stage. He once said:

> I went into the movie business for money. Art just sort of grew out of it.[1]

Again, we see the significance of managing an artistic career as a business.

At Keystone Studios, he invented the Tramp character, and he became an instant hit. Once his contract with Sennett was fulfilled he would leap from studio to studio, increasing his value exponentially. After Keystone he went to Essanay, then to Mutual, followed by First National, where he signed the first million dollar contract. It was 1918, just six years after arriving in the US. They agreed to build him a studio, and allowed him to continue having full artistic control of his work. He also earned money by licensing his image for merchandise.

After First National, he formed his own company, United Artists, along with Mary Pickford and Douglas Fairbanks. He had gone from being a pauper to an international sensation. All because he could make people laugh. Theater owners couldn't get enough of Chaplin. They wanted anything even remotely like him. Walter Kerr wrote:

> Chaplin had become so popular and, by this time, so utterly in command of his character that he seemed not so much a funny man as the funny man, the comic font itself, an absolute from which all other work in the vein must necessarily be derived, comedy was in effect defined as what Chaplin did, and Chaplinesque traits, bits of business, flourished everywhere.[2]

The Tramp was adapted for comics by E.C. Segar, who later created Popeye. That was followed by the Tramp being animated by Otto Messmer in 1916. From his direct experience recreating Chaplin with drawings, he was able to produce Felix the Cat, the first animated character with a well-defined personality. Prior to that, cartoons were populated with generic characters involved in simple slapstick gags.

Many live comedians adapted some of his style, but some went as far as creating shameless copies. If you really want to appreciate Chaplin, the best way is to watch several of his good films, then watch someone like Billy West or Billy Ritchie. The shortcomings are glaringly obvious. What stands out to me is Chaplin's ability to create an unbroken flow of action that never allows you to lose your connection with him. His performances, and everyone working with him, are perfectly timed. From the smallest expression to the biggest leap, he crafted each part of the entire range of motion. Tiny mannerisms, quick back and forth interactions. Simple movements done in a way that is

slightly exaggerated for comic effect. There are no lulls. Chaplin won't let you take your eyes off him.

Silent film historian and musical accompanist Ben Model has studied Chaplin's timing for years. Silent film comedies were shot on hand-powered cameras. In a procedure called **under cranking** the cameras were cranked slower to make the resulting motion faster. It is generally believed that it was done to boost the comicality of the motion. Model slowed down Chaplin films to what he calculated was real time, and he discovered something; Chaplin and his actors were acting at *slower* than normal speed. By running the camera slower, they could tightly choreograph the interactions. When projected at normal speed, it hid the effort put into synchronizing with each other, and it looks much more spontaneous. Of course, animators have always had this sort of control. What separates the best from the others, is the critical eye of the artist. Chaplin set extremely high standards for himself and was not easily satisfied.

Figure 4.4 Charlie Chaplin in *His New Job*, 1915

Chaplin relied heavily on trial and error. Sometimes he would build a set, get in costume, and just start shooting whatever came into his head. He would shoot thousands of feet of film trying out different ideas, then toss it away, rearrange the set and start over again. It was an extraordinarily expensive way to make a movie, and has never been repeated. He would improvise, searching for inspiration, with an entire cast and crew waiting in case he found the spark that would catch fire He didn't worry about the "story," it would come. He said:

> I don't care much about story—plot, as they call it. If you have the neatest tailored plot in the world and yet haven't personalities, living characters, you've nothing.[3]

His comedy was not conceptualized remotely. It had to be done in the first person. Later on, when creating features, he started to do some pre-planning, but even then his preparation involved him acting out the scenes, with someone to take notes on what he

was doing. He had to be fully engaged in performance, seize the idea, and build on it. Chaplin said:

> You can always improve detail and develop it if it needs development. But the life is there only once, and if it is lost by your being stolid about it, or slow, then you can't recapture it by hard work or long work. Create in a moment, fill in for a year.[4]

That quote suggests the need for animators to get up and act out their ideas while a video camera is rolling. When the body moves it will do things you wouldn't have been able to find through abstract thought.

When searching for funny ideas, it is also good to do as many different things as possible. In almost any creative effort it is important to dig past the first few thoughts. Those are usually the obvious ones, the ones average artists come up with. Chaplin pushed himself to find newer and better ideas. Even on individual scenes, he had expectations of very precise action. As a boy, Chuck Jones lived just blocks from Chaplin's studio. In an interview with Ron Barbagallo, Chuck Jones said:

> My father saw Chaplin do one scene sixty-two times before he got it the way he wanted it. Well, I don't have to pretend to do anything like that. On many occasions, I have drawn over fifty drawings to get one right.[5]

Unlike most other comedians of his day, Chaplin did not use gag men to help him out. If people on his crew offered suggestions, he usually rejected them. He rejected most of his own ideas too. But he did not discard them.

> But even though I reject them at the time . . . I may use them later in a different way. I let them sink into my mind, and later I find them valuable.[6]

That is another reason to plow through as many directions as you can. It helps you to build up a library of ideas. Comedy is a business that needs a constant supply of ideas. Chaplin stored more than just ideas. As an artist might sketch someone he sees on the street, Chaplin collected motion from people he saw. In fact, the Little Tramp's famous walk came about this way. Winston Churchill wrote about this in 1935:

> The feet are a "property"—the famous walk is the trick of a clever actor to suggest character and atmosphere. They are, in fact, the feet and walk of an ancient cabman, whom the youthful Charlie Chaplin had encountered in the Kensington Road in London. To their original owner they were not at all humorous. But the boy saw the comic possibilities of that uneasy progress. He watched the old man and copied his movements till he had mastered every step in that dismal repertoire, and turned it into mirth.[7]

Again, Chaplin took something he saw, the difficult shuffle of an old man, and turned it into a charming effect. He transformed things from negative to positive. While Charlie escaped his sad childhood, he never forgot it. His experience influenced his work. His hard driving work ethic wasn't only in service to simple laughs. Unlike most other silent comedians, he allowed room in his stories for emotions. In *City Lights* (United Artists, 1931), the audience can feel his love for the blind girl. In *The Kid* (United Artists, 1921), he becomes ferociously protective of the orphaned child he has adopted. This emotional foundation to his greatest films is what makes them so beautiful.

Figure 4.5 Charlie Chaplin in *The Kid*, 1921

Courtesy Everett Collection.

Buster Keaton

For me, it was Buster Keaton who triggered my lifelong love of slapstick comedy. A screening of *Seven Chances* (MGM, 1925) in my high school auditorium left a huge impression on me. I can still remember laughing at that movie. I laughed so hard my cheeks cramped up, and I could have fallen out of my seat.

Buster Keaton was often referred to as the great stone face, because he showed almost no emotion. Images of him smiling are extremely rare. While he did show very, very subtle expression in his eyes and brows, he was an actor almost completely of the body.

Joseph Frank Keaton was born to his mother Myra and father Joe Keaton on October 4, 1895. They were vaudeville performers who happened to be in Piqua, Kansas when Myra went into labor. He was later nicknamed "Buster" which is vaudeville slang for a hard fall. At three years old, Buster joined the family on stage, and they became The Three Keatons. In the act, his father would busy himself with some activity, and little Buster would misbehave and harass his father. Joe would get angry and toss the boy around the stage and into the orchestra pit. Myra would play the saxophone, which probably accentuated the action by timing with it. It was a shockingly rough and tumble act, and it was where Buster learned how to fall without being hurt. His father even sewed a suitcase handle into his jacket to help with the throwing. Sometimes Buster would laugh during the action, and they found the audience didn't respond as well as when he kept a straight face. That led to his always having the deadpan expression that would become his trademark. It was a marked contrast to the common acting found in Sennett films, that included as much facial mugging as was humanly possible.

Figure 4.6 Joe, Myra and Buster Keaton advertisement by Nyvall, N.Y. – Buster Keaton scrapbook

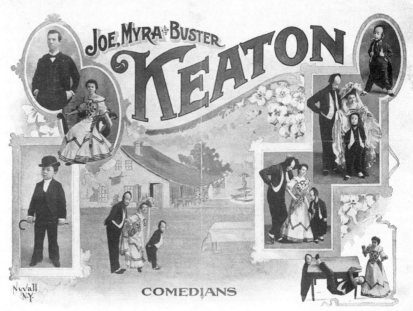

A Comedy Act, introducing Singing, Dancing, Grotesque, Acrobatic and Eccentric Comedy. Guaranteed to meet all expectations, when a place on the Bill is given. Mr. and Mrs. Joe Keaton, formerly a noted sketch team, known all over the land as "The Man with the Table," have as an added attraction little BUSTER, the tiny comedian, who has made millions laugh. Pronounced by Managers to be the only one attempting his style of comedy. Original pictorial three sheets in four colors at the H. C. Miner Litho Co., 342 West 14th St., New York. Paper can be ordered in any quantity, C. O. D.

At 22, as Buster was just about to exit vaudeville for a part in a legitimate play, he connected with Roscoe "Fatty" Arbuckle, who was the star of Comique Pictures. Keaton walked away from the higher paying theater job to work in short films with Arbuckle. He was so curious about how films were made, that on his first day, he disassembled and reassembled the camera, to know how it worked. He developed as a film maker faster than Chaplin, and much faster than Harold Lloyd. Film historians generally agree that among the silent comedians, Keaton showed the greatest understanding of cinematic construction. After just 14 pictures together, Arbuckle left to do feature films and Buster took over as the star of the shorts.

Keaton worked on a large scale. Chaplin took advantage of the camera by bringing the audience in closer than they could be in a live theater. He was more intimate. Keaton put his camera further away, and allowed himself much more room to move. Where Chaplin manipulated props on a human scale, Keaton worked with giant things such as steam ships, steam trains, riverboats, and chariot races. Sometimes he went for big numbers. In *Cops* (Associated First National, 1922), directed by Eddie Cline and Buster Keaton, he set up hundreds of policemen in their annual parade, then gave them a reason to chase him. In *Go West* (MGM, 1925) he drove a herd of cattle through Los Angeles. He even rode a dinosaur using animation. He was grounded in the world of powerful, elemental forces. Film gave Keaton the freedom the stage never could, which is why his work is the more cinematic of the two.

I like long takes, in long shot, he says. Close-ups hurt comedy. I like to work full figure. All comedians want their feet in.[8]

The big scenes and long shots created an emotional distance from the character. That worked well for his style of story, where his relationships were not the primary attraction. His relationships with females was a matter of routine, almost superficial. The real goal in his world was simply proving himself as a man. He also preferred the wide view and long, uncut shots so the audience could see he was actually doing the stunts. He had fantastic skills that were best shown as though you were watching him live. He didn't want to cheat with the camera. I believe that even in animation, excessive editing reduces the audience's connection with the events they are witnessing.

Like the other silent comedians, Keaton worked from a basic outline for the story. He allowed room to develop the ideas as he went along. Unlike Chaplin, Keaton did employ writers and gagmen to help with ideas.

Figure 4.7 Buster Keaton and Virginia Fox collapse in *The Electric House*, 1922

His character always begins the story as a humble figure. He is an awkward youth who has yet to earn any respect. He stumbles and struggles with common challenges, and embarrasses himself with failure. But he persists, and when a serious challenge comes, such as his girl being threatened, a hurricane making landfall, or his beloved steam train being stolen, he rises to the occasion and proves himself to be a hero. In some cases, when he succeeds, it is far beyond what he wanted, as in *Seven Chances* when his initial failure to attract a single bride is repaid with a thousand or more brides later in the picture.

A lot of Buster Keaton's comedy is built around the concept of the chase. It is easy to think of a chase in terms of Mack Sennett's Keystone cops racing after other characters through city streets or across open country. Buster did that on an epic scale in *Seven*

Chances, when he is pursued by hundreds of women in bridal veils, each hoping to catch and marry him for his money.

Buster also found ways to use the essential idea of a chase in many different ways. In *The Navigator* (MGM, 1924), directed by Donald Crisp and Buster Keaton, Buster and his lady friend find themselves alone on a steam ship. Neither knows the other is there, and they each search to see if they can find someone. With perfect timing, they run around decks and through doorways narrowly missing each other. *Our Hospitality* (Metro Pictures, 1923), directed by Jack Blystone and Buster Keaton, finds Buster trapped inside the home of the family his father has a feud with. He has struck up a relationship with the daughter, who is oblivious to the situation. Her brothers want to kill Buster, but their southern honor says they cannot harm him while he is inside their walls. They are doing what they can to politely facilitate his departure, while he is doing everything possible not to leave, not to be chased. Simply waiting for the chase to begin has a tension all its own. If he steps out one door, he will quickly run back in through another. Buster was able to use simple entrances and exits in comic ways.

In *One Week* (Metro Pictures, 1920), directed by Edward F. Cline and Buster Keaton, Buster is outside the kooky looking house he has built from mixed up directions. The wind picks up, and causes the house to spin in place. Buster wants to get back in, so he tries to jump through the door as it passes by. Some of his early short films used other "trick houses" with multiple secret doors, through which Buster could flee to different rooms to avoid being seen or caught. These types of trap door effects were common in stage productions, so Buster was probably familiar with them already.

Steamboat Bill Jr. (United Artists, 1928), directed by Charles Reisner, features his most famous gag, which may be the most brilliant "exit" ever. A hurricane is tearing

Figure 4.8 Buster Keaton survives a collapsing wall by standing where the window is. From *Steamboat Bill, Jr.*, 1928

Courtesy Everett Collection.

his small town apart and Buster is standing still in front of a house. The entire side of a house breaks free and falls over right on top of him. But the second story window is open, and he is saved by passing through the empty space. He is able to make a miraculous escape, without even moving.

Buster was also master of the solution gag. That is a when the comedian is faced with a seemingly hopeless situation, but solves the problem in a way the audience couldn't see. The value of a solution gag is measured by the danger the comedian is in, the cleverness of the solution, and the speed with which it is dispensed. He gets bonus points when the solution also provides a boost to the comedian's effort toward his goal. In *Sherlock Jr.* (Metro Pictures, 1924), the bad guy has locked Buster onto the roof of a two story building. As the villain is driving away in his convertible car, we see Buster, apparently helpless, 25 feet above. But he sees the railroad crossing gate that is standing vertically next to the corner of the building. Buster jumps onto the end and rides it as it tips downwards. He not only escapes from the roof, but lands neatly in the back seat of the villain's car, where he is comfortably chauffeured to the hideout. Keaton's best solutions were wonderful for their sheer elegance.

The General (United Artists, 1926), directed by Clyde Bruckman and Buster Keaton, contains my favorite solution gag. Buster is the engineer on a steam train, and he is following another steam train that has been stolen. In an effort to derail Buster's engine the thieves throw large wooden railroad ties onto the track. Buster runs ahead of the train and grabs the first of the two ties. He spends a lot of time struggling with that one, but he eventually gets it free. He is scooped onto the train's cowcatcher, and he is still holding the first tie as the second one comes into frame. He has perfectly set up the situation with timing so there clearly isn't time to go through it again. Buster solves the problem by throwing the first tie at the second one, hitting it on the end and flipping it off the track. Both ties are cleared in an instant.

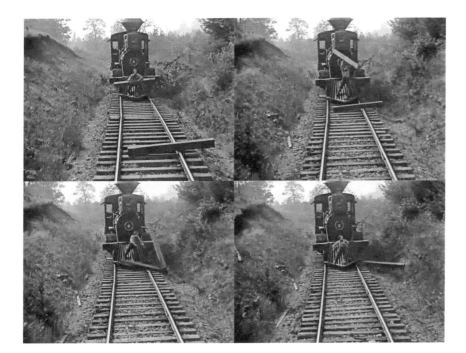

Figure 4.9 Buster Keaton clears a railroad tie from the tracks using another railroad tie, *The General*, 1926

Keaton's lack of facial expression, his long full body shots, his superficial relationships, all support his style of comedy. His work is not based on fear, or sadness, or anxiety, or any particular emotion. He understands that the universe doesn't care. He relies on nobody but himself, and his unblinking attention to the situation allows him to assess the predicament, and create a solution. But he does not solve all of his problems with absolute wisdom. That would make him into a super human, rather than a comedian that people can relate to. Keaton the film director has a way to keep him a little humble. Sometimes things happen that he can't react to. That is when his fantastic luck will step in, as when the wall falls over and the window saves him. Had he been jumping around trying to do something at that moment, he could have been killed. When he is not doing what needs to be done, Keaton is centered and calm, and lucky. He looks a little perplexed by what happened, then carries on with the next challenge. When he succeeds, he has no joyful leap or hardy laugh. He has simply stabilized the world, for the time being.

Rowan Atkinson

Figure 4.10 *Mr. Bean*, Rowan Atkinson, 1990–95

© ITV. Courtesy Everett Collection.

Rowan Atkinson was studying electrical engineering at The Queen's College, Oxford, when he decided to try out acting. He and fellow student Richard Curtis created skits for theater revues. At one point he challenged himself to create a silent act. He stood in front of a mirror and began working out how this character would move. Originally, he called that character, "the wiggly man." In searching for a better name, Atkinson and Curtis considered the names of birds, and vegetables. They settled on Mr. Bean.

Mr. Bean was developed through hundreds of live shows before being brought to television. Working with collaborators, the character continued to grow as each season progressed. They would choose a situation for Bean to find himself in, then suggest at least five different things that might happen. Like most physical comedians much of the work is a combination of meticulous planning and on set improvisation.

In developing Mr. Bean, Atkinson drew upon his appreciation for French comedian Jacques Tati. Tati worked through his character Mr. Hulot, an eccentric fellow who found friendship with children and dogs, and who flirted with pretty girls. But he was often out of sync with the fast-paced modern world of adults. He describes Tati's work as "The comedy of not much happening."[9] The style is not slapstick or acrobatic, but is still highly visual. He does ordinary activities in unexpected ways. Everyone around him is pursuing their normal lives, but when Hulot shows up, events go awry. He unintentionally sows confusion and disarray. Where others get frustrated with the situation, Hulot finds the comedy. If he realizes he has done something wrong, he skillfully avoids being caught. Tati's work is masterful, and it inspired Sylvain Chomet to create his animated feature film *The Illusionist* (Pathé, 2010), which was based on an unproduced Tati screenplay.

Atkinson has been the most successful practitioner of purely physical comedy in recent years, but he is equally capable of verbal comedy. He created the character Blackadder for the television series of the same name. Edmund Blackadder is a sophisticated person, who could be described as a high status character. It is uncommon for an actor to be able to create both high status characters, such as Blackadder, and a low status person like Mr. Bean. Generally, actors specialize in characters who are centered either in their mind, or in their body.

Atkinson once said that he doesn't laugh at comedy very much, because he is too busy analyzing what he is seeing. He presented his knowledge of physical comedy on a television program called *Funny Business*. The episode was titled "Visual Comedy," and featured Atkinson posing as a college professor discussing the history and techniques of physical comedy. He also played Kevin, wearing a skin tight leotard, providing examples of what the professor was talking about. This was augmented by numerous clips from other comedians. In this program, he touches on his own approach to making people laugh:

> Through his body language, the comedian can introduce intimacy and even elegance into the generally frantic world of physical humor . . . The comedy may lie simply in the shading of a facial expression, particularly now in the age of TV, where the close up is so common . . . This is the comedy of personality, rather than the comedy of gags. It's not about doing funny things, it's about doing something quite normal in a funny way. The skill lies in the accuracy of human observation, and the precision of execution.[10]

An example of this "shading of a facial expression" comes whenever Bean is doing something odd, and he realizes someone is looking at him. He never lets on that he is embarrassed. Instead, he will look back at the person, and do one very important thing. He raises his eyebrows. Why is this important? When you want a character to appear to be thinking, you lower their eyebrows and pinch them inward. Raising their eyebrows has the opposite effect. When Bean raises his eyebrows high, it is an indication that he is *not* thinking. He can't possibly be thinking of doing anything wrong, because he is not thinking at all.

Bean is often doing something he shouldn't. And sometimes he is even malicious. Atkinson says that Bean will "obey the rules, as long as they suit him."[11] He exists on the edge of society, and can step to either side of the line as he chooses. His too tight suit jacket and necktie gives him an appearance of conformity, but his behavior isn't as mature. Atkinson commonly thinks of Mr. Bean as having the mind of a nine-year-old boy. Like many boyish comedians, such as Paul Reuben's Pee-Wee Herman or silent film star Harry Langdon, his relationships with girls/women is comically clumsy. While he has an apparent silliness, he can be selfish and inconsiderate, if not downright nasty. This contrast makes his character unpredictable, which is how he keeps the audience wondering what he'll do next.

Sometimes popular live action characters are converted for use in animation. For example, Jim Carrey's Ace Ventura: Pet Detective was made into a television series. Generally the character is licensed out to a production company, and the original actor contributes very little. Since Rowan Atkinson owns his Mr. Bean character, he chose to produce *Mr. Bean: The Animated Series* at his own company, Tiger Aspect Productions. Atkinson was personally involved in every episode. He would spend a full day in story conference for each 11 minute episode, act out references for the animators, and record all of Mr. Bean's vocal sounds. While the animation doesn't carry Atkinson's personality quite like the real thing, it does allow him to engage in more action. He gets into car chases, finds himself in fantasy sequences, and has an evil twin. The animated series added a new character, Mrs. Wicket, his landlady. She is a grumpy old woman whom Mr. Bean both fears and aggravates. As they live in the same house, she fills in as a sort of parent character. That helps to maintain his child-like status. The program was created with help from longtime collaborator Robin Driscoll, so there is a consistent style and sense of humor.

Atkinson has discontinued his own appearances as Mr. Bean as he realizes the difficulty of an older actor playing a childlike man. He wisely took advantage of animation in creating a character that doesn't age.

Jackie Chan

Film historian Tom Gunning wrote about what he called the **cinema of attractions**. It describes the ability of motion pictures to show interesting things. These are things that that can entertain, or even astound audiences, but have nothing to do with story. Movies can break the flow of the narrative to display moments of wonder, of virtuosity, and of spectacle. Dance numbers, for example, do nothing to advance a story, yet many people thoroughly enjoy them. A lightsaber battle can be entertaining regardless of what's going on before and after. Hardly anyone goes to a martial arts movie to appreciate the plot. They go to watch sequences of extraordinary action, stunts, and sometimes comedy.

It has been suggested that the slapstick comedian evolved into the action movie star. The dangerous stunts utilize the exact same skillset. While some martial arts movies are serious and dramatic, a large number of them are light hearted and campy. If one performer were to be the true heir to the crown of slapstick comedy, it would be Jackie Chan.

Chan was born on April 7, 1954. He failed his first year in school, and was later sent to be trained at the China Drama Academy. That was where he learned martial arts and acrobatics. He began on stage at five years old with small parts. At eight he made his first film appearance in *Big and Little Wong Tin Bar* (Great Win Film Co.), directed by Lung To. Eventually he joined other top students as part of *The Seven Little Fortunes*, a troupe that performed in the **Peking Opera**. It easy for westerners to hear the word opera, and confuse it with the tragic stories and barrel chested singers we are familiar with. But Peking Opera is not that at all. In *The Theater and Cinema of Buster Keaton* author Robert Knopf writes:

> Vaudeville and the Peking opera share a surprising number of aesthetic elements. Both forms developed out of the fusion of other forms, blending comedy, acrobatics, singing, and music. Like vaudeville, Peking opera follows a variety format, using a skeletal script based on excerpts from longer plays and operas, interspersed with comic and acrobatic interludes.[12]

The martial arts used in the Peking Opera, and movies, are much more theatrical than actual martial arts. They are designed not for practical combat, but for style and choreographed interaction. At 17, Chan appeared as a stuntman in the Bruce Lee movies *Fist of Fury* (Golden Harvest, 1972), directed by Lo Wei, and *Enter the Dragon* (Warner Brothers, 1973), directed by Robert Clouse. In 1978, director Yuen Woo-Ping gave Chan the freedom to create his own stunts, and the resulting film, *Snake in the Eagle's Shadow* (Seasonal Film Corporation), began the comedic Kung Fu film style. That was followed by *Drunken Master* (Seasonal Film Corporation, 1978), Chan's breakthrough hit.

Chan has acknowledged Buster Keaton as one of his personal influences. His method of creating action films is nearly identical to the process used by the great silent film comedians. He works from a basic plot, improvising a substantial portion of the movie based on the locations and situations his character finds himself in. At each setting, he spends time searching for useful props and potential stunts. This is followed by trial and error, discarding any ideas that don't prove effective. The best ones get developed and after considerable rehearsal, they will start shooting. Then they will do as many takes as they need to get the shot right. This is not to suggest they have unlimited time. They are working on tight budgets and go through the entire process as quickly as they can. It is a physically exhausting operation. The ultimate goal is to make it appear that this all happened spontaneously.

Chan is continuously challenged to create stunts that nobody has seen before. He maintains a **stunt lab**, and a research room with files he has collected for developing his sequences. He has an "idea wall" where he pins up images and stories that might inspire future work. It is not unlike a research room at an art studio. He isn't interested in simple violence, he wants to produce exciting shows that can be funny, beautiful, spectacular or magical.

What makes Chan's stunts into attractions is reality. Chan has preferred working in China, rather than America, because he can continue to do his own stunts. All modern Hollywood films use stunt doubles and visual effects to create their action sequences. The danger is limited, and the audience knows the difference. Chan provides an experience similar to watching one of the great silent comedians. Keaton went out of his way to film his stunts carefully so the audience would have no doubt who they were seeing.

Unfortunately, virtuosity is something that animation doesn't effectively reproduce. Animation is a visual effect. While animation itself may be a virtuoso skill, the audience is judging the character, not the animator. A good way to describe this is with the example of juggling. Juggling is a virtuoso skill, it requires a great deal of practice and tremendous concentration. A human juggling six or seven balls is impressive. An animated character could juggle 15 balls and the audience might well yawn.

However, this is not to say an animated character should never juggle, or dance, or do something that requires expert skill. Here the lesson comes from W.C. Fields. Juggling was the skill that gave Fields entry to vaudeville. But there were others in the business who were better at it than he was. So he compensated for his lesser ability by having an unforgettable personality. Nobody remembers those other jugglers. While Jackie Chan's stunt skills are prodigious, that alone wouldn't have made him a star. He also has a charming personality, and his stunts are done with his special style. So, an animated character could juggle just three balls, and it could work, if he or she did so with an entertaining attitude.

The arrival of motion pictures started a series of challenges for vaudevillians and actors in general. Many believed that cinema would be a short-lived fad, and chose to ignore it. Those who only had a specialty act had only enough material for one film, and it was over. A few actors, however, transitioned to movies and became more successful than they ever dreamed.

This is not at all unlike the effects of computer technology on animation. As CG animation rose in popularity, traditional hand drawn animation has steadily declined. Some transitioned well but others did not. But, any animator will tell you that the basic principles are the same.

The arrival of sound on film, however, was the biggest change of all. When the movies could talk, much of the humor shifted away from the visual comedian, to the fast talking jokers. The era of the slapstick comedian who can flip up in the air and land on his backside is arguably over. Jackie Chan is not as young as he was, and there is no obvious successor to fill his shoes. It really is up to animators to learn the ways of the knockabout traditions.

In the 1930s, Gene Fowler wrote a book about Mack Sennett titled *Father Goose* and he included these words that are fitting here:

> The advent of sound and the collapse of the world's economic structure found Sennett with his back to the wall, but still full of fight. Then came the thrust from

nowhere, a sudden and unexpected stab which Sennett, like Caesar in the Forum, accepted as the unkindest cut of all.

The animated cartoon was a new and popular toy – especially to a world in despair. It preserved and accentuated a thousand-fold all the illusions of slap-stick. The pen was mightier than the bed-slat. By the exercise of a few thousand strokes of a cartoonist's quill, a whole animal kingdom of stars came into being and had an immortal existence in an inkwell.

These charming imps cost but little, were not given to fits of temper and knew not the weaknesses of the flesh. They worked for no salary, and for the sheer fun of it; they would never grow old.

What did a horde of prankish animals care about censorship? In a Sennett comedy, if anyone tied a tin can to a dog's tail, an irate humane society would release its furies. In an animated cartoon, india-ink dogs could be stung by bees, have turpentine applied to traditionally tender spots, be flattened by steam-rollers, reproduce their kind with strangers and otherwise defy the conventions.

A nimble rodent has become the world's hero. In the eyes of Mack Sennett, he must always remain a scraggly mustachioed villain whose mischief will never be undone.

Who killed Cock Robin?

"I did," said Mickey Mouse.[13]

Notes

1 Harness, Kyp. *The art of Charlie Chaplin* (Jefferson: McFarland & Company, 2008), p. 49.

2 Kerr, Walter. *The silent clowns* (New York: Knopf, 1975), p. 102.

3 Hayes, Kevin J. (ed.). *Charlie Chaplin interviews* (Jackson, MS: University of Mississippi Press, 2005), p. 81.

4 Ibid., p. 94.

5 Furniss, Maureen (ed.). *Chuck Jones: Conversations* (Jackson, MS: University Press of Mississippi, 2005), p. 205.

6 Hayes, op. cit., p. 30.

7 Schickel, Richard. *The essential Chaplin* (Chicago: Ivan R. Dee, 2006), p. 213.

8 Sweeny, Kevin W. *Buster Keaton interviews* (Jackson, MS: University Press of Mississippi, 2007), p. 171.

9 Atkinson, Rowan. *The Story of Bean*. July 31, 1997. Television.

10 Atkinson, Rowan, David Hinton and Robin Driscoll, "Visual Comedy." *Funny Business*. 22 November 1992.

11 Atkinson, Rowan. *The Story of Bean*. July 31, 1997. Television.

12 Knopf, Robert. *The theater and cinema of Buster Keaton* (Princeton, NJ: Princeton University Press, 1999), p. 152.

13 Fowler, Gene. *Father goose* (New York: Covide Feide, 1934), pp. 406–7.

CHAPTER 5

Essential Characters

This chapter describes a selection of characters who have appeared over and over again since the beginning of theater. By no means is this an exhaustive list of all known funny guys, but it is a good foundation to build on. Some of them are simple, and some are complex. Some are realistic, and others are not. All of them should be familiar in some way. Often it is because they represent some simple truth that we recognize. There are some basic human behaviors that will never change. We are all born foolish and spend our lives trying desperately not to look like it. We see foolishness in others, and love to see it made fun of. Foolishness may come in the form of the seven deadly sins of greed, lust, sloth, wrath, envy, pride and gluttony. Those weaknesses are easily exaggerated for laughs. Other characters seem to be free of any human need, and are able to thumb their nose at society. We love them for succeeding at what we wish we could do. Some make fools of themselves, some make fools of others.

The Commedia Dell'Arte Characters

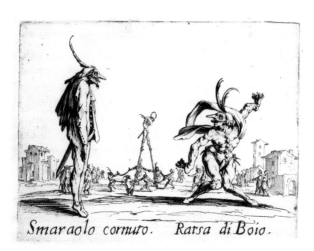

Figure 5.1 Two characters from commedia dell'arte

Back in Chapter 2, I introduced the classic Greek comedy, with its three basic character types, the eiron, the alazon, and the bomolochus. A thousand years later, the Italian commedia dell'arte built on this principle cast, and expanded their numbers with variations on the themes. These were the first **archetypes** of comedy. Archetypes, in this case, are characters who represent a common human behavior. They each have simple desires. They want to eat and make love. They desire money. They want to impress other people. They don't want to be a victim. How they handle these needs and desires is where the character comes in. Many of them are pretenders. One pretends to be educated, but knows nothing of value. One doesn't act his age. Another is not as reliable as he aims to come across. Typically, animators are taught to make characters visibly express what they are inside, but humans often try to cover up those things. Commedia actors, by overcompensating in the opposite direction, can actually highlight the shortcomings even more.

These characters live in a typical social structure of class and family. The situations are actually rather simple. Young men and women want to marry, and the elders interfere. The characters then confuse the situation, either through deception, or by simple mistakes. While their actions can be complex, the audience should have no problem recognizing what is driving them. Some of them speak to the audience, and others only relate to those on stage. There are four basic classes of characters in the commedia; the **innamorati**, the **vecchi**, the **zanni**, and a fourth class of solo characters.

The innamorati are the lovers' class. These are the romantic leads, the young men and women who are in love. A full commedia play would use four in total, two possible pairs. Their problems are mostly caused by their parents. While they are generally of high status, they have little power to solve their own problems. Unlike the others the innamorati did not wear masks. They could be ridiculous for their vanity and obsessive love. The really comic characters swirl around them trying to either interfere with their romance, or bring them together.

The vecchi class are the masters and the parents of the innamorati. They are high status characters who have power. Figures of authority are traditionally targets of comedy. Since most people don't have authority, they tend to resent the ones who do, especially when they behave foolishly themselves. Like many in power, they are out of touch with what's happening around him. They rely on others, and can be manipulated by their own servants.

First among the vecchi is **Pantalone**. He is an old man who is rich and is the father to at least one of the innamorati. He is either interested in a woman too young for him, or disapproves of the man interested in marrying his daughter. The other characters don't want to make him angry, so they must deceive him. He tends to be deceiving as well. His wife may be tricking him by having affairs of her own. He can afford servants, but foolishly trusts them. He is usually a thin old man with long legs. His mask had a long hooked nose and bushy eyebrows. He also had a pointed beard. His costume included a money pouch and a dagger. His steps are short and he can only go at one speed.

In Matt Groening's *The Simpsons* (20th Century Fox) Mr. Burns is the wealthy miser, with a long pointed noise just like the Pantalone mask. In *Despicable Me 2* (Universal, 2013), directed by Pierre Coffin and Chris Renaud, Felonius Gru is not only a self-described villain, he is also the overprotective father trying to keep a boy away from his daughter. Gru also has the very same nose. It may seem superficial, but it is a characteristic that often reappears.

Dottore is another old man with some position in the community. His name translates into "doctor." He is closely linked with Pantalone, either as a friend or as a rival. He pretends to be well educated, speaking in Latin, and faux Latin. He is the most verbal of all the characters and that is where his comedy comes from. He claims to know amazing cures for ailments, but none has ever truly worked. He lies so much that he has even fooled himself into believing his claims. He is a parasite who is happy to give long-winded speeches in exchange for food and wine. He may have a son or daughter involved in the romance as well. His mask also has bushy eyebrows like an old man, but his nose is bulbous, like a drunk. He dresses in the black of an academic, and usually carries a book. He has a large belly, as evidence of his gluttony. Any character who pretends to be educated can be a Dottore type. A variation could be the character who is truly educated, but is so lost in abstract thought that he is practically useless. The absent-minded professor is a modern example.

Dr. Zoidberg from *Futurama* (20th Century Fox, Matt Groening and David X. Cohen), exhibits some of these characteristics. He is doctor, but rarely contributes anything that helps solve problems. Wile E. Coyote sometimes describes himself as a "super genius." He has the intelligence to assemble elaborate mechanisms in his attempts to catch the Road Runner, but they always fail.

Figure 5.3 Illustration of Dottore by Maurice Sand

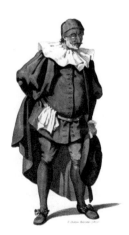

Figure 5.4 *Futurama*, Dr. Zoidberg, 1999–present

The **zanni** were the lower class characters, the servants. Zanni is the root for the English word zany. They were expected to be the funniest of the cast. Originally, Zanni was the name of one servant, but eventually it was subdivided into a handful of named characters with different traits. Later commedia plays would always have at least two of these, the first and second zanni. The first zanni was mischievous. He was also the intermediary with the other characters in the story. The second zanni was clumsy, stupid and silly. He was the assistant to the first, and being stupid allowed him ample room to screw things up. The zanni can speak directly to the audience, who tend to like them. The hierarchy of the zanni can be likened to the hierarchy of Looney Tunes characters. Bugs Bunny is always the first zanni, Daffy is always second to Bugs. But in a short with Daffy Duck and Porky Pig, Daffy is first, and Porky is second.

The role of the zanni is mostly found today in what you might called the **sidekick**. These are secondary characters who are connected to one of the main characters. The zanni of the commedia were always servants to someone more powerful. Sidekicks are friends, helpers, servants, pets, sometimes messengers, and are always comedic. It's not uncommon for them to be silent, such as Flit the hummingbird, and Meeko the raccoon from *Pocahontas* (Disney, 1995), directed by Eric Goldberg and Mike Gabriel, Abu the monkey from *Aladdin* (Disney, 1992), directed by Ron Clements and John Musker, Pascal the chameleon and Maximus the horse from *Tangled* (Disney, 2010), directed by Nathan Greno and Byron Howard.

Having a sidekick raises the status of the main character. It means he or she is not alone, they have an ally. They also have someone to talk to, which allows for some exposition of what the character is thinking. But because the sidekick is so often mute, they have limited influence in the story.

Villains tend to have sidekicks that can talk. The evil Jafar from *Aladdin* had his talking parrot, Iago. Villains so often share their evil plans with someone, it makes sense for it to be a conversation. When the sidekick does something foolish, they will try to explain themselves, which leads to being berated by the boss. **One way to display whether a character is good or bad, is by how they treat the fool.** Villains are mean to them.

Figure 5.5 The Grinch and his sidekick dog

Courtesy Everett Collection.

Sidekicks can also be called henchmen, which are more like employees. Cruella DeVille had Jasper and Horace Badun. In *Beauty and the Beast* (Disney, 1991), the handsome Gaston has his sidekick Lefou who behaves more like a **toady**. A toady is a **sycophant**, a little friend who hangs around with the tough guy. He doesn't do much other than help inflate the ego of the villain.

Arlecchino is the most famous of the zanni. He is usually a servant to Pantalone. He is the first zanni, unless **Brighella** is in the production. While he is dull witted and foolish, he more than makes up for that by being nimble and fast on his feet. He can have ideas, but they are always bad ideas that he can't pull off. He is the messenger in the story, and reliably makes a mistake in the delivery, which is a catalyst for confusion. Being dumb and full of energy gives him the ability to create problems, but also escape from them. His costume is multicolored shapes, known as motley. It is a fancy version of his original clothing, which was a poor man's outfit that had many patches of different colors. The **batocchio** is his prop, it is the bat, or the slapstick. That prop is the origin of the word slapstick we use to describe physical comedy with over the top violence. Over the centuries he evolved into the clever and magical **Harlequin**.

In *The Simpsons*, Bart Simpson is Arlecchino. A child has low status, and Bart can get himself into trouble, but he is not always clever enough to get himself out of it. He is quick enough to escape the school staff, but not to escape the school bullies.

The one named Brighella can be a zanni, a servant, or else he is in the middle class. He is an amoral coward. An entertaining liar who will serve his master well, as long as it is in his own interests to do so. If he is not a servant, he can own a small business such as a tavern or inn. He tries to dominate anyone who is weaker than he is. When dealing with someone with more authority, he will either bow and scrape to curry favor, or avoid them altogether. They can shift from being brutally honest to transparently lying. In animation, Bender from *Futurama* is a Brighella type character. He is self-serving and unreliable.

Figure 5.6 *Futurama*, Bender, 1999–present

I am going to piggyback Brighella onto what could be called the **comic sociopath**. This is a character who just doesn't really care about other people. They are not evil, just self-centered. They can display behavior that we sometimes wish we could. They are free of the pressure to be polite and understanding. Maybe the best introduction to this type is to be found on *Sesame Street* (Children's Television Workshop). The creators of the Muppets were thoughtful enough to include characters who were not all sweetness and light. Oscar the Grouch was one of them. Children find Oscar funny, and it helps them to recognize grumpy people can be harmless.

Figure 5.7 Oscar the Grouch from *Sesame Street*

Pedrolino is a valet who serves his master faithfully. He is young and sensitive, and is a likable character. He is downtrodden and wins the sympathy of his audience. He may pull some pranks, but always in service to his master. He is in love with Servetta, but she does not return his affections. In *The Simpsons*, as Mr. Burns is Pantalone, his assistant, Smithers, is his Pedrolino. Mr. Burns doesn't recognize the depth of Smithers' loyalty to him. It is that loyalty that we respect.

Commonly known as the braggart coward, the **Capitano**, or captain, is another pretender. He is the Greek Miles Gloriosus, and is in a category by himself. As the Dottore pretends to be educated, the captain pretends to be a brave soldier. He always comes from another land, so nobody can contradict his stories of victories in battle. Therefore, he tends to be a loner, without family or business. He is loud and tries to appear dangerous, but the smallest of creatures can terrify him, causing him to scream like a little girl. He can be used by the other characters in their plans. The captain is a satire on all military types. He wears a fancy hat and uniform to satisfy his powerful ego, but his doublet includes a yellow stripe down the back. He carries a sword but never uses it. He stands with his feet spread to appear ready, and walks with a marching action.

Figure 5.8 Il Capitano from commedia dell'arte

Courtesy Everett Collection.

In *Futurama*, Zapp Brannigan is such a character. He is the captain of a spaceship, and has achieved the ludicrous rank of "25 star general." The Capitano also believes himself to be extremely attractive to women. The cartoon skunk Pepé Le Pew has similarities with Il Capitano. In three cartoons, the story reverses and Pepé finds himself chased by the female. In Warner Brothers' *Little Beau Pepé* (directed by Chuck Jones), the skunk accidentally concocts a love potion by mixing perfumes. When Penelope the cat gets a whiff, she is irresistibly drawn to him. Pepé withdraws in fear of being pursued himself.

Servetta is the female servant, the maid. Where the zanni work in pairs, she is always solo, doing what she can to help the lovers. She is the most sensible person in the story, and is not easily fooled. Having at least one level-headed person in the ensemble can help keep the situation from appearing to be a mad house. She may have a relationship with Arlecchino, but is not love crazed. Pantalone and Capitano flirt with her. She can see what is going on in the story the way the audience does, and therefore she speaks to them, commenting on the events. Lisa Simpson fulfills the role of Servetta in *The Simpsons*. She has an astute perspective on events, but being a little girl, no one takes her seriously.

The Gifted Stranger

At the beginning of the *Mr. Bean* television series (1990–1995), we are shown an empty city street at night. Choir music plays. A beam of light shines down onto the cobblestones, and Mr. Bean appears to fall out of the sky and land on the ground under the spotlight. He gets up, brushes himself off, and wanders away, apparently not knowing where he is. It all suggests he is being dropped from heaven, either delivered, or kicked out. Any way, he is not like the rest of us. He is new to this world. And this is the nature of many comedic characters.

Many books on screenwriting, story development, and acting, suggest creating **backstories** for characters. This is common in representational theater and acting. A backstory is an imaginary history of what happened to the character before the current tale began. It can say a lot about the character, like where they came from, what their family is like, significant experiences they have had, and their relationships. Even things as small as their favorite food or color. By collecting a set of facts about a character,

it helps to define them as a specific individual. That definition helps in understanding how they may act in the situations they find themselves in. It makes them more real.

But clowns and cartoon characters are not real people. Giving them a backstory that anyone could relate to would diminish their mystery and make them more normal. Being normal would be the exact opposite of being unusual and interesting. Comic characters are free. They exist in the moment, and are not burdened with memory. In addition to having no backstory, they also do not worry about the future. They are not working day jobs to save money for their retirement. They are not watching their diets because heart disease runs in their family. They come from nowhere, apparently, and have no friends or family. They are strangers.

Take small children, for instance. They do not have backstories. They are strangers to this world and haven't fallen in line with the rest of us. Toddlers do not realize they aren't supposed to run up and down the aisle at a funeral. Nor do they hesitate to scream and cry at a wedding. They are newly arrived here and have their own ideas. They are less inhibited. Nearly everything they do is spontaneous. Dumping spaghetti on their own heads isn't a joke, it's an experiment. They are natural clowns. They get away with it because they are so cute.

The clown who does not behave properly is one of the most fundamental characters in comedy. We find it humorous to watch someone do things wrong. They may be a fool, and simply do not understand. Or they may be a trickster who cannot play the game the way everyone else does. If everybody followed the rules, life would be pretty monotonous. We enjoy watching someone do things that we are either too smart to do, or wouldn't have the courage. It is a sort of wish fulfillment to watch them make trouble.

A clown shouldn't be continually at odds with every aspect of the situation. A character who couldn't behave at all normally would soon grow irritating and tiresome. They cannot be too far outside reality. It is best when the character is actually likable in some way. Ultimately, they must find redemption. Children are redeemed by being naturally adorable. Grown ups who misbehave must do something else to redeem themselves for their transgressions. Harpo Marx would run amok in the movies, but when he sat down with the harp, he played like an angel, and was redeemed. Without the harp, he wouldn't have been quite as memorable.

Figure 5.10 Harpo Marx in a publicity photo for the song he has written called "Guarding Angels," 1954

Courtesy Corbis.

In the circus, the clown who acts like a fool always has some tricks up his sleeve. He can stumble and fall and be an ugly lout. But when he suddenly does a somersault and lands on the unicycle and rides off, he is redeemed. The stranger must be gifted in some way.

An animated character who hits all these marks is Stitch. In Disney's *Lilo and Stitch* (2002), directed by Dean DeBlois and Chris Sanders, he is a genetically engineered creature. He has no family, no backstory whatsoever. He was designed to be a powerful and dangerous creature. When he is sentenced to life in prison, he breaks out, steals a spacecraft and jumps into hyperspace which brings him to earth in the state of Hawaii. Stitch is taken to an animal shelter, where he pretends to be a dog. He is adopted by Lilo, who is an outcast herself. She is also a troublemaker for her sister Nani. Lilo and Stitch bond during a variety of adventures where Stitch makes all kinds of blunders. Stitch knows nothing of Earth, but he is genetically engineered to learn fast.

For instance, they go out to dinner at the restaurant where Lilo's sister works as a waitress. When Nani places two slices of cake on the table, Stitch gobbles them both up. That's bad manners. Lilo reacts with frustration and disappointment. Stitch realizes his mistake, and spits up both slices. He pushes them back into shape and replaces the cherry with this tongue. He topped his own mistake with another mistake. That's how to get the most out of a gag.

Figure 5.11 The alien Stitch gobbles up both pieces of cake, *Lilo and Stitch*, 2002

© 2002 Disney.

Lilo and her sister have no parents, and a social worker is threatening to put Lilo into a foster home. Stitch's behavior, and the other aliens who are trying to capture him, are making things worse. At the climax, the aliens have captured Stitch, and grabbed Lilo along with him. Stitch uses his extreme strength, his gift, to rescue Lilo. He has also learned the importance of family. He is redeemed.

If you make a character who is simply, and completely, dumb, or just won't follow the rules, you may create some laughs, but that is as far as you go. You may miss out on the real success. The fool may be stupid and clumsy, and the trickster may be clever and sassy, but if they succeed in the end, the audience will love them.

The Compliant Hero

The gifted stranger usually doesn't care if he is behaving badly. They often don't mind shaking things up some. They could be called disruptive. Most of us try to not be disruptive. We want people to like us, and we want to do the right thing. We want to be graceful, and

smart, and good looking, and witty. We want the boss to be impressed, the opposite sex to be attracted to us, and potential competitors to keep their distance. But very few of us are those things. We stumble, don't remember simple things, forget to comb our hair, and think of that funny line an hour too late. We don't consider ourselves gifted.

For the vast majority of us, we can enjoy a character we identify with. That would be the compliant hero. These heroes are much more realistic than the gifted stranger, so having a backstory is reasonable. They usually have families and friends. They probably hold down jobs and are known in their communities. Some comic characters really want to do the right thing. These heroes are still a bit strange, and have new ideas, but truly want to be accepted by others. They may have various shortcomings. They are often awkward in their efforts. They are struggling to become respected, but have trouble with the normal route. Compliant heroes must be risk takers. They routinely have to pretend to know what they are doing. They "fake it till they make it." If the gifted stranger can be compared to a young child, then the compliant hero is typically a young person who is on the brink of adulthood.

Harold Lloyd specialized in being the compliant hero. His "glasses character" very much wanted to be accepted into his social circle, to make friends in college, to win the approval of his brothers. He was an energetic go-getter, who often blundered and had bad luck. He was disrespected and had pranks played on him. But he persevered. Where the gifted stranger seems to have the skills readily at hand, the compliant hero must develop them through struggle with opposing forces.

Buster Keaton went through similar narratives. In *Steamboat Bill Jr.* (MGM, 1928), he arrives sparkling clean, fresh from college, to work on his father's greasy steamboat. He is out of place, but he tries to act like he knows what he's doing. He can barely walk the deck without hurting himself. But at the climax of the movie, when the hurricane strikes and he's alone on the steamboat, he rigs up the controls with ropes and singlehandedly saves the vessel. He just needed the right motivation.

Figure 5.12 Buster Keaton in *Steamboat Bill Jr.*, 1928

Alan Dale, in *Comedy is a Man in Trouble*, points out how this is the struggle that boys go through as they try to become men.

> Lloyd and Keaton interpret their physiques as the outer form of an inbetween stage in a boy's life, when his desperation to play a part in society around him far outdistances his know how.[1]

Flik, the protagonist of *A Bug's Life* (Pixar, 1998), directed by John Lasseter, is very much like Harold Lloyd. Flik is a clever young ant who only wants to help his colony with labor saving devices. He has new ideas, but they aren't accepted by the Princess or any other adult. His only friend is the Princess's younger sister Dot. That relationship shows he is still connected with childhood, rather than the grown ups. He goes on a mission to hire warrior bugs to protect the colony, but makes a terrible blunder when he mistakenly brings back circus performers instead. At the climax of the movie, Flik suffers a serious beating at the hands of Hopper, the bad guy in the story. This was also similar to Harold Lloyd, who could be engaged in realistic fights that were dramatic rather than comic. But Flik, like Harold Lloyd, never quits, and ultimately the ant colony is saved on account of his work.

In the animated feature *Arthur Christmas* (Aardman Animations/Sony, 2011), directed by Sarah Smith and Barry Cook, Arthur is the second son of Santa Claus. His older brother, Steve, is the consummate over-achiever who completely outdistances Arthur with his leadership skills. Steve is not only positioned to take over as the next Santa, he feels entitled to it. The story of the hapless younger sibling is an old one. Here, it is applied to the fantastic situation of the Claus family. Arthur is a bumbling boy, and much more sensitive than Steve. Steve may be more professional, but Arthur is much more caring. Arthur accepts his lot in life, and has no ill will toward his brother. He simply loves reading the letters from children. When Arthur discovers one present didn't get delivered, he can't stand the thought of a disappointed child. Accompanied by his grandfather and one elf, he sets out on a trouble-filled journey to finish the job. He is driven by the power of conviction. While he may not be the leader his brother is, his actions reveal he has the soul of Santa.

Figure 5.13 *Arthur Christmas*, Arthur (voice: James McAvoy), 2011

© Columbia Pictures. Courtesy Everett Collection.

Though I have described two basic paths for comedic characters, there is room for adaptation. Pixar's *The Incredibles* (2004) combines the concepts of gifted stranger and compliant hero. The superheroes were disruptive figures, not afraid of their gifts. But society grew afraid of them, decided they were too dangerous, and forced them underground. In order to blend in, they had to become compliant characters. Doing anything out of the ordinary might draw attention. In their suburban life at home, they are compared to a normal family, which shows how they are not so different from us. They are both gifted strangers, and regular people.

Amorous Characters

In long-form comedy, romance can be an important element. Tragedies end in death, comedies end in marriage, or at least the hope of it. Some romances are integral to the story, and the characters just happened to be put together by circumstances. For instance, Lightning McQueen and Sally Carrera in *Cars* (Pixar, 2006), directed John Lasseter and Joe Ranft, or Jonathan and Mavis from *Hotel Transylvania* (Sony, 2012), directed by Genndy Tartakovsky. In these situations there is usually a period of awkwardness and some misunderstandings, then things work out between them. Those sorts of relationships are mild in comparison to what I'm addressing.

I am interested in the character who goes after someone, or at least flirts with the opposite sex. This mostly means males. We are still heavily influenced by the tradition of the man chasing the woman. Still, things may be changing. The DreamWorks animated feature *How To Train Your Dragon 2* (2014), directed by Dean DeBlois, included a very funny example of a girl on the make. Ruffnut is the Viking girl who had to continually fend off the aggressive boys. But when she spies Eret, the hunky guy who is trying to steal their dragons, she is instantly infatuated and shamelessly displays her interest in him. Her change in character is sudden and extreme. She does not hold back her feelings at all. Eret is completely taken aback by her. The relationship is played solely for laughs, and is allowed to dissipate during the crisis. It is a very effective use of an aggressive female. That example still includes the fact that men are always shown as being uncomfortable with being pursued, if not downright frightened by aggressive women. Occasionally a woman is caricatured as so ugly she must desperately pounce on any available man. That old trope is extremely limited and hardly funny anymore.

There are some women who take control of their sex appeal. Mae West was a star of vaudeville and movies who used suggestive humor and double entendre in her act. She starred in her own play *Sex* in 1926. The twenties were a significant time in America, and Betty Boop expressed the new found freedom for women. She was the first female cartoon character to be unmistakably sexualized. Her style was modeled after actress Helen Kane. Betty would run away with men, but she also maintained a certain dignity. When being pawed by a bad guy she would sing "Please don't take my boop-oop-a-doop away."

Figure 5.14 Betty Boop in *Betty in Blunderland*, 1934

The **femme fatale** is an archetype that has existed since ancient times. This character is a beautiful woman who uses her charms to influence men, and sometime pull them into dangerous, even deadly, situations. *Who Framed Roger Rabbit* draws much of its style from film noir, and Jessica Rabbit has the presence of a femme fatale from the genre. Jessica is probably the most sexually alive character to ever appear in mainstream animation. She is a happily married woman, but isn't above using her charms to influence Eddie Valiant. It is rare for a cartoon woman to be empowered by sexuality the way she is.

That said, it is left to the men to get the laughs.

Figure 5.15 Bob Hoskins and Jessica Rabbit from *Who Framed Roger Rabbit*, 1988

© Touchstone Pictures & Amblin Entertainment, Inc.

One way for men to get laughs is to be the ridiculous villain. Such characters have been around forever. They tend to be either wealthy, hold a position of power, or be physically strong. In commedia dell'arte, the rich old man Pantalone would pursue women much younger than himself. Silent film melodramas had mustache twirling lotharios who held the mortgage on the heroine's farm. Bluto was always out to win Olive Oyl. Sometimes he would at least try to woo her with flowers and candy, and sometimes he just grabbed her by the wrist and dragged her away, caveman style. Disney has continued the tradition with Jafar from *Aladdin* and Gaston from *Beauty and the Beast*. Victor Quartermaine was the bad guy who wanted to impress Lady Tottington in *Wallace and Gromit: Curse of the Were-Rabbit* (2005). His vanity was evidenced by his incredible hair, which was actually a wig.

Figure 5.16 *Wallace and Gromit: The Curse of the Were-Rabbit*, Lord Victor Quartermaine, 2005

Courtesy Everett Collection.

Though he is laughable, the villainous lover takes himself very seriously. Mack Sennett explained:

> There's just a hair breadth between melodrama and comedy … You can make the latter out of the former by exaggerating it a bit.[2]

So it goes with the obnoxious lover. By taking those qualities that make something good, you can ruin it by pushing it too far. In a man, good looks, confidence, and a way with words are attractive qualities. Carry them out to their extremes and it becomes vanity, arrogance, and dishonesty.

In contrast to the villain, the comic male lead has to start out relatively powerless. Then he must distinguish his character by the approach he uses with women. The comedy

relies on the particular style. It should to be a proactive effort. Audiences want to see a character make his best effort, not procrastinate. And for a truly comedic relationship, it is important to have both actors be strong and interesting. The love interest must not be an average individual. Each must have something special going for them.

I'll start with a comedian, Groucho Marx. In the Marx Brothers films he would always court the high society dame played by Margaret Dumont. She was not young or beautiful, but had money, and that was enough for Groucho to be interested. She was elegant, and he was a clown, so it is an incongruous pairing. His technique was to charm her with devotion, then slip in an insult, and quickly switch back to being sweet. It worked for him, the woman paid no attention to the rudeness, and the audience laughed at the fun Groucho seemed to be having.

Chuck Jones gave Pepé Le Pew a fair amount of charm with his French accent and romantic dialog. The simple idea of a skunk who believes himself to be irresistible is a fabulous start. He appears to be a giving, romantic creature that a girl skunk might have no reason to dislike. For the joke to work, it was necessary to create a female who would be repelled by his odor, thus the cat, who accidentally gets the white stripe painted on its back. The terrible smell is a motivation for strong reactions from her. It is a simple mistake on Pepé's part that leads to the confusion. He can't interpret the female's behavior in an objective way. Pepé is loved for his absolute confidence, which he only loses as soon as the tables are turned.

Figure 5.17 *Heaven Scent*, 1956

© Warner Bros. Courtesy Everett Collection.

In the Disney feature *Wreck-It Ralph* (2012), directed by Rich Moore, the character of Fix-it Felix is a wholesome, good natured fellow who is suddenly smitten with the battle hardened Sergeant Calhoun. Again, they would make a very unusual couple. He doesn't hesitate to make his feelings known to her in his own sweet and sincere manner. It is revealed that Sergeant Calhoun had previously been engaged to be married. An alien bug killed the groom at the altar. In what is an exceptionally romantic concept, Fix-It Felix fixes Calhoun's broken heart.

After jumping into a dress with a wig and make up, Bugs Bunny could disarm an aggressive male opponent with a wink and a giggle. It's a very cheeky move that displays Bug's understanding of male psychology. He must also be very comfortable with his own sexuality to do it. Gromit pulled a similar stunt in *Curse of the Were-Rabbit*. In order to lure the were-rabbit out, he puppets a giant rabbit doll with sultry dance moves to a 1958 piece of music called "The Stripper."

But the greatest girl watcher in all of animation has to be Tex Avery's wolf. His boisterous expressions of interest in the red-headed dancer have no equal. But notice I said girl watcher. Virtually all of his energy is spent in extreme physical reactions to simply seeing her. Only once did he ever go beyond that. In *Swing Shift Cinderella* (MGM, 1945), directed by Tex Avery, he makes a charge at her. In the split second before he reaches her, she pulls out a hammer and flattens him.

The Rustic

One of the very oldest comedic characters is the **rustic**. Since theatrical productions are found primarily in cities, it has been common to make fun of the yokels who live out in the agricultural areas. Tony Staveacre describes these early origins:

> In the 16th century, the word clown made its first appearance in the English language. Originally cloyne or cloine, it derives from the word Colonus and clod which defines the farmer or rustic and by extension a country bumpkin.[3]

Such characters can be created in nearly any society, and will probably be recognized by anyone else in the world by their simple appearance. They tend to have ill-fitting, mismatched, and worn out clothes. Many have bad teeth, unkempt hair and poor posture. They are always portrayed as uneducated and unworldly. But only a few of them are really stupid. They may have skills that turn out to be valuable. Being "earthy," they are good candidates to demonstrate real human nature. They have wide potential as comic characters. The art is in focusing on some aspect of the character or context, and how that can be developed to suit the story.

For instance, in the 1960s, American television delivered several shows that were built around rural people. Shows such as *The Real McCoys, Petticoat Junction, Green Acres,* and *The Beverly Hillbillies*. These subjects allowed the writers to focus on wholesome humor. These country folk represented old time America. It was safe material during a tumultuous decade.

Rustics are often portrayed as good hearted people. *Li'l Abner* was a very popular comic strip about a young hillbilly clan from Arkansas. Abner Yokum was physically strong, and intellectually weak. He did, however, have a very positive disposition. He didn't recognize the devious behavior of his backwoods community, and the many characters both rural and urban who hatched plans for their own advancement. It had a fair amount of political and social satire, which made it successful among adults.

Rustics can also be morally ambiguous, such as Cletus Spuckler, the slack jawed yokel on *The Simpsons*. He seems to be suspicious of others, but not out to harm anyone. His character, though, is an excellent example of another behavior often attributed to hillbillies. It concerns their family structure. Cletus has what could be called a common-law wife, Brandine. It is suggested that they are related by blood as well. They have a brood of children so large they seem to not know the exact count. Both the inbreeding and overbreeding are stereotypes of the American hillbilly.

One animated short with a caricature of a rustic focused exclusively on romance. Sort of. Tex Avery's *Little Rural Riding Hood* (MGM, 1949) opens with a buck-toothed country wolf desperate to kiss the scrawny country girl. He gets a telegram from his suave city cousin inviting him to see the dancing red-head at the night club. The city wolf is elegant and restrained, in complete contrast to his uncouth cousin. At the club, the country wolf can't control himself, and must be returned to the farm. The city wolf drives him home, and there he catches sight of the skinny local girl. She is apparently just what he has been missing, and he goes through the same gyrations over her.

That country wolf visiting the city is one of the many variation of an age old story that has been re-imagined many times. It is the basis for one of Aesop's fables, *The Town Mouse and the Country Mouse*, where the country mouse is lured to the city, but flees when he can't enjoy a meal for the constant danger. Hanna and Barbera let Jerry Mouse take a solo trip away from Tom to visit the city in *Mouse in Manhattan* (MGM, 1945). While walking in the streets, looking up at the tall buildings, his head rotates so many times it has to unwind like a rubber band. There he experiences the highs and the lows: from a nightclub in a skyscraper, to a slum filled with alley cats. It is all too much for him, so he runs back home to the country and wakes up Tom the cat with kisses upon his return.

All this might suggest that the rustic is always to be laughed at. It's more about putting them with other characters who are dissimilar, and the misunderstandings that occur. Since most of the stories place the rustic in a city, it is the rustic who is out of his natural habitat. But many comedies have been built around the exact opposite situation, which is the city slicker who finds himself in the country among people whose lifestyle is strange to him. Then the locals will shake their heads as he does all the wrong things.

Lightning McQueen did exactly that when he got stranded in Radiator Springs in Pixar's *Cars* (2006). His high-speed thinking was challenged by the slow pace of life there. Instead of driving at top speed on a track, he was compelled to join the working class

and actually build a road. Mater, the tow truck, is the pure "rustic" (pun intended). His design uses the same elements of a human redneck applied to a car. He's a vehicle built for work, rather than luxury or speed. Instead of worn out clothes he is covered in rust and missing his engine hood. And he has big buck teeth. Sometimes country folk are described as backward. Mater is the world's best backward driver. In *Cars 2* (Pixar, 2011), directed by John Lasseter and Brad Lewis, McQueen travels to races in exotic cities around the world. Mater accompanies him, and now he is the one who is out of place and ignorant of local customs.

Figure 5.19 Pixar's Tow Mater is a rustic character

© Disney • Pixar.

Rustics may not be sophisticated, but they often have uncommon sense. By placing them in juxtaposition with characters who believe themselves to be superior, they can often unmask them as pretenders.

The Comic Villain

Figure 5.20 *The Cure*, Charlie Chaplin, Henry Bergman, 1917

Courtesy Everett Collection.

Comedy has nothing but room for characters to be funny. Even for the "bad guys." Early on in the movies, comedies tended to rely on basic **heavy** characters. The Mack Sennett films had large actors who specialized in playing giant cops, neighborhood bullies, and overweight rich men.

Charlie Chaplin often cast a Scottish actor named Eric Campbell to play against him in this way. He was a head taller and twice the weight of Chaplin. Campbell would stare down at Charlie with his grimacing mouth and fake angry eyebrows. The visual difference unmistakably set up the situation. Charlie would register his apprehension with the giant, but would soon outmaneuver him like a rabbit.

The oversized bad guy vs. the little good guy was put to use in the earliest animated films. The basic image for the heavy is an extremely simple and durable design. It could be a gorilla, a bull, a bear, or any other similar creature known for size and strength.

Disney's first villain, Pegleg Pete originally appeared in the *Alice* comedies, and was adapted later on for the *Oswald the Lucky Rabbit* (Universal Studios) cartoons. When Disney lost the Oswald character in a contract dispute, Pete went with Oswald. All Disney had to do was retain the basic construction of the character, but change his species to being a cat. It was this big angry cat who squared off against Mickey in *Steamboat Willie* (Disney, 1928). Pete is such an archetypal bad guy, he has continued to be used ever since, showing up in television, movies, and video games.

The generic heavy is useful, but has limited appeal. Bad guys *can* be appealing. They just need to have an appealing style, or attitude. Warner Brothers became quite good at creating appealing antagonists. Their menacing characters were as unique and as fully realized as the stars like Bugs, Daffy, and Porky. Yosemite Sam is a powder keg with legs, and permanently irritated. The Tazmanian Devil can be a whirlwind of energy, but is also a gullible dimwit. For a hunter, Elmer Fudd is a unusually sensitive.

Aardman Animation has created some wonderful bad guys. In the world of Wallace and Gromit, animals always seem to be smarter and more serious than the people. Playing a funny part in a very serious way is inherently comic. In Nick Park's *Wallace and Gromit: The Wrong Trousers* (Aardman Animations, 1993), Feathers the Penguin is that extremely rare thing, a silent villain. His expressionless face gives the impression that he is cold hearted and cunning. But since he is just a penguin (masquerading as a chicken), he is underestimated by the others. In order to carry out his evil plan, he needs to get Gromit out of the house. To do that he takes over Wallace's attention, and Gromit is soon forgotten. It is unusual for an animated villain to inflict such emotional pain on someone.

One characteristic that all villains share is arrogance. They have absolutely no respect for others. Victor Quartermaine is the obnoxious hunter in *Wallace and Gromit: The Curse of the Were-Rabbit*. This story revolves around the community of avid vegetable growers in Wallace and Gromit's village. While they are gardeners, he is their opposite, the hunter. He sneers at their unwillingness to use deadly force against the rabbits.

In recent years, it has been fashionable to build narratives around characters who have previously been used as villains, making them the star. *Despicable Me* (Illumination), directed by Pierre Coffin and Chris Renaud and *Megamind* (DreamWorks), directed by Tom McGrath (both 2010) are two notable examples. Shrek is an ogre who enjoys being disliked by normal humans. Wreck-It Ralph is the bad guy who no longer wants to be the bad guy. If they weren't the stars, they would be limited to carrying out their "evil" behavior, with no

sign of any other thoughts. As comic leads, the audience sees them in their off hours, so to speak. It is funny to see them dealing with mundane issues like managing their incompetent henchmen. Occasionally they meet someone who isn't afraid of them, and the interpersonal dynamic has to change. Donkey takes a liking to Shrek. Vanellope Von Schweetz is not intimidated by Wreck-It Ralph. Once someone doesn't take them seriously, the villain/hero become less certain of what to do next. That makes them appear awkward, which strips away their mask and exposes them as not so different from anyone else. It becomes clear they are accustomed to being treated a certain way. Like the Wizard of Oz, there is only a harmless old man behind the curtain.

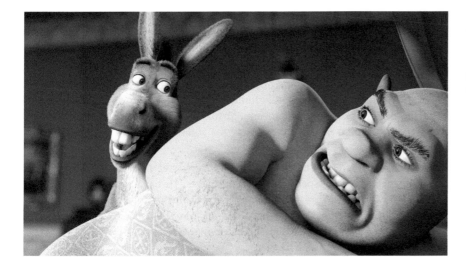

Figure 5.21 *Shrek The Third* (aka *Shrek 3*), Donkey (voice: Eddie Murphy), Shrek (voice: Mike Myers), 2007

© Paramount. Courtesy Everett Collection.

Sometimes they are given histories that explain what motivates them, just like a normal protagonist would have. Felonius Gru was emotionally neglected by his mother, so he is driven to prove his greatness. Megamind was always second place to Metro Man. When he is finally rid of Metro Man, he loses his inspiration. He realizes he needs the competition to feel good about himself. In *Hotel Transylvania* (2012), Dracula lost his wife to an angry mob, so he attempts to protect his daughter by keeping her safe at home forever.

How does one create an appealing bad guy? First, you don't want them to be really bad. To avoid truly dreadful behavior, we are going to look at the **sliding scale of vileness** proposed by tvtropes.org. The vileness of an antagonist can be estimated by considering three orthogonal parameters:

1. How much danger they, or their plans, pose.
2. How effective they are.
3. How much the audience is supposed to hate them.

These parameters were probably not created for comic villains at all, but it is useful in describing what might help to make them funny. A high score across the board would be a real villain, and not the least bit funny. An antagonist with a very low score would probably be completely non-threatening and toothless. So we are looking to be in the low to medium range.

Since we are hoping to have some level of appeal, we have to write off the third parameter. The audience isn't supposed to hate them at all. The audience should enjoy watching them and wonder how it's going to turn out. So that means the antagonist needs to have some value in either of the first two parameters. Meaning, they can have plans to do terribly dangerous things, but are just foolishly ineffective. Or, they can be quite effective at carrying out really stupid plans.

The generic heavy, for instance, poses a rather small threat. He relies on his muscle and fists to threaten just one or two individuals with a potential beating. But he appears to have real potential to do it, so his effectiveness is higher. The audience isn't supposed to hate him, but he isn't likable in any way, so he has some score on the third parameter. In contrast, the Looney Tunes character Marvin the Martian threatens to disintegrate the planet Earth. So he scores high on the first parameter. However, his equipment either fails or is easily neutralized, so his effectiveness is low. Audiences like Marvin.

Feathers the Penguin from *The Wrong Trousers* (Aardman Animations, 1993) has a rather ludicrous plan to use Wallace and his space trousers to steal a valuable gem. He's not out to harm anyone, and it's a rather funny idea, so he scores lower on the danger of his plan. But he does seem intelligent enough to carry it out, so he gains in effectiveness. Penguins seem to be naturally comical, so the audience can only dislike him just so much.

The Grinch is an interesting case of a villain. His plan to steal Christmas causes no bodily threat to anyone, but it is specifically cruel to children. He has the capacity to pull it off, although he does it with great comic style. It is the Grinch's story, but we are supposed to dislike him. However, in the spirit of *A Christmas Carol*, he is redeemed in the end. The redemption of a villain can be a powerful story when well told.

Figure 5.22 *How the Grinch Stole Christmas*, Grinch, Cindy Lou Who, 1966

© MGM. Courtesy Everett Collection.

It has become more important than ever to create an interesting antagonist for your comedian to work with. While the old favorites can always find new life, there are more possibilities than ever in creating a fresh villain.

The Blessed Innocent

This is a lesser used character, but helps to make a point. The blessed innocent is any character who is extremely vulnerable, but manages to survive a seemingly impossible situation. Popeye cartoons provide some good examples. In the cartoon *Lost and Foundry* (Fleischer Studios, 1937), directed by Dave Fleischer, the crawling baby Swee'pea wanders through a factory, never realizing how close he comes to being dismembered by the machinery. In *A Dream Walking* (Fleischer Studios, 1934), directed by Dave Fleischer, Olive Oyl goes sleepwalking. Her eyes are closed, and her steps are straight ahead, and measured in time like a metronome. Nonetheless, she manages to walk around on the iron girder frame of a building under construction, coming to no harm whatsoever.

When I began writing this book, I had intended to include Mr. Magoo as an example of this kind of character. Mr. Magoo, for those who may not know, was a stubborn old man who was extremely nearsighted. So nearsighted, he was practically blind. He would continually misinterpret what was around him, and other characters considered him to be just a crazy old man. He carried on with great confidence and, somehow, everything worked out.

But I learned that Mr. Magoo became a negative image for all blind people. When Magoo was a popular show, children with vision problems were teased and compared with the character. Children who were even related to blind people had their family ridiculed. Defenders of Magoo insisted he was simply obstinate, and all he needed to do was wear his glasses.

The bottom line is that Magoo suffers from a physical handicap. Physical handicaps are not acceptable sources of comedy. To have a character be handicapped, and look foolish for that reason, is simply wrong. This does not mean you can't ever use a handicapped character. Their character just has to be bigger than their limitation. Comedy is about behavior, and not about what we have no control over. A character can make a funny expression, but shouldn't be laughed at just for having a funny face. Crossed eyes, for instance, may get a momentary laugh, but as a fixed state, it wears out quickly.

I have described several types of characters that have been repeatedly made fresh by generations of actors and animators. There is always, however, room for more. Henri Bergson is probably the most famous thinker on the topic of comedy and he wrote:

> It is comic to fall into a ready-made category. And what is most comic of all is to become a category oneself into which others will fall, as into a ready made frame; it is to crystallise into a stock character.[4]

Creating the next great stock character is no small challenge. It would require a considerable amount of effort over a considerable amount of time. It also requires honesty. It isn't about being clever, it's about being real. The creator must be true to himself. Bergson also wrote:

> Any individual is comic who automatically goes his own way without troubling himself about getting into touch with the rest of his fellow human beings.[5]

I interpret that to mean it is important to not be concerned with what other people think. The character who gets laughs is not behaving himself. When people laugh at him, he doesn't stop and change to fit in. He wants them to laugh more. The comic character must stay on his path until he achieves his destiny.

Notes

[1] Dale, Alan. *Comedy is a man in trouble* (Minneapolis, MN: University of Minnesota Press, 2000), p. 59.

[2] King, Rob. *The fun factory* (Berkeley: University of California Press, 2009), p. 61.

[3] Staveacre, Tony. *Slapstick: The illustrated story* (London: Angus & Robertson, 1987), p. 14.

[4] Dale, op. cit., p. 65.

[5] Ibid., p. 66.

CHAPTER 6

Comedy Teams

Figure 6.1 *Madagascar 2*, 2008

© Paramount. Courtesy Everett Collection.

There are some physical comedians who can perform solo. I discuss them in Chapter 10 on props. Otherwise, nearly all comedians work in some sort of group. It could be just two people, or a large ensemble cast. In live action, it takes time and no small amount of luck to assemble two or more actors who click with each other. Once they have established a comfort level that allows them to do their best work they will often return to working with the same people over and over. Some of the most successful comedy teams, like the Marx brothers and the Three Stooges were made up of family members. Their relationships developed naturally. For animated film makers it is crucial to understand the dynamics found in successful comedy teams.

 The commedia dell'arte was always an ensemble performance. No single actor could claim to be the lead. Like any good improvisation, it thrived on the actors' familiarity with each other to know what was needed at any moment in the play. Television sitcoms rely on having characters that can sustain stories over multiple seasons, and on casting actors that have chemistry between them. At the conceptual level, the first question to be answered is: Why is this group together? Live situation comedies occasionally have shows where the cast seem to be just friends, but usually there is some other factor that brings them together. Very often they are either family or they work in the same place.

They could also be in the military, or they could regularly visit the same place. They may just live near each other. They could be roommates, neighbors, or simply live in a very small town where everybody knows everybody anyway.

Ensembles in animation also need a reason to be together. The world of *The Simpsons* includes multiple arrangements of characters. The Simpsons are of course a family, but Homer has separate time with his work associates, and his buddies at Moe's Tavern. The kids have their fellow students and the staff at school. Since animation does so well with non-human contexts, there are broader possibilities. The idea of neighbors can include animals confined to a zoo enclosure, as in the feature film *Madagascar* (DreamWorks, 2005) directed by Eric Darnell and Tom McGrath. The group can be a superhero team, like Powerpuff Girls or Teenage Mutant Ninja Turtles.

Another way to create an ensemble story is have a bunch of unrelated people brought together by a significant event. A prime example of a significant event is found in the opening of the film *It's a Mad, Mad, Mad, Mad World* (Casey Productions, 1963), directed by Stanley Kramer. On a winding mountain road, a speeding driver passes several cars, blowing his horn. He is driving very dangerously and ultimately runs off the road and crashes down a hillside. The drivers in all those other cars stop, and they and their passengers all get out to investigate. Now, a whole group of people with nothing previously in common are brought together. Just before the driver dies, he gives them a clue to a buried treasure. Within minutes, they are all racing to be the first to find the treasure, and hilarity ensues. The entire film is one long chase.

In ensemble stories, the situation becomes very important, as it keeps a general unity and direction to the stories. In this sort of comedy, there is not just one story, but multiple points of view that explore a situation. This allows for somewhat more complex storylines. *The Simpsons*, for instance, usually has at least two storylines going on in each episode. In *Scooby-Doo* (Hanna-Barbera Productions), Scooby and Shaggy often split up from the others and have their own experiences of the mystery. These plots need to be carefully juggled to maintain suspense, cutting away to leave the audience hanging on the outcome. Occasionally the story lines can cross, but they must all be tied up neatly in the end.

Sometimes the ensembles become so successful they become a true comedy team. What defines a comedy team? Basically, it's just a name that people recognize. They are still an ensemble. Once the name of a group becomes fixed, like Laurel and Hardy, or the Three Stooges, it becomes a valuable brand. Audiences will return to see their work because they are confident it will be similar to what they enjoyed before.

Duos

I'll begin with the simplest comedy team, the duo. In live theater and film, there are some famous examples of comedy duos, including Laurel and Hardy, George Burns and Gracie Allen, Dean Martin and Jerry Lewis. The comedy derives from the uneven relationship between the two. Sometimes one is referred to as the **straight man** and the other as the **stooge**. One is intelligent and the other is dopey. But that is a gross oversimplification that might limit creative thinking. When you begin with the idea that each character is unique anyway, then there are infinite ways for two characters to relate to each other. In fact, in animation there are more types of comedy teams than in live theater. I'll focus on

the three most common types of duos found in animation. The three are: **twins**, **antagonists**, and **odd couples**.

TWINS

Twins are the simplest comedy pair. This is when you have a pair of characters who are nearly identical. Disney's Chip 'n' Dale are probably the most famous example. There was also Heckle and Jeckle, the Talking Magpies, and the Goofy Gophers, Mac and Tosh, created by Bob Clampett. The Goofy Gophers had the unusual style of being overly polite with each other. That behavior was inspired by a comic strip called Alphonse and Gaston, two fellows who seldom accomplished anything because of their excessive manners. Generally, twins are not identical. Chip 'n' Dale had a small color difference, whereas Heckle and Jeckle each had a different accent to their voice. Twins always work together in opposition to another character. The other character has interfered with the twins' life in some way, and they make him miserable with a series of pranks. Because the twins have a numbers advantage in any conflict, it helps if they are disadvantaged in some other way. Chip 'n' Dale and the Goofy Gophers, for instance, are small rodents who must deal with a much bigger foe. They have an advantage in their ability to coordinate action with practically no planning whatsoever. There is an implied telepathy at work, two bodies working with one mind.

The Muppet characters Statler and Waldorf almost qualify as twins. These are the two old men who sit in the balcony and heckle the performers on stage in *The Muppet Show* (Created by Jim Henson-Henson Associates). They are perfectly in tune with each other, and can build on each other's jokes. Being old men makes them less threatening, so they can get away with bad behavior.

The twins idea can be extended to triplets, who work exactly as the twins, but simply add one to their numbers. Donald Duck's nephews Huey, Dewey and Louie are mischievous children who pull pranks on their uncle. The concept was revived for the Pixar film *Brave* (2012), directed by Mark Andrews, Brenda Chapman, and Steve Purcell, with Merida's little brothers Harris, Hubert, and Hamish.

ANTAGONISTS

The term comedy "team" can mislead people into thinking the members of the team are working together in some way. In live action that would be true, but in animation protagonists and antagonists can form a comedy team. Most commonly this will be a hunter/prey relationship: Tom and Jerry, Road Runner and Coyote, Bugs Bunny and Elmer Fudd. Hunters and prey have the advantage of an established relationship. The audience knows that cats hunt mice, and dogs pursue cats. The motivation is clear. So you can open the story, and the audience immediately understands the conflict. You don't need any exposition, you only need to create the specific situation.

The prey is usually more clever than the hunter. Bugs always outwits Elmer, and Tweety Bird has the resources to keep Sylvester the Cat at bay. An exception to the clever prey rule can be found in Tex Avery's Droopy Dog. In *Dumb Hounded* (MGM, 1943), Droopy pursues the Wolf who has escaped from jail. Regardless of the effort the Wolf puts into his escape, Droopy is always one step ahead of him. It works because he is small and mild mannered, which contradicts the typical hunter character. While we are on the Droopy/Wolf relationship, I will point out how it pairs two extremes of behavior. Droopy is one of the most rigid and subdued animals ever, whereas the Wolf may be the most highly energized character in cartoons.

There are two ways that an antagonistic relationship can be carried out. I'll call one **static** and the other **dynamic**. Static antagonism always keeps the struggle between them stable, meaning they are always enemies, and one is always the winner. Droopy and the Wolf have a static relationship, as do the Road Runner and Coyote; the Road Runner is never in danger, and the Coyote never has a chance.

Tom and Jerry have a more dynamic relationship, particularly in the Hanna-Barbera cartoons. While Tom, the cat, never gets to eat Jerry, he sometimes surprises the mouse, and gets the upper hand. Jerry, on the other hand, can go on the offensive with the cat

simply to irritate him. They can also set aside their conflict if an opportunity arises where it is mutually beneficial to live together peacefully. At the end of *Heavenly Puss* (MGM, 1949), Tom even hugs and kisses Jerry after he narrowly avoids being cast into hell for being a bad cat. A dynamic relationship is a more fluid arrangement that allows for more surprise. The chase can take unexpected turns. The prey can appear momentarily to have lost the battle, only to escape and defeat the enemy. Warner Brothers raised the level of troublemakers by creating comic antagonists like Elmer Fudd, the Tazmanian Devil, and Yosemite Sam. They are strong personalities. When combined with Bugs Bunny, Daffy Duck, and Porky Pig, they could mix and match characters to create many different dynamic interactions.

THE ODD COUPLE

One comedy pair that is basic to both live action and animated comedy is the odd couple. The term comes from the title of a Neil Simon play in which two divorced men are forced by circumstances to share an apartment in New York City. One is a persnickety, obsessively clean home-body, the other is a crude, cigar smoking slob. The name suggests they have a domestic relationship as well, so they share a home. I will apply the term to any pair of characters who are significantly different from each other, but have a relationship that transcends their differences. This is to separate them from pure antagonists. One of the original odd couples was Mutt & Jeff. They were comic strip characters who had very different bodies. One was tall and the other was short. Such physical differences are good, but it is much more important to have them think and behave very differently. It could be a smart character matched with a dimwit, like Pinky and the Brain, or bold paired with timid, like *Futurama*'s Zapp Brannigan and his lieutenant Kif Kroker.

Ren & Stimpy (Nickleodeon, John Kricfalusi) is an example of an odd couple pushed to extremes. They have similarities to Laurel and Hardy. Ren is ambitious and wants to be successful. He takes himself very seriously, and pretends to know more than he does. Stimpy is dull-witted, positive, and caring. His desires are much simpler; a litter box and making Ren happy. What makes *Ren & Stimpy* so different from other cartoons is how emotional they are. Ren's anger is second to none, and they can both demonstrate extraordinary sadness, wailing while tears spew from their eyes.

Figure 6.4 *Ren & Stimpy*, Ren opens Stimpy's skull to find his brain, 1991–96

Courtesy Everett Collection.

Aardman Animation Studio's Wallace and Gromit qualify as an odd couple. The owner/pet relationship is uncommon, and certainly unique to animation. Wallace is a bit daft, but has ideas and energy. Gromit is more intelligent, which is funny because he's a dog. The team works because they need each other. Gromit helps Wallace achieve his goals. If it weren't for Wallace, Gromit would have nothing to do. Together they work everything out. Gromit's performance is a very successful interpretation of Buster Keaton's stone face. However he is more emotional than Keaton ever was. In Nick Park's *The Wrong Trousers* (1993), he even cries at being replaced in Wallace's affection by Feathers the penguin.

At Warner Brothers, Chuck Jones would mix and match his characters to create fresh combinations. Porky Pig and Daffy Duck made a very adaptable duo. They appeared in a series of parodies, where each short had fun with a different genre of film. They took on Swashbucklers in *The Scarlett Pumpernickel* (1950), Westerns in *Drip-Along Daffy* (1951), science fiction in *Duck Dodgers in the 24th and a Half Century* (1952), Sherlock Holmes stories in *Deduce, You Say* (1956), and the obviously titled *Robin Hood Daffy* (1958). While Daffy was the driving force in each of these shorts, his performance could be adjusted as needed to fit the theme. Porky could be the butt of the joke, like in *The Ducksters* (1950) when he is a contestant on a game show, and Daffy is the host who abuses him for every wrong answer. Or Porky could have power, as he did in Fritz Freleng's *Yankee Doodle Daffy* (1943), where he is a movie studio executive, and Daffy is an agent pitching a movie idea to him. In this use of a comedy team, they are more like actors playing parts than characters creating the action.

Laurel and Hardy

Stan Laurel and Oliver Hardy formed the most famous comedy duo of all time. They very successfully transitioned from the silent film years to the sound era.

Stan Laurel was born in England, and went through the same comedy boot camp as Charlie Chaplin. He worked his way up with Fred Karno's comedy troupe, and traveled to

the US as Chaplin's understudy for *A Night in an English Music Hall*. He took over the role after Charlie left to work in the movies, but many theater owners refused the substitution and he was fired. It took Stan considerably longer than Chaplin to discover his personal style. Cinematographer George Stevens said:

> Some time before beginning at Roach, I had seen Stan work, and I thought he was one of the unfunniest comedians around. He wore his hair in a high pompadour and usually played a congenial dude or slicker. He laughed and smiled too much as a comedian. He needed and wanted laughs, so much so that he made a habit of laughing at himself as a player, which is extremely poor comic technique. How he changed! In those early days he was obviously searching for a formula.[1]

Oliver Hardy was born in the US State of Georgia, and acted in over 200 films before being paired with Laurel. Hardy disliked being overweight, so he adopted a delicate style of moving as an attempt to make himself appear lighter, and more graceful. Understanding how your character feels about himself can motivate choices for how they act. Hardy was partially inspired by a comic strip character named Helpful Henry. The Henry character was large, fussy, and had a high opinion of himself, but was actually a nice fellow underneath.

The pair had an excellent working relationship. Though Stan's character had the mind of a six year old, the actor was really the driving creative force behind the team. He was responsible for much of their direction, and handled the editing of the films. Hardy was happy to have more time to play golf, even if it meant he got paid less than his partner.

Like many comedians of the time, they previewed their films for test audiences before releasing them. The actors, writers, and directors would sit in various places in the audience with hand clickers. Each time the audience near them laughed, they would click the device, which would keep count of the laughs for them.

> "A Laurel and Hardy picture was usually previewed at least three times before we ever let it out," said Hal Roach. "We preview it first, then we cut it, maybe make some retakes, then look at it again."[2]

Laurel and Hardy films have a special comedic timing. They move at a much slower pace than many physical comedians. Part of the reason is they allow for a protracted set up for their gags. The audience can see what they are doing wrong, and so can anticipate the gag. Laurel learned this from working with Fred Karno. While audiences love surprises, they also enjoy the build up to the fall they know will happen. What matters is the style with which they carry out their foolishness.

> It was [The Director] McCarey's point of view, which Stan concurred with, that film comedy up to that point had been too fast, too hectic. As he would display throughout his career, McCarey's preference in comedy was for that which was based on strong characterization; his work is a celebration of the nuances and vitality found in the untrammeled expression of human personality.[3]

When things went wrong, it was always Hardy who was affected the most. Once he takes his fall, or gets covered in some mess, or his car falls apart, there is a long hold on his face as he looks at the camera. The audience can now savor his reaction to what has happened. Sometimes there would be a protracted look at Laurel, who probably caused the

problem. The audience can see that Stan feels badly for his friend. While Hardy may have a momentary outburst toward Stan, it is over very quickly, then it's back to business.

Now the gag is of secondary importance. More important is the reaction to the gag.[4]

This is not to say that Laurel and Hardy never surprise. Some of their best surprises are delivered by what Stan called his **white magic**. Innocent characters can sometimes do unreal things, because they are simply too dumb to know that they can't. A fine example is in *The Finishing Touch* (Hal Roach Studios, 1928), directed by Clyde Bruckman and Leo McCarey. A policeman is watching Stan and Ollie construct a house. Stan passes through the frame carrying one end of a ladder. The policeman watches as the ladder passes in front of him for a very long time, the ladder must be 100 feet long. When the other end of the ladder finally arrives, Stan is carrying that end as well. It is a unique example of a teleportation gag as described in Chapter 12.

Stan and Ollie are mostly remembered for their **tit for tat** comedies, which are sometimes referred to as **reciprocal destruction**. In these films, one of them unintentionally offends a third party, who then responds by damaging some piece of their property. That leads to retaliation by Stan, and it continues back and forth in that way. It is never actual fighting. Stan and Ollie never make the first aggressive move, but they don't back down either. When they do respond, it is always Stan who steps in first. He is slightly less of a coward than Ollie is. After Stan has started it, Ollie takes his turns as well. From there it steadily escalates with each vengeful act topping the one that came before. Neither party attempts to stop the other while they are carrying out their action, so they appear to retain their dignity while simultaneously being humiliated. Charles Barr called it the **open ended gag**[5] because it seems to have no limits. The smallest misunderstanding can lead to tremendous damage.

Figure 6.6 *Big Business*, Stan Laurel, Oliver Hardy, James Finlayson, 1929

Courtesy Everett Collection.

They were the quintessential fat man—skinny man team. While their body shapes may be contrasting, they were not what you would call opposites. Unlike the whiteface and auguste clown, neither Laurel nor Hardy was the straight man. Hardy was only marginally smarter than Laurel. There is a balance of power between the two of them, and it is maintained primarily by a deep and abiding friendship. Though they are different from each other, they are both equally different from the rest of the world. For additional discussion of duos, see "Circus" in Chapter 3.

Trios

If comedy duos come in many different forms, the trios have even more possible combinations of personalities. In classic Italian theater, the old master might have two servants, one clever, but untrustworthy, and the other stupid. These were the first and second zanni. The master of course, wasn't really all that smart himself. Together they formed a trio that would be involved in plots to keep the master's daughter from marrying the man she loves.

Each character is a step down in intelligence. One character has, relatively speaking, some leadership ability, then each of the other characters is progressively less smart. The leader almost always has bad ideas, if not downright crazy schemes. Even if one is a leader, there is usually a balance of power, with all characters influencing the course of events.

An exception to the rule of all characters having some level of stupidity, is the group member who is smart, but has no power. He or she just gets pulled into the vortex of the others. Often this character represents reality, and what it might be like to be in a crazy situation. Lisa Simpson is the most intelligent member of the Simpson family, but often she can do nothing to stop the foolishness carried out by Homer and Bart.

Comedy trios don't have to be friends. They can be antagonists just like duos. Bugs Bunny, Daffy Duck and Elmer Fudd appeared together in three short films built around Elmer's confusion about which hunting season it is. The films were *Rabbit Fire* (1951) *Rabbit Seasoning* (1952), and *Duck! Rabbit, Duck!* (1953) (Warner Brothers), directed by Chuck Jones. Daffy is the instigator, actively trying to put Elmer onto Bugs. Bugs and Daffy both have the same goal of self-preservation. Elmer Fudd wants to shoot *something*, and Daffy and Bugs both understand that. Elmer is the simpleton in play between them. Elmer may be the stupidest one, but he holds the gun, so he is not without power. The comedy develops over who can trick whom. Bugs can easily manipulate Elmer into shooting Daffy. Daffy can only persuade Elmer when it helps to set up the joke, or because Bugs has tricked him into *asking* to be shot. A fair portion of the comedy is derived through Bugs' tricky dialog, when he takes advantage of Daffy's argumentative and contradictory nature. Daffy is single minded and rigid in his goals, whereas Bugs adapts better to changes. Elmer has the redeeming quality of being a somewhat nice guy. He wants to follow the hunting laws, and that is the weakness that both Bugs and Daffy are playing on. One of the rules for Elmer's character is that he thinks literally, so he is persuaded to believe anything printed on a sign. This is especially true when he sees the sign that says "Elmer Fudd season," which puts him on the defensive. Another time Elmer demonstrates his politeness, when he says "I'm sorry fellas, but I can't wait any longer." That was a character driven way to interrupt the dialog between Bugs and Daffy and get the action moving again. Daffy's primary flaw is his impatience, which leads to carelessness. He is in a hurry to get his way. That allows the always calm Bugs to take advantage of him. Daffy tries to be clever, but truly clever characters make it look effortless. Explaining your evil plan is the first step to failure.

The Marx Brothers

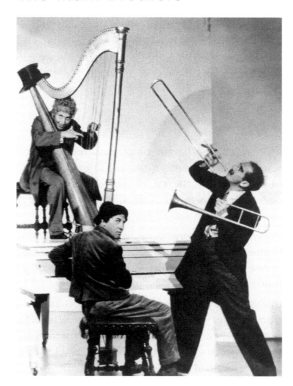

The Marx Brothers were basically a trio, since the fourth member, Zeppo, was a very mild straight man. The three of them were an uncontrollable force in comedy. Their natural skill was so great, the studios didn't know how to best use them. Producers of the time thought that all comedies needed romantic storylines to hold the films together. They tried to shoe horn the brothers into their usual product, rather than allow them as artists to find their natural avenue of expression. All the Marx brothers really needed was a location filled with serious people where they could show up and create anarchy.

The characters you see in the movies are not much different than who they were in normal life. As a family, they grew up together, and honed their comic style and interactions on the stage. Watching the Marx Brothers is probably the closest thing you can see to watching the original commedia dell'arte. Their comic business flowed in a most natural way. Chuck Jones made an observation of Groucho Marx that reminds me of the old commedia characters who pretended to be stupid, or smart, or brave.

> Groucho pretends that he is crazy, but he isn't, and you know he isn't. You know he's playing at it.[6]

Chuck Jones has called Bugs Bunny a mix of the intellect of Groucho, and the zaniness of Harpo. This playing at being crazy is evident in the way he quickly shifts gears in his performance. In his book *What Made Pistachio Nuts?*, Henry Jenkins writes:

Anarchistic comedies place a relatively low value on expressive coherence, openly creating disjunctures between character and performer or allowing for fairly abrupt shifts in the performance style. In the course of a single scene in *Monkey Business*, Groucho Marx adopts the style and rhetoric of a patriotic stump speaker, a dance instructor, a gangster, a quiz show host, a little boy, and a flirtatious woman, all while remaining one step ahead of a mobster and his seductive moll.[7]

Groucho and Bugs are verbal comedians, and the ability to speak helps with their capacity to slip into playing multiple personalities. Chaplin was also able to mimic a variety of characters, and that was one of his strengths as an actor. Character consistency is great, but if you choose to go the Groucho route, you must commit to it 100 per cent. The pseudo-crazy character cannot slip into being normal, or the illusion is destroyed, and the audience will lose faith in the character.

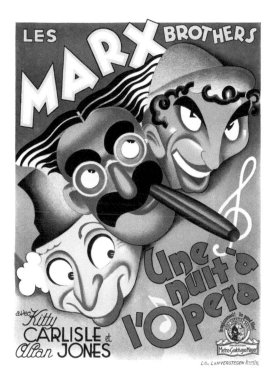

Figure 6.8 *A Night at the Opera* (aka *Une nuit a l'opera*), from left on Belgian poster art: Harpo Marx, Groucho Marx, Chico Marx, 1935

Courtesy Everett Collection.

When the Marx brothers were all on the stage together, they would unleash their full zaniness. But in the movies they often broke out into pairs, and each combination had its own method for comedy. Groucho would set up gags for Harpo to act on with his visual style. When Groucho worked with Chico, he was confused by Chico's mispronunciations and nonsense. Chico could work with the silent Harpo as though there were no language problems at all. Groucho's best moments were when he was working against one of the other characters in the movies, such as the matronly Margaret Dumont.

The brothers originally created their characters as generic vaudeville types. Groucho was a German/Jewish type, Chico was an Italian type, and Harpo was an Irish Patsy Brannigan character. That way they had all the angles covered. When a reviewer wrote that Harpo's strong New York accent ruined any illusion of being Irish, he gave up speaking altogether, and started his career as the pantomime actor in the group. With Groucho's insult comedy, Chico's verbal confusion, and Harpo's visual humor, they had very different tools to create a wide variety of comedy.

The Three Stooges

Figure 6.9 Advertising trade card for the Three Stooges, 1937

Of all classic comedy teams, the Three Stooges may have had the most staying power. In comedy film with sound, their work is truly the purest presentation of slapstick. By replacing members when necessary, they had a long career that resulted in 190 short films of reasonable consistency.

Moe Howard, Larry Fine and Shemp Howard started out as second bananas, so to speak, to Ted Healy, a vaudeville star of the 1920s. The term **stooge** is theater lingo for the person who is the butt of the headliner's jokes, or **he who gets slapped**. Ted Healy and his Stooges appeared in the feature film *Soup to Nuts* in 1930 (Fox film corporation), directed by Benjamin Stoloff. It was a flop, but the Stooges were praised in the reviews, and they were offered a contract with Fox. Healy claimed they were his employees, so

the Stooges left him to start their own act. Healy hired three replacements, because what could be so hard about being stupid? The replacements failed to get any laughs, proving that there really is something special about those three actors. They have a likeability factor that is not easy to define. Shemp left to pursue a solo career, and was replace in the trio by his brother Curly.

The Stooges interpersonal dynamic is described well by the term **nice, mean, & inbetween**.[8] Curly is the most childlike and despite his size he can be very timid, so he is considered the nice one. Moe has the tendency to be angry and mean towards the other two. They are the extremes of the trio. That puts Larry in the middle, he is the inbetween guy who can sometimes interrupt the conflict between Moe and Curly.

There is a theory of comedy that people will laugh at those they feel superior to. You can't help but feel superior to the Stooges. Even young children can see how dopey they are. Kids also respond to the giant messes they make, and valuable objects they destroy. Through ignorance or carelessness they can create a mountain of foam from bathtub beer, a flood from a ridiculously bad job of plumbing, or trigger a full on pie fight. They don't do things by half, they go all in with no hesitation. In vaudeville, one of the prerequisites was **enthusiasm**. It is hard to find acts that match the intense energy of the Stooges.

Often the Stooges' writers will create a pretext to get them to some unusual place. If they want them to be cavemen, they start out as office cleaners at a movie studio, where the director recognizes their talent as ignorant brutes, and casts them in his caveman movie. If they want to be in high society, they are delivering ice to a house before a party, they irritate the cooks so much they quit. The Stooges then have to take over and cook. To go to a cannibal infested south Pacific island, they start out as goofy tree surgeons, who must search for a rare tree. As characters who aren't part of normal society, they are free to go wherever they want to.

> As Moe would put it, when it came time to think of a plot, they considered, "where would we be most out of place?" The emerging tensions of being in this wrong place lead to disagreements, which led to slaps or insults.[9]

Figure 6.10 Lobby card for *Disorder in the Court*, 1936

For the Stooges to solve a problem, their efforts go far beyond the initial situation. Each small error they make leads to bigger mistakes. In Del Lord's *They Stooge to Conga* (Columbia Pictures, 1943) they are called in to repair an electric doorbell. They wind up climbing a power pole and rewiring the entire neighborhood. Stories don't have to open with a huge problem, your characters can blunder their way into creating their own disaster. It's like pulling a loose thread in a sweater and ending up with a pile of yarn on the floor. The writers must have some idea of what it takes to do a job in order to find places where things can go wrong. Then, they have to get clever in their foolishness. The goal is to make the audience ask themselves **how can anybody be that dumb?**

In the Stooges you can find elements still commonly seen in other comedy works. For example, the idea of the acrobatic fat man. Seeing a fit circus performer do flips is impressive, but when a large man such as Curly pulls off serious pratfalls, it has a very special effect. The silent film star Roscoe "Fatty" Arbuckle had the same skills. This same unexpected talent can easily be applied to oversized animated characters, such as Po in *Kung Fu Panda* (DreamWorks, 2008), directed by Mark Osborne and John Stevenson.

There is no better act to introduce the idea of **shtick**. Shtick is a Yiddish word that describes a piece of business used by comedians. It is behavior that is presented so commonly it becomes associated with the particular comedian. An example of animated shtick would be Donald Duck's fits of anger when he hops about spitting out unintelligible swear words. No Stooges film would be complete without an exchange of eye pokes, face slaps, and head bonks. The audience is familiar with it, and anticipate seeing it again. If you watch enough Stooges films you will see that they do mix up the routines and try to create fresh variations. The violence is so over the top, and amplified with sound effects, that it gains the unreal quality of a cartoon. Their shtick also includes signature vocals such as the "nyuk-nyuk-nyuk" laugh, or the word "certainly" being pronounced "soitenly."

Curly also had triggers that would send him into a crazed fit. This is an interesting trait to give a character. Some characters have triggers based on some obvious connection to their physical appearance. They are insecure about something, and if another character points it out, they can go into a rage that is way out of proportion to the offense. In Curly's case, his triggers are not a regular part of his character, but are created to be useful for a single story. Also, Curly's triggers make no sense. For example, in Lou Breslow's *Punch Drunks* (Columbia Pictures, 1934), hearing the music to *Pop Goes the Weasel* sends him into an unstoppable frenzy. Because of that, Moe signs him up to be a professional boxer, and he plays the music when it's time to win the fight. In Clyde Bruckman's *Horses' Collars* (Columbia Pictures, 1935) seeing a mouse can send Curly into paroxysms, and the only cure is for him to be force fed cheese. Animated characters sometimes have these mysterious reactions that suggest a subconscious force is at work. For example, Bender the robot in *Futurama* can have a violent reaction when anyone speaks badly about turtles. This is powerful and irrational behavior. When characters behave this way, nobody in the story can ignore them, nor can the audience. You just can't do it all the time.

The Stooges were the quintessential slapstick trio. They created their films for theaters, but they found a second life on television, where they were discovered for generations after. Their fame was renewed, and their careers extended. Their original films have been rereleased on DVD, and recreated in a feature film directed by the Farrelly brothers.

Send in the Clones

Computer animation has the capacity to easily reproduce multiple versions of characters who look similar, if not identical. For simplicity I will simply call this style of comedy **Clones**. Humans are so attached to the idea of individuality, there is a natural interest when seeing what appears to be multiple copies of one person. The mind is challenged to distinguish them, and so we pay very close attention.

In the early days of cinema, film makers learned to use split frames to allow the same actor to appear two or more times in the same shot. Buster Keaton used the effect in his short film *The Playhouse* (First National, 1921). The technique allowed him to be the conductor of a minstrel show, six musicians, nine dancers, and several audience members. In a single shot he was able to be all nine dancers on the stage moving in sync. It was all done in camera, and required extremely careful timing with his camera man to get it correct. It was, ultimately, a novelty dream sequence that opened the rest of the short film. Novelty is all well and good, but for cloned characters to be really successful, they must follow some simple rules.

Animated twins and triplets can work together seamlessly, as though they are telepathic. But that completely reverses when moving to four or more characters. For some reason, if four characters were to work in sync with each other, it would become creepy. It's as though they are controlled by a central brain like robots. So, with clones, they must *not* work in unison. The comedy comes from the difficulty they have working together. Although they look the same, they must be clashing in some way.

Disney found a way to create action and struggle between multiples by using sports. They did a series of sports themed cartoons using teams made up entirely of anthropomorphic male dogs who looked like Goofy. It was like an entire planet of Goofies. Sports worked well because the teams were all working together as units, but still clashing in competition. They weren't so much stories as a series of comical "highlights" from the games. The team uniforms augmented the uniformity of the actors, and allowed for some variation in color to tell them apart. Goofy's comedy style was maintained for all the athletes as well as the spectators and officials.

Clone characters have reached a new high water mark with the minions from the animated film, *Despicable Me* (2010). The minions come in one-eye and two-eye versions, are different sizes, and have slightly different hair. But they seem to have been manufactured from a base model. They are the same shape, and exactly the same color. It's reasonable to say they are clones. Their personalities are pretty much interchangeable. They all have the same childlike desires and emotions. They behave like a room full of kindergartners. They are good natured, easily distracted, and not above some ineffectual violence. Like children they are mostly out to have fun, and eat. The drive for food is significant. Comedy characters are often motivated by common desires that anyone can relate to, such as eating or attracting the opposite sex. Minions, by definition, are dedicated to their master. Having them attracted by food gives them some much needed personality. These small desires, plus immature behavior, provides material for conflict. By observing how children behave, and misbehave, you can find inspiration for comical behavior. In clones, because of the "central brain" idea, misbehavior is a simple way to show that they are individuals, and not robots.

Ensembles of Four or More

Groups of four or more need to be made up of very different characters. The ideal for a sports team is for everyone to work together in perfect unison following an intelligent plan. In comedy, it is the opposite of that. They should appear to be incapable of doing anything requiring cooperation. Providing your characters with separate needs,

abilities, and personalities will allow you to find multiple ways for them to disagree and misunderstand.

The penguins of DreamWorks' *Madagascar* are a good modern example. The four penguins are Skipper, the fearless leader, Kowalski the genius and inventor, Rico, the largely silent dope whose talent is regurgitating whatever prop they need, and Private, the cute, innocent one who tends to be the most reasonable. They act like they are a military unit and follow the "team of misfits" formula commonly found in war movies. Despite being so different, they actually work together fairly well. It's just they are all a bit stupid so they do a good job of carrying out stupid plans. You can't have your characters be absolute idiots, they need to be able to move forward in some way to have a story.

When you go beyond four members of the team, you might need to create sub-teams within the group. The television series *Gilligan's Island* demonstrates this, as well as other lessons put forth in this chapter. The show put seven castaways onto a deserted island. They include: Gilligan, the goofy young sailor; Skipper, his impatient captain; Mary Ann, the innocent country girl; Ginger, the beautiful movie starlet; the professor, an educated inventor; and the wealthy married couple Mr. and Mrs. Howell. They have almost nothing in common with each other. Just as mentioned above, they are brought together by an unexpected event, the hurricane that strands their tour boat on the island. Being stuck there together is the situation that holds them together, and guides the storylines. Within the group of seven, there are two pairs who form smaller teams. Gilligan and the Skipper had their fool vs. straightman partnership. It would be redundant to have a second duo using the same form of interaction, so Mr. and Mrs. Howell were different. They used a kind of "twin" comedy, primarily because they had been married a long time and understood each other very well. Being rich, they had lived lives somewhat isolated from what normal people do. Each one seemed to be as clueless as the other, and were often both confused by what was going on. Rich people don't have to worry about much, so they are relieved of having to be smart.

Figure 6.13 *Gilligan's Island* (from left): Dawn Wells, Tina Louise, Russell Johnson, Jim Backus, Natalie Schafer, Alan Hale Jr., 1964–67

Courtesy Everett Collection.

Carrying on with the island theme, the animated television show *Total Drama Island (TDI)* was created by Tom McGillis and Jennifer Pertsch in 2007 for Teletoon. *TDI* is a spoof of the reality show *Survivor*, and is like *Gilligan's Island* tripled in scale. Reality shows always throw random people together in the hope of creating fireworks between them. Over half the first episode is spent introducing the 22 teenage contestants on the show. Each of them is a caricature of common teenage clichés. There are the dumb good looking ones, a goth girl, a punk boy, a geeky fat guy, jocks, etc. There is also a pair of girls who dress and talk the same, so they form a kind of twin duo. Survival TV shows pit two teams against each other, so they break up into sub-teams because of that. There is both competition and the need to get along by characters who don't like each other. All the elements are there to create conflict and comedy.

From a simple comedy duo, up to a complex 22-person cast, the essential ingredients stay the same. Mix characters who don't work well together, or who make foolish choices, and put them into challenging situations. Make them responsible for most of their own problems. Whether they succeed or fail is not as important as how many laughs they can create along the way.

Assemble Your Own Team

Theatrical entertainment in general is a group effort, and animation is certainly no exception. This is an aspect of animation that isn't discussed enough. Successful studios often have at their heart a community of directors. Pixar has its **brain trust** that reviews all projects in development and production. The great directors at Warner Brothers were a band of rivals who had individual styles, but learned from each other as they went along. Each of them had his favorite writers, story men and animators. The silent film studios had teams of gag men all throwing in ideas. In television comedy, scripts aren't written alone at home. The staff goes to the office, gathers in a conference room and works on it together. The "director" is rarely the sole creator of the work. If you want to create funny animation, try some of these suggestions for gathering help.

- Find co-creators who share your vision, and who you are comfortable working with. This doesn't mean you always agree. Far from it. The comfort level will make it possible to accept rejection and suggestions more easily. Professionals have to take rejection and criticism constantly. Ultimately the question is, can you make each other laugh?

- Find advisors and mentors. These are people with some qualifications who may be able to give insights into the process. Find consultants for specialty areas, like editing, dialog or cameras and ask for comments on what they know the best.

- Show the work in progress to average people, especially those in your target audience. If you are making it for children, show it to kids. If you want to make college students laugh, show it to college students who are not studying film making or theater. You want average viewers.

- If you feel confident enough, post the work in progress on an online forum, and ask for criticism. This is the age of crowdsoucing. Ignore everyone who says it's awesome. People like to be encouraging, which is nice but not helpful.

- If you screen your work publicly, pay close attention to the audience reaction. That is what it's all about. The great silent film producers measured audience reactions carefully, and often changed the work based on what they learned. They sometimes discovered things were funny that weren't intentionally so.

- Allow time for the team to develop. Each project is an investment, and if you walk away from a team, you will have to start looking for a new one.

- Once your project is released, get together with your team and have a post mortem to analyze what you could do better next time.

By being part of a team, you will be able to learn from your colleagues, and discover new things every day.

Notes

[1] Nollen, Scott Allen. *The boys: The cinematic world of Laurel & Hardy* (Jefferson: McFarland & Company, 1989), p. 10.

[2] Skredvedt, Randy. *Laurel and Hardy: The magic behind the movies* (Beverly Hills: Moonstone, 1987), p. 69.

[3] Harness, Kyp. *The Art of Laurel & Hardy* (Jefferson: McFarland & Company, 2006), p. 52.

[4] Ibid., p. 53.

[5] Barr, Charles. *Laurel & Hardy* (Berkeley: University of California Press, 1968), p. 36.

[6] Furniss, Maureen (ed.). *Chuck Jones: Conversations* (Jackson: University Press of Mississippi, 2005), p. 171.

[7] Jenkins, H. *What made pistachio nuts?* (New York: Columbia University Press, 1992), p. 147.

[8] TV Tropes <http://www.tvtropes.org>.

[9] Epstein, Lawrence J. *Mixed nuts: The story of comedy teams in America* (New York: PublicAffairs, 2004), p. 169.

CHAPTER 7

Context

> Chaplin has his comedy "locations" down fine. It's easy to be funny in a billiard room, or a bakery, he says; a bathroom is inherently humorous; one chuckles even at the thought of a taxidermist's shop; a taxicab, facetiously nicknamed "the robber's delight," is potentially funny, but a ballroom and a horse and buggy are synonymous for sighs.
>
> Grace Kingsley[1]

At the beginning of any movie or performance, the first question in the viewer's mind is "Where am I?" When the theater curtain rises, the audience will immediately evaluate the scene before the actors can speak their lines. Movies almost always begin with an establishing shot, so the audience can orient itself. Just as people go to shows to watch characters that are larger than life, they enjoy stories that happen in interesting places.

Physical comedy is driven primarily by character, and less so by plot. Since the plot is less important, the context becomes more important, since it provides the elements to work with. These elements can range from some simple props to a complex social situation. From mundane suburban streets to bizarre surreal worlds, animated characters enjoy the widest variety of settings found on film. But at the start of any project, it is a blank canvas, and that can be daunting. Charlie Chaplin would often start with a place where he thought he could find funny things to do. He would build a set, fill it with actors, and begin searching for inspiration with what he found there. Chaplin already had his character established. He just needed a fresh context to work in. Assuming you are starting with a character, you will want to give him a world that will work for his style of comedy.

But before delving into comedic context, I would like to discuss animation settings in general. For my purposes, I break it down into three basic kinds of worlds for animated characters to live in. Some might overlap or fall in between these. The first could be called **generic**. This is the simplest environment, and should be easily recognizable by the audience. It could be a city, a village, a forest. While that may sound dull, do not think such a context is automatically weak. For instance, the Simpsons live in the city of Springfield, a satire of average America. The viewer is instantly comfortable with it and

can relate to the workplaces, schools, shops, churches, and other social situations. The longevity of the series can be partly attributed to this infinitely flexible and expandable world. Places that are unusual, or very specific, can put limits on the range of stories to be found.

Figure 7.1 *The Simpsons*, the Simpsons' house, "Brick Like Me" (Season 25, ep. 2520, aired May 4, 2014)

The great French film maker Pierre Etaix said,

> The defining characteristic of comic cinema is that it begins with a situation everyone's familiar with, that everyone has experienced or has seen happen to others. If your initial situation is authentic, the sky's the limit. You can even take it into the realm of the fantastic. But if you start out with an extraordinary situation, you'll be trapped in a corner.[2]

The generic environment is also the home of fairytales and myths. Such stories are so grounded in human nature they can easily be adjusted to any location, any society, at any time in history. What the generic environment requires is a set of strongly defined characters. In the days of silent film, comedies were often shot in common environments, such as city parks and other open air places. The building of sets was reserved for period stories, involving cowboys, swashbucklers, and desert sheiks. When possible, they would find an interesting event and build a film around it. For example, the great silent comedy producer Mack Sennett once heard that a local reservoir was to be drained, so he sent a cast and crew out to create a short comedy that could make use of the draining lake. The context can drive inspiration, and improvisation with what you find can deliver the sort of spontaneity that makes comedy feel alive.

While working at a small studio named Duck Soup, I had the opportunity to design a short CG animated film. My first thought was to find a place and characters that could be built and rendered with the off-the-shelf software that was available. That led to a short film about a boy who builds a snowman, only to see it abducted by some stupid aliens who mistake it for an earthling. The snow covered exterior removed the need for things

like grass and leaves on trees. The boy in the snowsuit had gloves to cover his fingers, a scarf to cover his mouth, and a hat to cover his hair. All of those would make production easier. In their early days, Pixar and DreamWorks both found insects to be computer friendly subjects, and the results were *A Bug's Life* and *Antz* (directed by Eric Darnell and Tim Johnson), both released in 1998. In these cases, the context came first. In computer graphics, hard surfaces have always been easier to work with. The Blue Sky film *Robots* (2005) directed by Chris Wedge, takes a basic "country boy goes to the big city and must fight to succeed" storyline and applies it to a world built by and for robots.

The second context I am calling the **enhancing** environment. These places tend to be more fantastic or unusual. It is the most common kind found in animated films. In these kinds of stories, it is easy to imagine that the context came first. For instance, Hanna-Barbera Productions' *The Flintstones* and *The Jetsons* are standard situation comedies revolving around families. But the stone age/space age gimmick gives them whole new worlds of material to work with. Where the generic environment leaves you wide open for possibilities, the enhancing environment will make it easier to focus on ideas that naturally occur for that context.

Figure 7.2 *Jetsons: The Movie,* George Jetson, 1990

© Universal. Courtesy Everett Collection.

The third type I will call the **active** context. It is a world that *is* a character. Where the enhancing environment is still rather general and allows the characters some free range, this world has a specific situation that is an influential element in how the story starts and develops. An example would be found in Pixar's *Wall-E*. The condition of the future Earth is the reason for the little robot's entire existence, and the story unfolds around the return of natural life to the Earth. Sony Pictures Animation's two *Cloudy With a Chance of Meatballs* movies (directed by Phil Lord and Chris Miller, 2009; directed by Cody Cameron and Chris Pearn, 2013) take place on an island where a food producing robot takes control of the weather. The food raining from the skies creates a very unusual context that drives the movie. *Usavich Rabbits* (2006) was a series of short films created by Satoshi Tomioka for MTV in Japan. The two rabbits begin the series in a Russian prison, where their lives were contained in their cells. A Russian prison is possibly one of the least funny places on Earth, but they handle it with an extremely comic attitude.

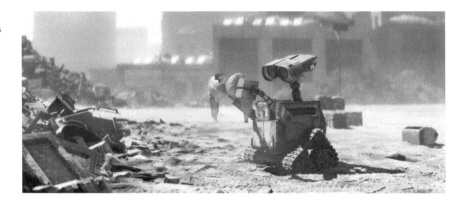

The Shifting Context

Some stories shift from generic environments to fantastic. Often, the normal world is used as a springboard to a different dimension. *The Wizard of Oz* (MGM, 1939), directed by Victor Fleming, begins in dreary black and white Kansas before flying off to technicolor Oz. Pixar has built a considerable number of its movies on this idea. The toys of *Toy Story* (1995), directed by John Lasseter, live lives parallel to Andy's in his otherwise uninteresting home. *The Incredibles*, like many superheroes, live in a typical modern city. Carl Frederickson of *Up* (2009), directed by Pete Docter, has nearly exhausted his average life before breaking free to live out his dream and explore the jungle. In *Ratatouille* (2007), directed by Brad Bird, the hidden world of rodents can venture into a restaurant kitchen and take it over. In *Monsters, Inc.* (2001), directed by Pete Docter, David Silverman, and Lee Unkrich, every child's closet door is a portal to Monstropolis. Using the familiar as an entryway to the fantastic is an excellent way to ease the audience into unusual places.

Characters can be tied to a single context, or they can be free to find themselves in various places or even times. The Three Stooges provide a good example of this. The Stooges could be tramp outcasts or married homeowners. They could be convicts in a prison, or doctors operating on patients in a hospital. They could be in the Old West, a medieval castle, or on a rocket ship. Having that freedom is probably a major reason for their longevity. Because of the simplicity of their comedy, they could easily have become stale by staying too long in one place. Once they had exhausted the comedy potential in hanging wallpaper or fixing plumbing, they could move on to fresh ground. The important thing is they bring their particular style with them. Ren and Stimpy took advantage of this flexible approach. They could be a dog and cat in the street, or living in a house like a married couple, or astronauts who had been in space too long. The latest Mickey Mouse short films from 2014 were set in many different cities, providing constant variety.

Milieu

The **milieu** is the social setting of a story. In the way a physical environment can be designed especially for a story, so can the inhabitants and their ways of working together. In many early silent comedies, all of society is caricatured. Nearly everyone, except the star and maybe his or her love interest, is in a bad mood. There are controlling fathers, jealous

husbands, neighborhood thugs, bullying waiters, nightstick wielding policeman, angry bosses, scolding wives, disapproving churchmen, dangerous animals, and misbehaving children. They are quite dramatic, and create a world full of tension for the comedian to work in. If everyone were nice, it would be quite boring. It helped if the characters were already primed for a fight. These films were short and had to get to the action quickly.

In the clash of comedian and context, there is no milieu more vulnerable to mockery than high society. Charlie Chaplin grew up poor in class conscious England, and his art is all about class. His Tramp character belonged in the world of the poor, but also found comedy by trespassing into the world of the rich. When he wasn't the Tramp, Charlie was the drunk dressed up in formal evening clothes. It is at the extremes of society where the laughs can most easily be found. The Marx Brothers invaded high society and brought anarchy to its careful order. They would begin with a stuffy upper-class situation, such as a vacation resort, a college, or a luxury ocean liner, and just have fun with it.

Comedic characters generally belong to the lower classes. They are traditionally shown as accepting their lot in life, and are simply trying to make the best of it. Their desires are for basic things like love and food. The deep desire to elevate one's status is typically used as a negative trait, because it shows an essential dissatisfaction with life. Social ambition motivates the villain. In *The Boxtrolls* (2014), Archibald Snatcher wants nothing more in life than to join the aristocratic White Hats and eat their cheese.

Context for Satire

From primitive times to the present, all healthy societies have allowed for a small amount of fun to be made of otherwise sacred rituals. In our more secular culture, that mockery is applied less to the church and more to other institutions that take themselves seriously. Corporate board rooms, health spas, fashion shows, courts of law, hospitals, prisons, even funerals can provide potential for laughs. The military is a perfect situation to drop a misfit into. The army has firm codes of behavior to follow and sergeants who will react badly towards anyone who goofs up. Occasionally, TV shows will have one episode where the comedian ends up in boot camp. There are multiple ways for the character to react to the stress. Ren and Stimpy joined the army for one episode. Stimpy falls right in line immediately, and pounds out push ups like a champ. He contrasts with Ren, who tries to avoid the exercise by bribing the Sergeant. Ren temporarily loses his mind from lack of sleep, but ultimately they graduate. Bugs Bunny gets drafted into the army in *Forward March Hare* (Warner Brothers, 1953), directed by Chuck Jones. Private Bugs makes the best of it, but his unintentional screw-ups result in his Sergeant slowly being busted down until he is a private as well. Different characters, different reactions.

All great physical comedians develop their personal style. And that style will often include working in a similar context. Jacques Tati, perhaps the greatest "silent" comedian of the sound era, made movies that were commentaries on the modernization of France. He felt that charming old Paris was being replaced by a cold steel and glass metropolis. That inspired him to create gags to demonstrate how he felt about it. He was particularly fond of using architecture to express his ideas. To shoot his film *Playtime* (Specta Films, 1967), he built a full size city block at enormous expense. He also wrote his stories to find fun in fashionable homes, high efficiency workplaces, and modern methods of transportation.

Quiet Context

It has been my observation that a silent comedian is often funnier in a situation where silence is the norm. I noticed this from watching two classic *Mr. Bean* stories which involve such scenarios. In *The Library* (ITV, 1990), directed by Francois Reczluski, he is in a library looking at a valuable antique book, which he damages by his mishandling of it. He then further damages it through his attempts to fix or hide the mistake. In *The Exam* (ITV, 1990), directed by John Howard Davies, he is taking a school examination, and his insecurities lead to all kinds of inappropriate behavior. If a character is expected to be quiet, he is automatically compelled to express himself non-verbally. Tex Avery directed *Rock-a-Bye Bear* (MGM, 1952), which is about having to keep quiet. Spike the dog is hired by a bear to watch his house while he hibernates for the winter. The bear angrily screams his demands to keep the house absolutely silent while threatening him with a club. Spike has a rival dog who wants his job. The rival lays painful traps around the house, but when Spike gets hurt he is too afraid to scream. He repeatedly has to run out the door and up the hill to let it out. Avery set up the situation demanding quiet, then makes it practically impossible to be quiet.

Modern Life

Finding good contexts for physical comedy in our modern world may be more challenging than it was early in the last century. One reason is the fact that people are not engaged in nearly as many different physical activities. Modern engineering and the digital lifestyle have erased many kinds of labor and functions that were common just decades ago. And our increased sense of safety makes those dangerous jobs of days gone by seem old fashioned.

One way to describe the change is through kids and how they play. Hal Roach owned the studio that produced the Laurel and Hardy films. One day he was watching some children play in a lot near his office, and he was inspired to create a series of films about children. This led to *The Little Rascals/Our Gang* (1929–1944) comedy shorts. The Little Rascals were poor, and mostly on their own. Traditionally, comedic characters are the underclass. Adult society had little intervention. They used castaway objects to create worlds to play in. The pure charm of their junkyard playgrounds and hand-built vehicles were a large part of their fun. These kids could make something out of practically nothing, constructing boxing rings, theatrical productions, and fire engine companies from piles of broken stuff. Worlds of trash have been created for animated films as well. While cleaning up the garbage covered Earth, the little robot Wall-E collected interesting items and stored them in his container home. The child-like Boxtrolls gathered cast-off items from the streets to build and experiment with.

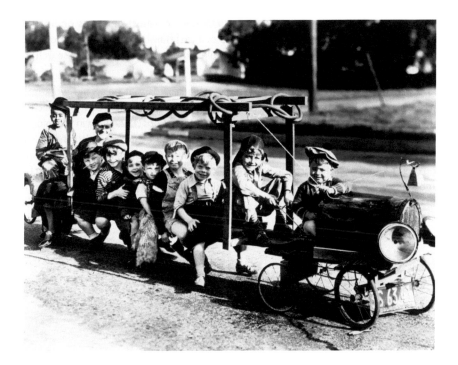

Figure 7.5 *The Little Rascals* ingeniously created playthings from found materials

Courtesy Everett Collection.

Kids on TV are no longer poor. At the very least they are middle class. In recent years, we have had shows about genius kids with secret labs, super computers, and unlimited resources. They must be extremely wealthy to finance all of that. The characters have come to rely on technology with keyboards and screens. Just a few lines of code and you can produce a robot to do the work. It has become entirely mental, not physical. What it leads to mostly is lots of talking about stuff and less actual doing.

In the days of silent film, directors and actors could choose from a broad array of scenarios involving manual labor. Pianos were moved up huge flights of stairs, office windows were washed from teetering planks, beer was delivered in huge barrels,

construction workers stood on girders to pound in hot rivets. A street scene could involve hoisting a safe to a third floor window, an elevator that rises through the sidewalk, or a policeman directing traffic by hand. Vehicles were not slick and comfortable like they are now. There were rattletrap model Ts, overstocked trucks, and fire engines with firemen dangling off the back and sides. Inventors had messy workshops with actual tools to build mechanical wonders. The world was dirty and people were sweaty.

The world has changed, and people prefer to see art that is relevant to the lives they are living now. Modern animators just need to understand the basic concepts, and find updated versions of the same ideas. Here are some Buster Keaton inspired examples. Many of Keaton's films were built around giant props. Props so large, he could live inside them, which makes them qualify as a context. *The Navigator* (1924) took place on an empty ocean liner that goes adrift in the ocean. *Steamboat Bill Jr.* (1928) was built around a steam powered river boat. In *The General* (1926) he is the engineer on a locomotive of the same name. Those large props were also mobile. Something similar is found in the Pixar feature *Up* (2009). Carl Frederickson must move his home, but doesn't want to leave his house. With the help of a vast number of helium balloons, he breaks his house free of its foundation and takes to the sky, and goes in search of adventure.

Keaton's large mobile elements also included huge crowds that he would work into massive chases. By arranging these mobile elements, he created a fluid context, which is inherently unpredictable and interesting. In the short film *Cops* (1922) he is in the middle of a parade of policemen when he catches a bomb tossed by an anarchist. The police think he is the anarchist and pursue *en masse*. In *Go West* (1925) he is a novice cowboy who drives a herd of cattle through Los Angeles. In *Seven Chances* (1925) he is chased by a mob of hundreds of women dressed in wedding gowns. A similar fluid situation is

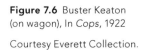

Figure 7.6 Buster Keaton (on wagon), In *Cops*, 1922

Courtesy Everett Collection.

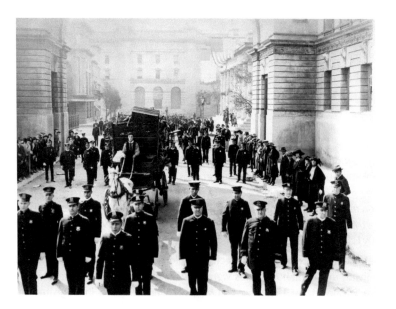

found in automobile races, where multiple cars are moving at high speed on a race course. This idea was used for Pixar's *Cars* (2006), as well as DreamWorks' *Turbo* (2013), directed by David Soren.

Characters do not exist in a vacuum. They are influenced by their environment, and should have an influence on things around them. If your story is totally focused on character behavior and interaction, they may seem to be no place at all. By thoroughly understanding what the context can provide, you open up many more possibilities for your character. Integrating them into their worlds will help to make them more believable. And of course, a thorough knowledge of comedy history will give you valuable references on how funny ideas have been successfully delivered in the past.

Notes

[1] Hayes, Kevin J. (ed.). *Charlie Chaplin Interviews.* (Jackson, MS: University of Mississippi Press, 2005), p. 18.

[2] Etaix, Pierre. *Pierre Etaix: The Criterion Collection.* 2013. DVD.

CHAPTER 8

Structure, Style, and Theme

This chapter is about creating stories for funny cartoons. One of my big reasons for wanting to write this book is to present a counterpoint to conventional film storytelling. In animation, there is an emphasis on "story" that has led to adopting standard narrative formulas that don't take advantage of what animation can do.

Hollywood is filled with thousands of aspiring screenwriters. They spend money to buy books and take classes that will help them learn the craft of writing the salable feature film screenplay. Those are the sorts of books that feature film screenwriters should read. The small number of writers employed to work on feature animated films are well versed in mythic archetypes, three act structure, character arcs, backstories and script formatting. Those elements can be included in long form animation, but for short form cartoons, there usually isn't enough time. As in music hall and vaudeville entertainment, short cartoons have to move fast. Performer-based comedy is more concerned with the connection between comedian and audience than it is with completing a checklist of story points. Some of the things in this chapter will apply to long form storytelling, but my intent is to provide an alternate approach to the rules laid out for Hollywood screenwriters.

I should illustrate what I am saying about the difference between conventional film narrative and performer-based comedy. As an example of what conventional film narrative is like, below I paraphrase the sort of thing I have read in various books and articles on screenwriting:

> Stories should have a protagonist with a goal, but who also has at least one flaw. Then you need an adversary, or a problem, that seems insurmountable to the protagonist. Ultimately, the protagonist overcomes his flaw, and succeeds despite the difficulties. In the process, he learns a lesson about himself and changes for having the experience.

This is a useful formula that can be applied to comedy. It actually is the type of formula that Harold Lloyd might have used in creating his feature films. Of the great silent film stars, Harold Lloyd's "glasses character" was the most like a real person.

But consider a Bugs Bunny cartoon, such as a typical hunting scenario with Elmer Fudd. You would basically have to turn that formula inside out to describe it. Fudd is the one with the goal, to kill a rabbit. He is the one with the flaw of being dim-witted. Bugs is the adversary preventing him from achieving his goal. But Fudd never succeeds, and he never learns his lesson. Bugs seems to have no serious goals, except maybe to go on vacation. He has no significant flaws. Bugs only acts when provoked and he never has to learn a lesson. Bugs leaves the story exactly as he started. But during those minutes, the audience laughs. It is time well spent. When the audience laughs, they never stop to analyze why.

Many people believe you can't teach comedy. Many comedians don't want to dissect it. My approach is to describe the many ways people have done it before in order to simply share the valuable lessons I have found. All comedians learn from other comedians. If you watch a cartoon or movie, and really understand what is happening, it will make it easier to use those methods in your own work. I will introduce you to stories for physical comedy through the topics of style, structure, and theme.

There are many different styles of comedy, and considerable overlap between them. I have already outlined some styles of comedy earlier. Commedia dell'arte and English pantomime are two of these examples. In a later chapter I will discuss surrealism, which is different from anything else. Let's start with a look at comedy as opposed to **farce**. Here is a useful quote from Chuck Jones:

> Comedy is unusual people in real situations. Farce is real people in unusual situations.
>
> chuckjones.com

A real situation is, for example, a hunter hunting rabbits. That is a completely normal event. But if the hunter is a bit odd, and the rabbit is exceptionally clever, it can become comedy. Bugs Bunny is an unusual personality. That's what most of this book is about, unusual characters. For this chapter let's get away from characters a little bit and discuss story.

Farce is any story where the writer creates strange circumstances that cause misunderstanding and confusion among the people who were just going about their business. Coincidence can multiply far beyond what would be accepted in a normal story. Farce often includes physical comedy, which fits in with the direction of this book. Farce depends on wildly improbable situations and characters that react strongly to them. The characters are self-centered and are trying to achieve some sort of goal. But things go wrong, and their choices only seem to make things worse.

There is farce in animated films, to be sure. One of the easiest ways to create disorder is by the use of identical twins and mistaken identities. The twins are always the funny ones, and they get put up against a straight man. The straight man in the story doesn't realize there are two of them, as both are never in the room at the same time. Their entrances and exits are choreographed so only the audience sees what is going on. The

twins go about their business, sometimes having no knowledge of each other themselves. Each twin will have their own agenda, and misunderstandings will happen very fast, causing the straight man to doubt his sanity.

In the MGM short *Droopy's Double Trouble* (1951), directed by Tex Avery, Droopy and his ultra-strong twin brother Drippy are butlers at a wealthy man's estate. Drippy is butler in training, and is told not to allow strangers on the property, an order which he immediately takes to heart. When Droopy's friend Spike shows up, he secretly lets him in the back door. So Droopy and Drippy each have a radically different attitude toward Spike. When Droopy leaves the room, Drippy immediately enters and sees Spike as a stranger. He then pummels Spike with no mercy. Spike recovers from the beating when Droopy returns and makes him comfortable again. After Droopy exits, Drippy comes back to repeat the brutal cycle. It is important that the story sets up Spike as a jerk. Just before entering, Spike says he'll "work this soft hearted runt for everything he's got." That reveals him to be deserving of what is to come. The audience shouldn't feel bad for this character getting beaten badly for no good reason.

Figure 8.1 *Droopy's Double Trouble*, Poster Art, 1951

Courtesy Everett Collection.

The writers at Warner Brothers found Sylvester the Cat to be useful in creating farcical situations. Chuck Jones directed *Scaredy Cat* (Warner Brothers, 1948). Sylvester and Porky Pig move into a creepy old house. While Porky sees nothing unusual, Sylvester is terrified and shivering with fear. For this film, Sylvester seems to be playing the role of a real cat, and so he doesn't speak. When they go to bed and Porky turns the light out, Sylvester sees malevolent mice who are attempting to kill Porky. They try to drop an anvil on Porky while he sleeps, but Sylvester jumps in to save him. When the lights come on, the mice are nowhere to be seen, and Sylvester is left poised with the weapon, as though *he* is attempting murder. All Porky sees is Sylvester's bizarre behavior. This is why Sylvester doesn't speak, so he can't simply explain what is happening. It is necessary in farce for characters to not understand what is happening to them, or the whole story would come to an easy end. Their confusion is a significant part of the humor.

Robert McKimson used a kangaroo character named Hippety Hopper with Sylvester as well. Sylvester would try to impress his son with his mouse catching ability. He would go in for a mouse and find Hopper, who he mistakes for a giant rodent. Hopper then throttles the cat. When the son looks in, the kangaroo is gone, replaced by a normal sized mouse. From his perspective, his father lost a fight to a mouse.

So, it is important to know which direction you are taking with your story. Is the character creating the laughs with his behavior, or is the writer devilishly playing with his character's perceptions? Once you commit to one, you will need to carry it out completely.

Parody and Satire

One of the easiest routes to creating comedy is by making fun of something the audience already knows. YouTube is filled with spoofs of *Star Wars* (Lucasfilm), pop songs, and television commercials. Once the audience has recognized the characters and situations as something they know, you can immediately get to the business of putting a new spin on the subject.

But not all mockery is the same. Primarily, it comes down to the difference between parody and satire.

Parody often involves making fun of a particular work, say a specific TV show or a book. Alternatively, it can take on an entire genre. Parody is mostly concerned with the superficial style of the original, rather than the content. It is crucial that the source material takes itself seriously to begin with. For *What's Opera Doc?* (Warner Brothers, 1947), Chuck Jones took the most basic parts of an Elmer Fudd/Bug Bunny chase story, but dressed it up in the trappings of an opera. He took the musical style, the historical costumes, the dramatic stage sets, graphic effects, and even the "tragic" ending. Each of those elements were further exaggerated and stylized, and the result is one of the most acclaimed Looney Tunes ever.

Figure 8.2 *What's Opera, Doc?*, from left: Bugs Bunny, Elmer Fudd, 1957

Courtesy Everett Collection.

Satire will also begin with familiar material, though usually not a specific work. What really separates satire from parody is its purpose. Satire uses humor to deliver a social, political or moral message. The satirist must have a point he or she is trying to make about established institutions and behavior. The message can be delivered by a gentle ribbing or a scathing attack. It all depends on how strongly the satirist wants to make his or her point. Ridicule, exaggeration, metaphor, and analogy are all useful tools in satire. What matters is the potential to make an audience both laugh and think.

Over its many seasons *The Simpsons* has satirized American life with an entire ecosystem of characters. Krusty the Clown runs a merchandising empire, Montgomery Burns is the quintessential uncaring rich man, Kent Brockman is a shallow news reporter, Mayor Quimby is the self-serving politician, Grampa is treated like too many old people are. However, the Itchy and Scratchy cartoons that Bart and Lisa enjoy watching are pure parody of the violent cartoon.

Caricature is an important part of the animator's toolbox. Historically, caricature has found its most powerful use in political cartoons. Creating laughable images of important people is the most direct way to mock their political views. The online animation and electronic greeting card company Jib Jab produces short animated films that make fun of celebrities and political figures. When the target of satire is a specific individual, it can be called a **lampoon**.

During World War II, American animation studios produced films to shore up the war effort. Popular characters were put into situations where they could demonstrate the expected attitude, often by going bravely into the fight. Adolf Hitler provided an excellent target for Donald Duck, as seen in Disney's *Der Fuehrer's Face* (1943), directed by Jack Kinney. Creating a satire of an individual is acceptable, but not so with an entire race or religion. Other cartoons of that era used racist caricatures of the Japanese people as a whole. Satire is a weapon to use against powerful personalities or questionable ideas. When it is used to ridicule a large group, such as the population of an entire region of the world, it is sure to misrepresent the complex reality of things, and create negative and damaging stereotypes.

If you want to make fun of something that is popular at the moment, it's best to do it quickly, while the public still cares about it. As time goes by, it will become less relevant. A parody of a hit song from five years ago won't get nearly as much appreciation. Where parody is best served fresh, satire can have a much longer shelf life. Good satire addresses common human foibles that never seem to go away. Satirical plays from centuries ago are still performed, whereas the parodies that are a decade old will probably have lost most of their humor.

Beginnings, Ends, and Middles

There are many different ways to create comedy. In addition to some of the styles and structures I describe in this chapter, I want to include some fundamental concepts about creating and presenting comedic narratives. This is not a prescription or a

formula. That is anathema to creative comedy. I just want to provide some time tested advice from some of the greats. This presupposes that you have one or more characters well thought out. If not, you should go back to Chapter 5 on character, and start there.

The story must be designed for the character. As Charlie Chaplin said:

> I don't care much about story—plot, as they call it. If you have the neatest tailored plot in the world and yet haven't personalities, living characters, you've nothing.[1]

Before you even begin the story, you need subtly to inform the audience that it is a comedy. To do this, you create what Gerald Mast calls a **comic climate**. This can be done with something as simple as the title. Light-hearted music is an excellent way to set the tone, which is why Looney Tunes opened with the energetic "Merry Go Round Broke Down." Funny looking characters could make the audience laugh just by looking at them. They can open with a joke, or have an odd sounding voice. The environment design can be exaggerated and stylized. You must consciously signify your intentions, otherwise the comedy will get off to a slow start.

Whatever style or structure you choose for your film, you absolutely need three things: a beginning, a middle, and an end.

In the chapter on context I pointed out how the first thing the audience wants to know is where the story takes place. Once your comic climate is established, you must present the context for the story. Then it is crucial to get the story moving by starting as far into the action as you can. Don't have characters sitting around wondering what to do. If your characters are bored, the audience will be bored too. They could, however, be extremely comfortable in some way. In that case it's your job to ruin that for them right off. Some other character enters and quickly gets the story rolling. Either way, they should be fully engaged in something that is important to them. The audience should understand exactly what it is and it should be something they can relate to. Simple, common desires are the best subjects for comedy. Maurice Charney provides some good advice for this:

> Perhaps we could describe comic plots as mechanisms of acquisition. Something is always being sought, pursued, hunted, bargained for, or stolen—something of value, be it love, sex, or money. The plot begins with an announcement of the stakes and an account of the limiting conditions and attendant difficulties.[2]

Elmer Fudd does exactly that when he says: "Be vewy quite. I'm hunting wabbits."

Now you have a character who wants something, and the context presents a challenge. It can be a completely normal situation, so long as the audience understands the challenge. Hunting in a forest is challenging. Being a door-to-door salesman is challenging. Seeing a pretty girl in a window across the street is a challenge to a lonely young man.

At this point, I am going directly to the ending of the story and will come back to discuss the middle. Here's why: middles are not as important as endings. What happens in the middle matters, of course, but you need a plan on where you are going. You choose your destination and then work out the route to get there. The story cannot just wander towards whatever end you happen to reach. Improvisation can create fabulous moments in comedy, but it is not how complete stories are built. When beginning a project, you should have some idea of how long a film you can produce. You figure out how much time your beginning and ending will need, then the middle can be filled or cut to make it work. Go directly to looking for a good ending. This idea is supported by Buster Keaton.

> When myself and the three writers had decided on a plot—we always looked for the story first—and the minute somebody came up with a good start, we always jumped the middle. We never paid any attention to that. We jumped to the finish. If a man gets into this situation, how does he get out of it? As soon as we found how to get out of it, then we went back and worked out the middle. We always figured the middle would take care of itself.[3]

It goes without saying that comedies have happy endings. So your good guy has to win. Or, at the very least, survive. There are many different styles of comedy, but they all have that in common. More than anything, the audience wants a memorable ending to the story. By planning for the end first, you have blue sky opportunities to find that exciting climax. Have your character in a seemingly unsolvable predicament. Then get them out of it. There is a famous saying in show business: "Always leave them laughing." Tex Avery said in an interview with Joe Adamson:

> The real problem was to build up to a laugh finish. Gosh! If you build up to a point and the last gag is nothing, you've hurt your whole show, audience-wise. So in all of them we attempted to be sure that we had a topper.[4]

Oddly enough, there are rare cases where endings can be completely predictable. Think of Scooby-Doo cartoons. They always end with the unmasking of the monster and the discovery of the local man who would have gotten away with his scheme had it not been for those meddling kids.

Where traditional story telling requires a **resolution**, cartoons don't necessarily need an absolute end to the story. Some shorts, such as certain Tom and Jerry cartoons, will have a climax and a brief pause, but then go right back to the chase as the iris closes on the screen.

A less common, but perfectly viable procedure was to actually start with an idea for the climax. Some films have been inspired by an idea for a great ending. Harold Lloyd did exactly that for his most famous film, *Safety Last* (Hal Roach Studios, 1923), directed by Fred Neymeyer and Sam Taylor. His idea was to find himself hanging from a building high above a city street. In fact, they even went so far as to film the entire ascent of the building first, before they even knew what would happen to get him started on the journey. They went back and made that up later. That's how important endings are.

Figure 8.4 Harold Lloyd hangs from a clock in *Safety Last*

Licensed under public domain through Wikimedia Commons.

Some words now about the middle parts of a story. At the very least, the path to the end requires two things. First, it needs to be funny. Chapter 9 on gags and comic events will help with that. Second, the events need to unfold in a natural, believable way. One thing causes another. By believable, I do *not* mean realistic. Strange things can, and should, happen. That is the nature of chaos. The art is in presenting the material so that the audience accepts it. It must work with the characters and style you have set up for yourself. You must always check back with your character and get his permission. The character might need a prop or skill to solve his final problem. Earlier in the story, you can prepare for that in some subtle way. In Buster Keaton movies, he often went through early failures at challenges he would later succeed at when it becomes really important. In *College* (United Artists, 1927), he comically fails in every attempt to join a sports team, but at the end he courageously runs through a decathlon of events in order to save his girlfriend from the bad guy. All those things were planted because they knew what he would do at the end. It was a consistent theme.

You will want to keep a level of suspense by keeping the challenges coming. Things should feel out of control, even dangerous. Be mindful of the tempo of the work. Is it steadily building toward the climax? Or does it have unwanted dull moments?

Finally, think about what is your very last shot. What image are you leaving the audience with? Are they laughing with your character, or at him? I have seen more than a few student shorts that end with a sad sack character who got the worst part of the slapstick

violence. He glumly looks at the camera while the frame irises out. Those works are influenced by Wile E. Coyote, and are badly done. You might get small laughs at that, but people won't be asking for more. Compare that with Charlie Chaplin's famous final shot, of him walking away down the road alone. He may have gained nothing from his adventure, but he still has that lively step, and the audience knows he'll be okay.

In order to send audiences out singing, feature films sometimes end with song and dance numbers that include the whole cast. In recent years, it has become almost common for a post-credits scene that has one more gag, or perhaps a hint towards a sequel. Warner Brothers put their brand on memorable final shots by adding the Porky Pig sign off: "Th-th-that's all folks!"

The Chase

Figure 8.5 *Wallace and Gromit: The Wrong Trousers*, 1993

Courtesy Aardman Animation.

Slapstick chases took place on the live stage before film was invented. But the chase flourished when it was introduced to film in its earliest days. The unlimited use of space, moving cameras, and editing across scenes allowed the chase to become practically a genre in itself. While it was used in melodrama to create tension, it really found a home in comedy. Mack Sennett took inspiration from the chase comedies produced in France, and put them to work in his own silent films. It was an ideal structure for Sennett, as the chase could be 100 per cent action, which didn't require character and subtlety.

By its very nature, the chase allows for no dull moments. It is continuous action that builds tempo. Comedy loves momentum. Get the laughs rolling, and the audience will be completely engaged. Chases have enormous potential for surprises with sudden changes of direction and unseen obstacles. Both the chaser and the chased are at risk. A good chase ends with a bang, so that's where planning your ending becomes crucial. It is a very simple structure for comedy, so doing it with style and energy is important.

Entire feature films have been built around chases. More accurately they are built around the identical twin of the chase, the race. These tended to be epic, slapstick filled, all-star affairs. *It's a Mad, Mad, Mad, Mad World* (United Artists, 1963), directed by Stanley Kramer, is one long race between multiple parties to reach a buried treasure. *The Great Race* (Warner Brothers, 1965), directed by Blake Edwards, and *Those Magnificent Men in their Flying Machines* (Twentieth Century Fox, 1965), directed by Ken Annakin, are two other examples. *The Great Race* was also the inspiration for the animated TV series *Wacky Races* (Hanna-Barbera Productions).

Creating the motivation for the chase is the first step. It could be a simple antagonistic duo, such as a cat and a mouse. Tom and Jerry chases done at MGM are great to study, because they did so very many of them and they were tasked with not being too repetitive. That is where imagination is needed. In *Yankee Doodle Mouse* (1943), the chase has a warfare theme, with eggs being labelled "hen-grenades" and fireworks substituting for anti-aircraft weapons. *Tee for Two* (1945) takes place on a golf course, with lots of golf related gags. In *A Milky Waif* (1946), Jerry takes in an abandoned baby mouse, who must be taught to run from the cat, and then how to smack him in the face with a frying pan.

There are many ways to make a two character chase interesting, but add a third character, and the number of possible variations grow. In *Flirty Birdy* (1945), Jerry is pursued by both Tom and a large bird of prey. Jerry has to deal with each on his own, as well as be repeatedly stolen by the other one. The situation reverses in *Kitty Foiled* (1948), when a cute little canary becomes Jerry's ally, and Tom has to deal with both of them. One short, *The Truce Hurts* (1948), opens with Tom, Jerry and a bulldog crashing out of the house in a three way fight, but within seconds the bulldog calls a truce. By the end of the cartoon, when a T-bone steak is on the line, they fall back into precisely the same animated cycle they left off with (Tom and Jerry: MGM, directed by William Hanna and Joe Barbera).

Chases were a favorite of Tex Avery as well. In *The Early Bird Dood It!* (MGM, 1942), a worm is fed up with being chased by a bird, so he hires a cat to chase the bird. In *Happy Go Nutty* (MGM, 1944), Screwy Squirrel escapes from the nut house and is looking for some action. He goes out of his way to invite the dog to chase him. Avery's great film *King Size Canary* (MGM, 1947) is a four way chase between a cat, a bird, a mouse, and a dog. The kicker here is a bottle of grow formula that causes gigantic growth in whoever drinks it. They take turns drinking from the bottle, and expanding to be larger than whoever was chasing them. The pursuit then reverses.

Though it really isn't politically correct anymore, romantic interests certainly initiated a few chases. Some Tom and Jerry shorts had Jerry interfering with Tom's pursuit of pretty girl cats. Pepé Le Pew's pursuit of females was good natured fun. What would a Marx Brothers movie be without Harpo running along behind some good looking actress?

Few things bring out human awkwardness like roller skating. It makes for comical motion, and can also make for interesting chases. In *A Date to Skate* (Fleischer Studios, 1938), directed by Dave Fleischer, Popeye tries to teach Olive Oyl to roller skate. She loses control and rolls right out of the skating rink into the perilous city traffic. Popeye pursues Olive to rescue her, which of course requires spinach. This is also a good example of how not all chases are malicious in nature. Charlie Chaplin put his entertaining style of dance to work while wearing skates. In *The Rink* (Mutual, 1916), Charlie has a run in with Mack Swain in a roller rink. Swain is large and unskilled, which allows Chaplin to harass him then gracefully roll away.

The climactic sequence from Pixar's *Monsters, Inc* (2001), involves a wild chase through the closet door warehouse. The doors are each portals to children's bedrooms. To escape, the characters jump into and out of the doors. Chases on the live stage were sometimes called **door slammers** as they often involved people running in and out of rooms, just missing whoever they are running after or away from. The *Monsters, Inc* closet door chase is a bit of an homage that takes that idea to an entirely new level.

Chases don't always need to be high-speed cross-country affairs. The idea of the chase can be played out in many forms. For instance, in Harold Lloyd's famous film *Safety Last* (Hal Roach Studios), the chase is a slow motion, vertical ascent up the side of 1920s era skyscraper. Each floor brings with it peculiar challenges. In the Marx Brothers movie *Monkey Business* (Paramount Pictures, 1931), directed by Norman McLeod, the foursome are stowaways on an ocean liner. As the captain of the ship chases Chico and Harpo around a dinner table, the two of them grab food to take with them before they exit. In my discussion of Buster Keaton, I describe how his use of entrances and exits produced quick, stop-and-go chases.

The chase shows no sign of getting old as a comedy structure. It just depends on interesting characters and motivations, with some clever gags to keep the laughs coming. A big exciting ending is great, but make sure the journey is fun.

Rivalry

Figure 8.6 *Droopy's Good Deed*, from left: Droopy and Spike, US poster art, 1951

Courtesy Everett Collection.

One of the most basic comedic structures is simple conflict between two relatively equal parties (unequal combatants generally use the chase structure). These stories aren't simple fights, they are more of a competition to see which party can outdo the other. I chose the word **rivalry** because of the rivals act in vaudeville that I described earlier. It is a good word to describe a head-to-head challenge.

The reason for the rivalry can be nearly anything. It can be food, money, romance, a sports trophy, or simple honor. What matters is that the audience understands why it is important to those involved. One of them, the star of course, is the good guy, and the other is the troublemaker. Often, but not always, the star prevails in the contest. Some Laurel and Hardy shorts end with no clear winners. The boys are just lucky to get away without being arrested.

The comedy is in how the rivalry is carried out. A real fight is a messy thing, and is not at all like it is depicted in the movies. In storytelling, we need a sequence of events the audience can follow, not a jumble of activity. So the structure tends to take the form of a simple back and forth contest. It is the style that matters, and each comedian develops their own way of carrying out the battle.

I have already mentioned the Laurel and Hardy tit for tat films, which place the pair into a struggle against someone who has offended them. Beginning as an honest misunderstanding, it steadily escalates into widespread destruction and humiliation. In these films, it is curious how one party will stand idly by while the opponent carries out an attack, such as using scissors to cut off his neck tie, crushing his hat, or ripping the door off his house. That is a crucial part of the Laurel and Hardy style of comedy, which is slower and more deliberate. It is a gentlemanly and elegant method of battle. It is as though there are rules of engagement being followed. While they are not above destroying the other person's property, they wouldn't think of being rude and interrupting them. It is more honorable to stand and "take it like a man."

Popeye cartoons very often used the rivalry structure. The rivalry between Popeye and Bluto over Olive Oyl is the motivation for many of their cartoons. It could take the form of simple **one-upmanship**, with each of them trying to impress Olive with feats of strength. Occasionally Bluto would simply grab Olive by the arm and run off, and Popeye would have to rescue her. It would then become a back and forth effort with Olive acting as a sort of ball in a game. Ultimately, it could result in a full on fist fight. This is one of the few times where this happens in the rivalry structure. But again, style is paramount. Popeye and Bluto can throw punches and wrestle so fast, they become a great ball of dust with only fists and heads appearing momentarily. That can't be kept up for long, because it's really just an effect. The real style comes when they each punch something, or each other. The punch becomes a demonstration of both strength and imagination. A blow can literally transform matter and re-sculpt it into something that makes a statement, such as when Popeye punches a bull and turns him into a butcher's stand displaying all the various cuts of meats and sausages. That is Popeye's style.

Tex Avery directed several shorts at MGM where Droopy was in head-to-head competition with a bulldog named Spike. These films followed the same routine. Essentially, Droopy would humbly do his best, while Spike would cheat using the most elaborate plan he could put together. In *Droopy's Good Deed* (1951), Spike pretends to be a boy scout in contention with Droopy for the title of "Best Scout" which will earn him a trip to meet the President. While Droopy follows the boy scout book to the letter,

Spike ignores all the rules and simply tries to knock off Droopy with explosives and booby traps. Of course each time it backfires horribly. In *Daredevil Droopy* (1951), Droopy and Spike both apply to a circus for the position of "daredevil dog." Droopy easily conquers each challenge, while Spike fails miserably, despite taking huge advantages. In *Wags to Riches* (1949), Droopy inherits a fortune from his owner, while Spike gets left out of the will. Since Spike stands to take over if Droopy should die, that leads to a film full of failed attempts on Droopy's life. Luck always favors Droopy, while Spike proves that cheaters never prosper.

Creating Constraints

Animation has the capacity to do absolutely anything an artist can imagine. If you have the tools and team to do whatever you can think of, it is easy to get carried away. That can be a problem, because comedy thrives on simplicity. In creating your story ideas, you should set some boundaries. Define the world and what the characters are allowed to do, and what they are not allowed to do. This is particularly important if you are creating a series. A reliable and familiar world will help the audience relax and enjoy the events. It will also help you to focus on specific directions.

When Chuck Jones created his Coyote and Road Runner cartoons, he set what he called **disciplines**. These disciplines were important in maintaining a consistent style of comedy. Here are his ten disciplines.

- The Road Runner cannot harm the Coyote except by going "beep beep" to scare or surprise him off a cliff. No outside force can harm the Coyote—only his own ineptitude or the failure of Acme products. Trains and trucks were the exception from time to time.
- The Coyote could stop anytime—if he were not a fanatic. (Repeat: "A fanatic is one who redoubles his effort when he has forgotten his aim"—George Santayana.)
- Dialogue is strictly forbidden, except "beep, beep" and yowling in pain.
- The Road Runner must stay on the road—for no other reason than that he's a roadrunner.
- All action must be confined to the natural environment of the two characters—the southwest American desert.
- All (or at least almost all) tools, weapons, or mechanical conveniences must be obtained from the Acme Corporation.
- Whenever possible, make gravity the Coyote's greatest enemy (e.g., falling off a cliff).
- The Coyote is always more humiliated than harmed by his failures.
- The audience's sympathy must remain with the Coyote.
- The Coyote is not allowed to catch or eat the Road Runner, unless he escapes from the grasp.

Limits are a part of life. Even if you have characters with magical powers, you don't want them to be gods. It is interesting to see them deal with challenges with only the tools they are given.

Theme

A great many comedies have been built around two things: a character and a theme. Theme is not very different from context, but is more about actions than about place. Themes are activities that are commonly known to the audience, or at least understood. The idea is for the comedian to explore the topic through his own unique point of view, and find fresh ideas that nobody has done before.

The process is simple. Choose a theme, and make a list of things such as what props are found, common character types associated with it, what the environment is like, and what typically happens. Then explore the possibilities of doing things in unusual ways, and exaggerate the known characters.

Many Goofy cartoons were created this way. Goofy is an all-purpose slapstick comedian, and was sufficient to be the third banana behind Mickey and Donald. But on his own, he is not the strongest character, so Disney put him into shorts based on themes with no real stories at all. Many of them were sports themed, with Goofy trying gymnastics, hockey, baseball, football, tennis, golf, swimming, skiing, and basketball. Over time he became a generic suburban father character, engaged in normal activities like catching a common cold, owning a dog, and taking vacations. Interestingly, he had films about dealing with bad habits such as smoking, gambling, overeating, and aggressive driving. Mickey Mouse, on the other hand, would never have been shown engaging in those activities. As the corporate image, he had to maintain certain dignities. The public has been known to complain when favorite characters engage in unseemly behavior.

In 1903, Edwin S. Porter created one of the earliest narrative films when he directed *The Life of an American Fireman* for the Edison Company. It's not a comedy, but plenty of comedians have taken a spin with firefighting. It is an exciting subject, with the classic fireman's pole, the race to the scene, managing crazy fire hoses, and rescuing other characters. Mickey Mouse and the gang were in *Mickey's Fire Brigade* (Disney, 1935) directed by Ben Sharpsteen. Donald Duck was the title character in *Fire Chief* (Disney, 1940), directed by Jack King. Charlie Chaplin directed and starred in *The Fireman* (Mutual,

Figure 8.7 *The Simpsons*, from left: Eduardo, Homer Simpson, "YOLO (You-Only-Live-Once)" (Season 25, ep. 2504, aired November 10, 2013)

1916). Hal Roach put his Little Rascals in *Fire Fighters* (1922), directed by Robert F. McGowan and Tom McNamara.

One of the oldest themes is boxing, simply because boxing presents a conflict in its most basic arrangement. Two men, inside a squared ring, fighting. The slapstick possibilities are obvious. Of course, the hero is the underdog and tends to be small in comparison to "the champ." In the ring you can alternate between rivalry and chase. Real boxing has almost no props, but that doesn't mean you can't introduce something. Horse shoes in boxing gloves is one of the old tricks. Boxing has been a classic theme done by Charlie Chaplin, Buster Keaton, Harold Lloyd, Bugs Bunny, and others. Mickey Mouse didn't box himself, but he put a robot in the ring in *Mickey's Mechanical Man* (Disney, 1933), directed by Wilfred Jackson. Even Jacques Tati did a boxing film early in his career before developing his much more subtle style of comedy.

Going to college has been a popular theme. It's been done by Buster Keaton, Harold Lloyd, and Pixar with *Monsters University* (2013), directed by Dan Scanlon, not to mention *National Lampoon's Animal House* (Universal, 1978), directed by John Landis. College works well as a subject because it always involves new students arriving in a strange place, and having to learn to adapt. It's also full of young men and women who are just escaping the restraints of home, and are likely to do ridiculous things, just because they can. Colleges are also staffed by authority figures who are easy to make fun of.

Ghosts and ghost hunting is one of the most evergreen themes to work with. Animation works well for creating scary beings. Mickey Mouse, Donald Duck, and Goofy worked together in *Lonesome Ghosts* (Disney, 1937), directed by Burt Gillett. In that film, the trio advertise their ghost exterminating service. Some bored ghosts call them to their haunted house to have fun with. Popeye used his strength to exorcise a ghost ship in *Shiver Me Timbers!* (Fleischer Studios, 1938), directed by Dave Fleischer. The scary comedy theme continues to be strong with movies such as Ivan Reitman's *Ghostbusters* (Columbia Pictures, 1984), Tim Burton's *Beetlejuice* (Geffen, 1988), and Edgar Wright's *Shaun of the Dead* (Universal, 2004). Audiences love seeing people scared, even when they know the threat isn't real. Scooby-Doo and the gang have been chasing, and getting chased by, phony demons, monsters, and ghosts in TV and movies since 1969. The success of Scooby-Doo demonstrates how a simple formula can be successfully reused over and over again.

The list of possible themes is enormous. Restaurants, kitchens and eating, car racing, dentistry, the zoo, lumber jacks, babysitting, house building, boat building, plumbing, big game hunting. Even something as simple as a picnic can be a start for a good short film. For an excellent resource, I recommend Anthony Balducci's book, *The Funny Parts: A history of film comedy routines and gags*. It is a theme-based history of gags and how they have been reused and developed by various comedians.

The possibilities in comic story construction are much larger than in drama. If you can make the audience laugh, they will accept virtually any kind of story. It isn't about following the rules or principles. It's about giving your characters the opportunity to express themselves in ways that people can relate to.

Notes

1 Hayes, Kevin J. (ed.). *Charlie Chaplin Interviews*. (Jackson, MS: University of Mississippi Press, 2005), p. 81.

2 Charney, Maurice. *Comedy high and low: An introduction to the experience of comedy* (New York: Peter Lang Publishing, 1987), p. 82.

3 Sweeny, Kevin W. *Buster Keaton Interviews* (Jackson, MS: University Press of Mississippi, 2007), p. 73.

4 Adamson, Joe. *Tex Avery: King of cartoons* (New York: Popular Library, 1975), p. 173.

CHAPTER 9

Gags and Comic Events

What, all this junk, the yak-yak-yak? It would've broke my heart! Dialogue gags are a dime a dozen, but a good sight gag is hard to come by.

Tex Avery[1]

To get laughs with animation you have two choices. Gags and jokes. A gag is intended to create laughter with visual humor. A joke uses words for the same purpose. Tex was right, gags are hard to come by, requiring considerable time to develop and integrate into the action in a natural way. American television animation has relied on verbal jokes because they are far more efficient in terms of production. A group of writers can sit around in a room and pitch storylines, then fill in some jokes, and before you know it the script is ready and there is only limited expectation on the artists to make it look good. Visual gags require much more time to invent, develop, and work into the action. Jokes don't really affect the storyline, whereas visual stunts will physically change the situation for the characters. Gags need careful timing and acting, which require more time than lip-syncing words.

One aspect of visual comedy does make it easier though. A joke heard once is used up, whereas a good sight gag can be successfully recycled. That is why comedic actors will reach back into their memory for gags to reuse. Something previously rejected might fall into place later on. The commedia dell'arte actors had their lazzi (comic routines) ready at all times. Bugs Bunny often used his trick of dressing up as a female, and nobody complained that he'd done that already. That was part of his lazzi, and each time it was a little different. Reused material must feel like spontaneous events, not pulled from a catalog and dropped in to fill the time. If you can identify the root idea of a gag, it can be modified to suit a new situation or a different character. By reading this chapter and watching as much physical comedy as you can, you will have a foundation of ideas to get you started.

Comic Events

People love funny gags. In many, many films, it is the gags the audience remembers. But it is important for me to explain the difference between a plain gag and a **comic event**. The term comic event is used by Steve Neale and Frank Krutnik to distinguish humor that grows from the story, more than the characters.[2] Where gags can be dropped anywhere by a skilled performer, comic events are more the responsibility of the writers and storypeople.

Feature films tend to be representational stories that aspire to create a world that feels real. If a performer steps out of the story to do something for a laugh, it disrupts the narrative flow. While they may enjoy the humor, the audience will lose confidence that the character is really engaged in what is going on. It breaks the illusion. Comic events, on the other hand, grow naturally out of the story.

I will give an example from the Aardman film *Wallace and Gromit: The Curse of the Were-Rabbit* (2005). Wallace and Gromit have a huge vacuum to humanely suck all the rabbits out of Lady Tottington's yard. Victor Quartermaine, the antagonist, is there as well, and he wants to shoot the rabbits. When Wallace turns on the vacuum, Quartermaine takes aim at a bunny. The rabbit gets sucked into a hole just as the gun goes off. The rabbit finds itself flying through the tunnel *toward the light* as if it

Figure 9.1 *Wallace and Gromit: The Curse of the Were-Rabbit*, Lord Victor Quartermaine, Wallace, Lady Tottington, 2005

@ DreamWorks. Courtesy Everett Collection.

has been killed and is going to heaven. It ends up inside the big glass container, floating on air, with clouds in the background, further giving the impression of having arrived in the afterlife. If you were to view the rabbit alone, it would not be funny. It is only in the context of the story that the humor is found. Following up on this, Quartermaine's hairpiece has been sucked into the vacuum as well. When Wallace goes to retrieve it for him, he mistakenly pulls out a black rabbit instead, and plops it onto Quartermaine's head. While putting a rabbit on a bald man's head is a gag that would be funny on its own, it is also a comic event that works perfectly well with the story.

For animated shorts such as *Looney Tunes* or the *Pink Panther*, the audience simply expects the character do all sorts of funny things. They just want to be entertained, so there is much more room to create any gag that works with their style. I want to emphasize that neither of these is better than the other. Some people dismiss gags as being inferior to comic events. They each have their time and place, and it's important to know the difference. Since the concepts that follow are applicable to both gags and comic events, I will use the word gag as a shorthand for both forms.

A Statement on Violence

As much of slapstick comedy involves depictions of characters doing things that would injure or kill a real person, I am compelled to make a statement on violence in animation.

In all physical comedy there is an implied promise that nobody receives real physical injury. That way, the audience is free to laugh without guilt. This does not mean that the characters do not feel pain. Pain can be funny when the actor plays it for laughs. Acting out pain realistically never happens in slapstick comedy. Cartoon characters, of course, are impervious to permanent damage. They can suffer the most outrageous disfigurement, and return to normal by the next scene. Nearly everyone understands that. Comedic violence is a parody of violence. It is not supposed to look real.

As characters can feel pain, they can also be injured for comedic purposes. Characters, both good and bad, live and animated, have found themselves in the hospital, bound up in bandages, limbs in plaster casts and sporting black eyes. This often leads to further comedy. In the Laurel and Hardy short film *County Hospital* (Hal Roach, 1932), directed by James Parrott, the story begins with Ollie in the hospital. He has broken his leg and it is elevated and bound up in a cast. Stan goes in to visit and, through his clumsy and idiotic behavior, spends the rest of the film making things even worse for Ollie.

Like any art, slapstick comedy requires certain skills to make it work. If it is well done, most people find it funny. Some do not, and some never will. Times and tastes change. If there are lines that should not be crossed, the lines can also move in either direction. You absolutely need to know your intended audience. Not all cartoons or slapstick comedies are for children. As with all popular art, it is good to get feedback and opinions about your specific work before releasing it.

My simple philosophy on this is that cartoon characters are acting out human resilience using exaggerated action. It is less about physical injury, and more about the strength of the spirit to keep moving despite the problems.

The Anatomy of Mirth

For an overview of gags, I am using the **anatomy of mirth** defined by M. Wilson Disher in 1925. This is an enjoyable description of essential physical comedy. As physical comedy is less influenced by time and style, it is still very relevant. Disher describes it this way:

> If the anatomy of mirth be vivisected without reference to psychology, the primary jokes appear to be divisible into six kinds. To give each a name would require some philological ingenuity. They can be indicated, however, by these terms: Falls. Blows. Surprise. Knavery. Mimicry. Stupidity.[3]

I love the formal language to denote such silliness. Each of these is a category of gags, and characters will specialize in certain categories, and may combine some together. No single character uses all of them, as some are given to fools and others to tricksters. A pair of antagonists might make them all work in a single act, but it is advisable to build the comedy around a chosen style. Audiences like to feel consistency in characters.

Falls

The proverbial banana peel that reminds us we are subject to gravity; falls are the most basic way for a character to lose their dignity. The more pompous the character, the funnier it is when he or she falls. The characters mostly bring it upon themselves in a seemingly magical act of instant karma. Good guys can fall, but it's funnier when it is someone dislikeable.

Figure 9.3 *The Finishing Touch,* US, 1928. Stan Laurel, Oliver Hardy, 1928

Courtesy Everett Collection.

Falling on one's derriere is considered funny because it is the part of the body least likely to produce pain, and reduces the possibility of actual injury. Dropping someone on the butt is a way to say "it's okay, he's not hurt." In the word **pratfall**, the "prat" is the buttocks.

The important thing to remember about falls is this: **It's not the falling that is funny, it is how the character reacts to the fall**. When Oliver Hardy falls face first into a layer cake, it is his cake covered face and his **slow burn** that people find funny. A character who gets extremely angry at his falls is only deserving of another fall to top the first one. So setting up a fall is only half the challenge. Creating a laughable reaction is paramount. Even better is to create a style of reaction specific to your character.

In animation, falls are set up by the story artist, and carried out by the animator. Animated characters are able to add a special talent to the comedy of falling, by having them suspended in the air long enough to have an emotional reaction *before* falling. Falls are definitely a gag that needs to be carefully applied, because they halt the story momentarily. It is crucial to figure out how to get the character back up and transition back into the story. Maybe someone has to help them get up. Laurel and Hardy could take the time to struggle to their feet, and perhaps milk the scene for further falls and laughs. Characters might be involved in high-speed action, in which case they need to simply bounce back up.

Blows

Slapstick is all about blows. Blows can be intentional, as in a Punch and Judy puppet show, or accidental, such as when a character steps on a rake only to have the handle smack him in the nose. Much of what was said about falls applies to blows. The humor is not in simply having the character be struck. The art is in what happens before and after the blow. It is the set-up, style, choreography, and timing that can make people laugh.

The reaction to the blow is very important. One character might stagger around in a silly manner before falling into the mud. Another might howl and rub the afflicted area. Another might freeze and cross his eyes while a six-inch bump grows on his head. Charlie Chaplin knocked a brutish fellow in the head with a policeman's night stick, and the man only stared angrily back at him. The follow up to the blow must be at least as interesting as the set up.

Figure 9.4 Charlie Chaplin and Eric Campbell in *Easy Street*, 1917

Courtesy Everett Collection.

Popeye had more style than anyone when it came to punches. Popeye was able to increase the anticipation by having the set up for the punch become an art form in itself. Popeye's muscles and tattoos could become animated to express the explosion of power that was about to be released.

The goal of any artist is to have their style recognized, and the Three Stooges created a comedy of blows that is recognized around the world. Their palette of punches, slaps, and pokes would punctuate whatever foolishness they were playing at. It was common

for them to string them together, and add fresh variations to old favorites. Their reactions to the blows are strong, but very brief. Within seconds they let it go and get back to the story. They don't let it go on too long.

The unintentional blows make use of the element of surprise.

Surprise

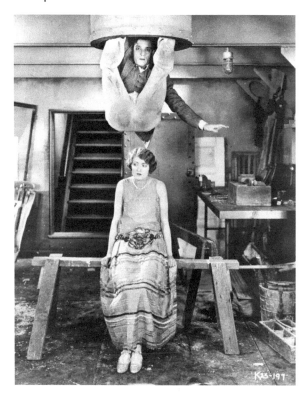

Figure 9.5 Buster Keaton in *The Navigator*, 1924

Courtesy Everett Collection.

Disher writes:

> Surprise is the result of the sudden, not necessarily of the unexpected.[4]

People know the jack will spring out of the box, just not when. Surprise is dependent upon the proper set up. It is better to prime the audience, so the action makes sense.

This is one effect that the director, rather than the performer or animator, can be responsible for. Surprise is one of Tex Avery's most common techniques, such as when Droopy Dog suddenly appears where the Wolf has gone to hide. The Wolf would be surprised, and his distorted reactions are what defines the memory of Avery's films. Simply seeing a character be surprised is fun. That aspect of surprise, the specific reaction, can be developed by the animator.

Surprise can be integrated into any of the other forms of mirth. Rowan Atkinson said about falls:

> If someone falls down, it is funnier if they disappear.[5]

Having the character drop out of sight, is a small surprise that inexplicably amplifies the humor of the event. Laurel and Hardy loved to use the mud puddle for this effect. They would step into, or even drive over, what appears to be a shallow puddle in the street, only to disappear, automobile and all, into a well-deep pool of water.

Atkinson also points out that sudden appearances can be funny as well. In the television show *Seinfeld* (West-Shapiro Productions, created by Larry David and Jerry Seinfeld), Jerry's neighbor Kramer, played by Michael Richards, would burst straight into the apartment without knocking, often in some state of agitation.

Combining the sudden appearances and disappearances can be done on stage, with people running in and out of doors in rapid succession to create a comical chase effect. That method was used routinely in the *Scooby-Doo* (Hanna-Barbera Productions) chase sequences.

Knavery

Knavery is defined as showing unprincipled, untrustworthy, or dishonest behavior. It may sound as though that would be the character of a villain, but it is also found in comic heroes. Disher was most likely familiar with the Grimaldi type of clown who cleverly stole sausages to feed his appetite. He took pleasure not only in the food, but in how cunning he was in getting it. He is a funny sneak thief. The commedia archetype of Brighella is a knave. Creating this character begins with the writer, is developed by the story person, and polished off by the animator.

Basically, it's comical to see poor people use their wits to survive, as long as they aren't harming anyone who is even poorer than they are. And sometimes even then. They are tricksters, and their shamelessness is appealing. The more style they have, the funnier they are. When Charlie Chaplin wants to steal a donut, he pops it in his mouth a split second before the counterman turns his head to look. Freezing his face, he waits while the counterman eyes him suspiciously.

They don't always have to succeed. It can be funny when they are caught. One of Harpo Marx's most famous gags was to fill his overcoat with silverware he had stolen from a hotel. When a police officer shook his hand, the silverware would noisily pour out of the other sleeve. Each time he shook it, more knives and forks would fall on the floor, and all the time Harpo would show no sign of embarrassment.

In the *Ren & Stimpy* episode, "The Boy Who Cried Rat" (Nickelodeon, 1991), directed by John Kricfalusi, the duo is homeless and hungry. Stimpy suggests they look for work. "Work? Have you lost your mind?" is Ren's reply. He concocts a plan to sneak into a house and pretend he is a rodent. He has a Mickey Mouse ears hat as a disguise. Then Stimpy will knock on the door and offer his services as a mouse catcher. They expect to make easy money with the crazy scheme. Of course, it backfires when the home owners expect Stimpy to eat the fake mouse he has caught. The knave needs a stupid partner. It can be his adversary who is fooled by his tricks, or it can be his partner who may screw them up. Stimpy is obviously Ren's stupid partner.

Mimicry

Mimicry is any form of pretending to be someone, or something, else. There is an entire category of stand-up comedy built around doing impressions of famous people. Occasionally Bugs Bunny would pretend to be a well-known person, such as in *Buccaneer Bunny* (Warner Brothers, 1947), directed by Friz Freleng, when he presents himself to be Captain Bligh, as played by the actor Charles Laughton. But that is only a small portion of the ways a comedian can use mimicry.

Mimicry is a playful kind of comedy, but challenging. The greater the skill of the actor, the greater the comedy. It requires an ability to see and repeat the many small things that someone else would do. If it is done well, the audience immediately understands what is going on. The work of mimicry would fall primarily to the animator, rather than the story person.

Probably the easiest form of mimicry is to intentionally mock someone who is in the same scene. Simply following and exaggerating what the other person does can be quite entertaining. Usually it is a way to show disrespect towards the other. The sheer rudeness is what makes people laugh.

Another form of mimicry could be called **blending in**. Charlie Chaplin's Tramp could pretend to be almost any person he needed to be, such as a parson, a policeman, or a parent. Audiences admired Charlie's skill, and the Tramp's fearlessness. In the movie *Rango* (Paramount, 2011), directed by Gore Verbinski, the titular chameleon used mimicry when entering the town of Dirt. He didn't want to stand out and attract attention, so his first concern was to blend in. To do that he adopted a cowboy stance and imitated their walk. When confronted with belligerent locals, he took on the persona of a skilled gunfighter, changing his voice, language, and action. After all, he was an aspiring actor. The talent helped him to live another day.

Figure 9.6 *Rango*, Rango (right, voice: Johnny Depp), 2011

© Paramount Pictures. Courtesy Everett Collection.

Sometimes blending in can be done badly. In the live action *Son of Paleface* (Paramount, 1952), directed by Frank Tashlin, Bob Hope attempts to blend in to a western town, but his costume is comically outlandish, and his western talk is all wrong. It is mimicry combined with stupidity.

A male dressing up as a female falls under mimicry. While Bugs Bunny is well known for fooling others by dressing in drag, Yosemite Sam got into the act in *Buccaneer Bunny* (Warner Brothers), when he put on a dress to get into a lifeboat first. As you know "women and children first!"

Finally, any sort of **faking it** can be made into an act. In the movie *The Goldrush* (United Artists, 1925), Charlie Chaplin is snowbound in a cabin and starving, so he makes a meal out of an old boot. He and his cabin mate sit down to eat the boot, and the other fellow behaves like the miserable wretch he is, grimacing through every bite. Charlie, in complete contrast, acts as though he is partaking in a delicate meal. He sustains the act from the persnickety cleaning of the plate before serving, to twisting up the laces on his fork like spaghetti, to belching after the meal is over. He is imitating the eating of real food, and has added every detail he could think of. He is attempting to fool himself.

Stupidity

Figure 9.7 Harpo Marx, date unknown

Courtesy Everett Collection.

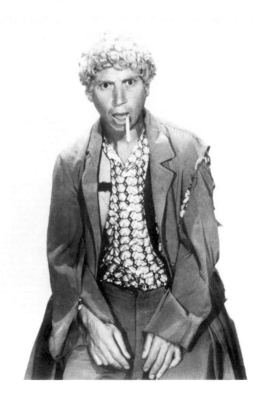

The classic fool can always get a laugh. It is, however, still an art. It takes a thoughtful mind and careful practice to perfect the art of playing stupid. It must be staged well, and you must understand everything about the character. He must have a motivation for trying to do something that is beyond his ability. Above all, you must know how he

handles his failure. Does he care? The one thing the stupid character can never do is quit. He must carry on and fail further, or succeed. It is his only hope. By persisting in doing something stupid, the comedy keeps going. When the Three Stooges mistake a large powder puff for a pancake, they don't stop after one bite and spit it out. They keep working at it. They carry it out way longer than any reasonable person would. What starts as a simple mistake becomes stupid because they don't stop.

I want to emphasize that stupidity can be demonstrated by completely normal people. Stupidity is the comedy of mistakes, and *anyone* can make foolish choices. I can confidently write that *everyone* has made mistakes. Stupidity is the thing we can all relate to. Most of our mistakes are based on not understanding what is going on. As I am discussing visual comedy, I find the word **perspective** to be useful. Perspective can describe something either literal or figurative.

Figuratively speaking, a character's mind may have influences that restrict their ability to perceive the world. A person who is obsessed with chasing something may pay no attention to the fact that they have just run off a cliff. A genius inventor can be so consumed with a project that they forget to put on their pants. A drunk's mind may be so addled by alcohol that they don't realize they have snuck into the wrong house.

We can also use the literal definition of perspective. A character can only see what is in their field of vision. If they are carrying a stack of boxes they may not see the end of the pier. If it is a farce and identical twins are involved, the carefully timed switching of the two will take advantage of the characters who only see one of them at a time.

Buster Keaton would sometimes build gags around the idea of his own limited perspective. In *The General* (1926) he is running his steam train. Ahead of him on the tracks a loose box car is coasting along. When the box car rolls onto a side track, Keaton switches his engine onto the main line. He sees the boxcar go down the other track. Then he goes to busily stoking the fires to power the steam engine. While he doing that, the camera shows the tracks merge back together, and the box car rolls back in ahead of him. When he sits back in front of the window, he is confused as to how the box car got back there. Again he looks away to manage the steam valves on the engine, and while he is turned, the box car falls of the tracks and crashes. When Keaton looks forward again, the box car has disappeared. From his perspective, an entire box car magically reappeared and disappeared.

In the Pink Panther short *Smile Pretty, Say Pink* (DePatie-Freleng, 1966), directed by Hawley Pratt, the little white man is a photographer out in nature. He believes he is alone. Whenever he puts the camera to his eye, the Panther pokes his head into the shot just as the flash goes off. Then, just as quickly, he hides again. When the little man looks at the pictures afterward, the trick is revealed. This gag plays on the character's momentarily restricted view. The Pink Panther often worked this way. He waits until the right moment or operates behind someone's back.

Comedy is often a clash of perspectives. One character can see something, where another one can't. One character understands, the other is ignorant. The trickster can manipulate the perspective of the fool. As you watch a comedy, consider how characters' perspectives are causing their mistakes. Sometimes the foolish character is the one who really does sees what is going on, but nobody believes them. Refer to Chapter 8 for the description of farce, which plays heavily on limited perspective.

The audience also has a perspective. Allowing the audience to see what is going on, and knowing what one character doesn't, makes them feel superior. On the other hand, not letting the audience see what is about to happen, you set them up for a surprise. We are all made fools of by the limits of our own perspective. Like the magician, a comedian must control what he shows the audience.

As you watch comedy, animated or live, see if you can identify which category the gags fall into. In production, there should be a dialog between writers, story artists, and animators to develop how the gags are set up, and how they are carried out in performance.

Gags in Sequence

Gags are the building blocks of physical comedy. Frank Thomas and Ollie Johnston refer to an individual gag that stands alone as a **spot gag**. A spot-gag has no relationship to any other gag in the show, and does little if anything for the story.

Spot gags were often found in Fleischer cartoons, where animators were tasked with putting something funny into each of their shots, without much coordination between them. In all of the Road Runner cartoons, each of the Coyote's failed attempts to catch the Road Runner is simply an extended spot gag. Still, they all consistently follow the style set up for the character. For example, the Road Runner would never stick his leg out to trip the running Coyote. That would break the guidelines set up by Chuck Jones for how the show works.

Single gags are good, but the real power of gags is in how they are assembled. Get the laughs rolling, and it will be easier. Comedy is well served by momentum. Maurice Charney gives us this simple explanation.

The comic action is developed by repetition, accumulation, and snowballing.[6]

Running Gags

Running gags may be the most basic method of assembling funny material. If something is funny once, it can be tweaked to play again. Because they are repeated for laughs, running gags are almost always gags, and not comic events. In the DreamWorks/Aardman film *Flushed Away* (2006), directed by Sam Fell and David Bowers, there is a running gag involving slugs who are frightened. They scream and try to run, but because they are slugs their screams are tiny and they run very slowly. It isn't the exact same thing every time, though. First it was just one slug, then several, then a whole herd of them. This is a simple repetition and variation of a successful gag.

A good example of a running gag is in the Academy Award nominated film from the Three Stooges, *Men in Black* (Columbia Pictures, 1934), directed by Ray McCarey. The Stooges are new doctors at a hospital. When exiting the superintendent's office, Curly slams the door hard enough to break the glass, which the handyman witnesses. The second time Curly exits and slams the door, the glass breaks, but the handyman is already

there with the replacement glass. The third time, the handyman is there when they arrive, so he opens to door for them. When they exit, the door is slammed and broken once more. Finally, after the handyman has again replaced the window, the Stooges run down the hall toward the office door. The handyman sees them coming, picks up his toolbox, and smashes the glass himself. Breaking glass is mildly funny, but the handyman brings a changing human emotion to the repeated gag that makes it even funnier.

Tex Avery often used running gags. In *Wild and Wolfy* (MGM, 1945), the Wolf is in an old west saloon, and Droopy is bothering him. The Wolf wacks Droopy with a big mallet, and calls out "Hey waiter!" An elegant waiter wearing a tuxedo strides in, takes the mallet and removes Droopy from the shot. A second time in the saloon, the Wolf gets rid of Droopy by calling "Hey waiter." Then during a chase on horseback, Droopy somehow appears on the back of the horse the Wolf is riding. When he calls for the waiter again, the waiter rides up on a horse behind them, wacks Droopy with the mallet, and carries him away. At the end of the picture the Wolf is in his hideout. Droopy surprises the Wolf, hits the wolf with the mallet, and calls "Hey waiter" in his Droopy voice. The waiter arrives, picks up the Wolf and takes him away. The gag is repeated with variations four times, and because it is present in the finale, it also acts as a final **punchline**.

The Rule of Three

A sequence of gags can take advantage of something known as **the rule of three**. Human beings are naturally interested in finding patterns. Three is the smallest number needed to confirm a pattern, and comedians routinely take advantage of this. If the viewer sees something happen twice, he or she assumes it will happen the same way the third time. This is a form of running gag. However, instead of doing it differently every time, the gag is played the same way the first two times. The audience will notice the repetition, and begin to see a pattern. Because they are waiting, you are committed to

finishing with a third gag of some kind. Just having two gags will leave them unsatisfied. What happens the third time is where the comedian can take advantage of that suspense. He can either surprise them with a change, or fulfill their prediction and give them a sense of satisfaction.

In a chase scenario, here's how it would work. The trickster character runs around a corner and waits for the stooge to follow. When the stooge turns the corner, he gets hit in the face with a frying pan. The exact same thing happens a second time. The third time, the audience has been trained to expect the same result. However, and here is the important part, the stooge notices too, so he tries to avoid the same thing happening again. When the stooge stops before turning the corner, he is acting out what the audience is thinking. The first character, being the trickster, also knows the stooge isn't that dumb. So when the stooge does something like peek around the corner first, the trickster does something unexpected, like kicking him in the rear.

Here is an excellent example used by Steve Neale and Frank Krutnik. In the Marx Brothers movie *Duck Soup* (Paramount, 1933), directed by Leo McCarey. Harpo sits on a motorcycle, and Groucho jumps into the sidecar that is attached. Harpo turns the throttle on the motorbike, which takes off leaving the sidecar, and Groucho, behind. The exact same thing happens the second time. Groucho won't fall for the trick a third time, so he puts Harpo in the sidecar and he sits on the motorcycle. At that point, Harpo and the side car unexpectedly drive off, leaving Groucho behind yet again. Had the gag played out exactly the same way, it would have made Groucho look really stupid for having fallen for it all three times. Nobody would have expected the sidecar to be able to move on its own, so it is an understandable mistake.

Figure 9.9 Harpo Marx and Groucho Marx in *Duck Soup*, 1933

Courtesy Everett Collection.

Laurel and Hardy often used the rule of three, but they would do the same dumb thing three times in a row. Part of their comedy was that they didn't learn from their mistakes. Neither of them is a trickster. The audience suspects a pattern, and feels satisfied when it is confirmed. In their style, the anticipation of the gag and the reaction after the gag

were really more important than the gag itself. It is the careful delivery that makes it work. Predictability is not necessarily bad, because it sometimes makes the audience feel superior to the clown.

The Gag That Builds

Frank Thomas and Ollie Johnston define the gag that builds as follows:

> The gag-that-builds is made up of a series of gags that increase in intensity. Starting with a comic situation, individual gags relating to the same circumstances are carefully added, each becoming wilder and funnier until a climactic event crowns a complete routine.[7]

The gag that builds uses the snowball effect, steadily growing larger and larger. It creates a natural momentum that the carries the audience along with it. If you weave enough gags together, they become the comic events of the story.

Here is a live action example of how a simple mistake can start a chain of events that leads into a complete disaster. In the live action movie *The Party* (United Artists, 1968), directed by Blake Edwards, Peter Sellers plays a foreign actor mistakenly invited to a fancy Hollywood dinner party. Eventually he needs to urinate, and just getting to the bathroom is a challenge. When finished relieving himself he flushes the toilet. The toilet continues to run long after it should have stopped. Concerned, Sellers tries to fix it. He lifts the lid on the tank, and while fiddling with it, a painting falls off the wall and lands in the tank water. He pulls the picture out and to dry it off he reaches for the toilet paper. For some reason, all the toilet paper runs off the roll and onto the floor. He wipes the painting, smearing the paint and ruining the picture. To clean up, he puts all the paper into the toilet. He then accidentally breaks the tank lid. While replacing the lid, one piece falls into the tank and causes it to flush. Now clogged with paper, the toilet overflows, and even the bidet is spraying water into the air. Water is flooding out under the bathroom door. Terribly embarrassed, and trying to escape he slips out the window and onto the roof, and from there falls into the pool. He is rescued from the pool, and to warm him up he is given alcohol. He gets drunk, and things get wilder from there.

I can imagine that the idea for the sequence was simply to put him in the awkward situation of having the toilet overflow. Having toilet problems at someone else's house is a very common anxiety. Common anxieties are excellent comedy material. Each step in the process is then engineered, having as many funny things happen along the way as possible. It is starting with the end in mind, and figuring out how to get there with the materials and characters you have available. That way, it feels natural, and not forced.

In the days of silent films, a series of gags or a careful set up could lead to what they called **toppers**. That is a gag that is funnier than the gags which came before. Just when the audience thinks it's seen it all, the toppers get ever bigger laughs. Harold Lloyd said:

> Then we have a topper on a topper—and sometimes we get a topper on a topper on a topper. And believe me, the topper that's on the topper is generally the best.[8]

Tex Avery's *King Size Canary* (MGM, 1947) has toppers built into the very concept of the film. It isn't a series of different events, but one gag getting bigger with each use. In this film, a stray cat sneaks into a house looking for food (a routine motivation). He finds a

scrawny little canary, which is hardly worth eating. Noticing a bottle of "Jumbo Gro" plant food, he feeds it to the canary. The bird then expands beyond his expectations, and is big enough to threaten the cat. The cat responds by drinking the formula himself, and outgrowing the canary. Before running off to chase the canary, the cat throws the bottle out of the window where it is consumed by a bulldog. The bulldog becomes bigger than the cat, and chases the cat around the city. A fourth character, a mouse, then drinks the Jumbo Gro and becomes the size of an office building. The cat and the mouse alternately drink the formula until they are bigger than the entire planet. At that point, they are out of room and have to stop the picture. Avery has applied the same gag over and over, and simply built it to absurd proportions. If it were only the cat and the canary, it would have been too simple. By adding in the mouse and the dog, he creates various dynamics between the characters, so it begins to feel unpredictable.

Playing With Tropes

I have made the case that gags can be adapted and reused over time. In an animated series, characters are often expected to follow certain formulas, which can mean they are routinely in similar situations. It is up to the story people to find ways to keep the material from becoming monotonous. For example, the creators of *Popeye* were faced with that very problem. In most *Popeye* cartoons, Popeye eats spinach to gain strength and win a fight. Finding variations of this event was necessary to keep it interesting.

The web site TVTropes.org is a very useful online wiki that has a tool for this sort of thing. Tropes are elements in a story that the audience recognizes and understands. Here is how they describe tropes:

> Tropes are devices and conventions that a writer can reasonably rely on as being present in the audience members' minds and expectations. On the whole, tropes are not clichés. The word clichéd means "stereotyped and trite." In other words, dull and uninteresting.

> Above all, a trope is a convention. It can be a plot trick, a setup, a narrative structure, a character type, a linguistic idiom ... you know it when you see it.[9]

For example, I previously mentioned the trope of showing a character who is caught in a moral dilemma by having an angel on one shoulder and a devil on the other. Each of them presents their case before the main character decides his action.

The TVTropes site includes a page titled **playing with tropes**. It describes numerous ways tropes can be manipulated for different effects. Gags can be manipulated in the same way.

Let's see how playing with tropes can be applied to the trope of Popeye eating spinach to make himself strong. First there is a description of how a trope can be manipulated, and then the example. In many cases, the examples are taken from actual Popeye cartoons, which are named. A few of the others, I made up the ideas to fit the description. Two examples refer to the trope outside of Popeye. Not all of the variations will be funny, but are included anyway. These Popeye cartoons were produced by Fleischer Studios.

Played Straight: This is the basic trope that almost everyone should recognize.

Popeye is losing a fight, eats his spinach, gets super strong and wins.

Justified: The trope has a reason In-Universe to be present.

Popeye signs an endorsement deal with a spinach producer, and must eat the spinach to get his paycheck.

Inverted: The trope (or its elements) are reversed. Some tropes have more than one possible inversion.

The inversion of the Popeye spinach gag is to have Bluto eat the spinach. This happened in *Hospitaliky* (1937). The goal of the fight is to choose who gets into the hospital to be nursed by Olive. Popeye feeds Bluto the spinach, and Bluto beats up Popeye, putting him into the hospital.

Subverted: A trope is set up to occur, but then the writer pulls a fast one on the audience and the trope does not occur after all.

In *Never Sock a Baby* (1939), Popeye and Swee'Pea are hanging over a waterfall. Popeye pulls out his can of spinach, the triumphant music starts, but the can is empty! Popeye and Swee'Pea plummet over the falls. Then Popeye wakes up at home, having dreamed the entire thing.

Double Subverted: The trope is Subverted, and then Subverted again so that it occurs after all.

In *A Date to Skate* (1937), Popeye doesn't have any spinach, so it appears the gag won't happen. But he asks the audience for help, and a silhouette of an audience member tosses one into the screen. Trope completed.

Parodied: The form of the trope is twisted and used in a silly way, specifically for comic effect.

During an episode of *The Simpsons*, Homer drinks a can of beer, and has the same reaction Popeye does with spinach.

Deconstructed: The intentional use and exploration of the trope, played far straighter than usual in order to show the trope as poorly thought out, impractical, or unrealistic. The deconstruction is usually much less nice than the source trope, although not always.

What if when Popeye was about to eat the spinach, Bluto took out his own can of spinach, and threatened to match him. That could lead to a discussion of spinach eating as a sort of arms race, with nothing but destruction ahead. At this point they shake hands and call it a draw.

Reconstructed: A Reconstruction reassembles the Deconstruction into something that resembles the original trope, but that would still work in reality. In other words, this is the inversion of a Deconstruction.

Following the deconstruction posted above, Popeye calls Bluto's bluff. Popeye and Bluto both eat the spinach. But Bluto can't stand the taste and spits it out. Popeye wins.

Zig-Zagged: None of the above, or more than one of the above; this category covers miscellaneous variations. Examples include a trope that gets triple subverted, both inverted and played straight at the same time, or, well, just done confusingly.

In *Wotta Nitemare* (1939), Popeye has a crazy dream about Bluto and Olive. When thrown off a cliff, he pulls out cans of carrots, beets, corn and beans. Eventually he gets to the spinach and he eats it. He then wakes in bed to find himself pulling the stuffing out of his mattress and eating it. He goes out and beats up Bluto anyway.

Figure 9.10 *Wotta Nitemare*, top from left: Popeye, Bluto (aka Brutus), Olive Oyl, bottom: Popeye, 1939

Courtesy Everett Collection.

Averted: The trope is simply absent from the work. It is not used, mentioned, or implied at all. As there are literally thousands of tropes, and many, many possible uses for most of those tropes, Aversions are generally not worth noting unless they are especially surprising, such as for a nearly universally used trope or a trope that is very common in the genre.

Sometimes Popeye doesn't use the spinach at all, most commonly in shorts involving his mischievous nephews, Pipeye, Peepeye, Poopeye and Pupeye. Violence is not an option with family members.

Enforced: The trope occurs solely because of outside expectations or obligations placed on the writer, such as executive meddling or censorship.

In what I think is Popeye's strangest film, *Cartoons Ain't Human* (1943), Popeye takes on being an animator. He animates himself eating spinach and saving the day.

Implied: The trope isn't shown, but the audience is indirectly led to believe that it happened off-screen.

If Bluto is found battered and semi-conscious, with empty spinach cans strewn around him, it would be implied that Popeye had carried out his trope.

Played For Laughs: The humorous elements of a trope are played up. Differs from Parodied by being a straight use. Normally only applicable for serious tropes, but can show up for any trope.

The short *Let's Celebrake* (1938) takes place in a dance hall on New Year's Eve. Olive Oyl's rickety old grandma eats the spinach, then she and Popeye engage in a high energy swing dance. It is a particularly good natured Popeye film.

Played For Drama: The serious or melodramatic elements of a trope are played up. Normally only applicable for comedic tropes, but can show up for any trope.

In *I Yam Love Sick* (1938), Olive Oyl has switched her affections to Bluto. To win back her love, Popeye plays sick. He winds up in the hospital, and appears to be dying. Olive runs in with a can of spinach to revive him. After the spinach is poured into his mouth, Popeye's heart starts pumping like a steam train, but then stops. He seems to be dead. Olive throws herself on Popeye, weeping. When Popeye is satisfied, he sits up and laughs.

Exaggerated: The trope is used to an extreme. Please note that this does not necessarily have to be used humorously—a trope can be exaggerated yet still played completely seriously.

Popeye could be exaggerated with the *Itchy & Scratchy* treatment. He could consume excessive amounts of spinach, go berserk, and punch Bluto so hard his flesh tears clean off his skeleton.

Downplayed: The trope is used to a far lesser degree than typical.

Popeye wakes up in the morning, and instead of drinking coffee, he nibbles on a spinach leaf to perk himself up for the day.

Lampshaded: A trope is Played Straight and explicitly pointed out by one or more characters.

In the Merrie Melodies cartoon *The Major Lied 'til Dawn* (1938), directed by Frank Tashlin, a big game hunter must fight a bunch of animals. He says: "By Jove, if it's good enough for that sailor man it's good enough for me." Then he pulls out the spinach, eats it, and fights the animals.

Invoked: A character is genre savvy, and/or uses their knowledge of a trope as a reason for their own actions, hoping that the effect will come through as it does "in fiction."

In *It's the Natural Thing to do* (1939), Bluto invokes Popeye's spinach eating. In this short, he and Popeye enjoy their fighting. They set the violence aside to act like gentleman for a while. They get tired of that and go back to brawling. Bluto intentionally throws the spinach to Popeye so can eat it and carry out the normal trope.

Defied: A character recognizes a trope is about to happen, and takes steps to avoid it.

In *Twisker Pitcher* (1937), a baseball themed short, Popeye drops his spinach can, Bluto picks it up and says "What a break for me" and eats the spinach. Bluto replaces the spinach with grass and tosses it back to Popeye. Later on, when he has only grass, Popeye must plant spinach seeds and they magically grow in time to save him.

Exploited: A genre savvy character, aware that a trope will occur (or is occurring), uses it to his advantage. If the trope is not yet in effect, the character who exploits it may invoke it in the process.

If Popeye and Bluto were fighting in a diner, where Wimpy was eating, Wimpy could toss the spinach to Popeye before grabbing an armful of hamburgers and running out the door.

Discussed: The trope may or may not be used, but it is explicitly discussed by genre savvy characters in a relevant situation where it could occur.

A goat who eats tin cans is a trope of its own. In *The Hungry Goat* (1943), the titular goat will eat any metal, and is eating the battleship Popeye is on. For some odd reason, the captain of the ship has gone to the movies, and is in the audience watching this very Popeye cartoon. A kid in the audience comments: "Ah why don't Popeye eat his spinach and sock him one?" Popeye doesn't eat the spinach, and the goat ends up in the audience, having the last laugh.

Gender Inverted: This is specific to Always Female and Always Male tropes. A trope that is part of either category is used on the opposite gender anyway. It should simply be listed as Inverted unless another Inversion is also possible.

In *Never Kick a Woman* (1936), Olive Oyl ate the spinach to fend off a muscular woman who had romantic intentions on Popeye.

And just for fun, here are some other variations on the spinach eating gag.

In *The Football Toucher Downer* (1937), Swee'Pea eats spinach and punches Popeye.

In *Protek the Weakerist* (1937) Olive Oyl has a girlie dog who eats spinach and beats up Bluto's Bull Dog.

In *I Like Babies and Infinks* (1937), Swee'Pea won't stop crying. Popeye mistakenly eats a can of onions. The resulting fumes cause Bluto and Popeye and Olive to cry, which causes Swee'Pea to stop crying and laugh at them.

In *Seein' Red White and Blue* (1943), a wartime cartoon, Popeye and Bluto are fighting Japanese spies. Popeye eats some of the spinach, then feeds the rest to Bluto, and together they take on the enemy.

In *Flies Ain't Human* (1941), a bothersome fly eats the spinach, and becomes a terrible nuisance. In his efforts to kill the fly, Popeye destroys his own house.

So you can see that the elements can be shuffled and dealt out like cards to create new variations on an idea. Great gags can be created through a variety of methods including spontaneity, ingenuity, trial and error, and creative re-engineering. You should be willing to try anything. There is no sure-fire formula for it. Visual comedy is an art, and like all arts there are no shortcuts.

The secret to creating great gags is simply coming up with **lots** of ideas. The more you do, the easier it will be to tell the good ones from the weaker ones. Pitch your best ideas

and listen for the reaction. Discard any that don't work like you hoped. The great Disney/Pixar storyman Joe Ranft once told me that the job of the story artist is to come up with 100 ideas, of which 99 will be rejected. Gag ideas are subject to the same math.

Figure 9.11 *I Likes Babies and Infinks*, US poster, from left: Olive Oyl, Swee'Pea, Bluto (rear), Popeye, 1937

Courtesy Everett Collection.

Notes

1 Adamson, Joe. *Tex Avery: King of cartoons* (New York: Popular Library, 1975), p. 199.

2 Neale, Steve and Frank Krutnik. *Popular film and television comedy* (New York: Routledge, 1990), p. 44.

3 Disher, M. Wilson. *Clowns and pantomimes* (Bronx: Benjamin Blom, 1968), p. 7.

4 Ibid., p. 15.

5 Atkinson, Rowan, David Hinton and Robin Driscoll. "Visual Comedy." *Funny Business.* 22 November 1992.

6 Charney, Maurice. *Comedy high and low: An introduction to the experience of comedy* (New York: Peter Lang Publishing, 1987), p. 82.

7 Thomas, Frank and Ollie Johnston. *Too funny for words!* (New York: Abbeville Press, 1987), p. 26.

8 Dardis, Tom. *Harold Lloyd* (New York: Viking Press, 1983), p. 169.

9 TVTropes: <http://www.tvtropes.org>.

CHAPTER 10

Props

I know a man who claims that all inanimate objects are perverse. He says that things deliberately hide from him. I believe this man has discovered an important new law.

Mack Sennett[1]

Prop is theater shorthand for **property**, which is any movable object in the scene. The term is often used specifically to describe something handled by an actor, which is how I am using it here. Props are anything the actor or character interacts with. It can be as small as a needle or as large as a steamship. It can be a single item or a preposterously complex machine. Props are hugely important in physical comedy, and this chapter will look at some of the common ways they can be used.

There are some comedians who specialize in working with props. Classically, they are called **eccentrics**. The eccentric clown is a topic I could have placed in the chapter on characters, or in my discussion of gags and comic events, or even as a comedic structure. The comedic use of props is a topic large enough to warrant its own chapter. Here is the definition of an eccentric from John Towsen:

A solo clown whose comic effects are derived primarily from his fascination and frustration with objects, rather than out of any conflict with his fellow clowns.[2]

Eccentric comedy may actually be the one people can relate to the most. The best comedy is found in normal life, and we all recognize the little struggles; fixing a leaky pipe, moving furniture, assembling a tent. We understand how wrong things can go. Eccentric comedians explore ways of dealing with the material world. This is one of the fundamental skills a physical comedian learns in training. They are given a common item, and tasked with finding funny things to do with it. It is a useful way to practice improvisation. It requires imagination and a lot of trial and error to work out what will make people laugh. Different characters will have different attitudes when dealing with things. One character might have an emotional reaction, like Donald Duck when he gets frustrated and angry. Another character may be embarrassed at his failure. Another might accept the momentary setback and try again. What really matters is having a distinctive style.

Much of Buster Keaton's comedy was with objects. Noel Carroll writes this about him:

> Keaton's character emerges not through declaiming, posturing, or emoting, but in the process of action, or better, in interactions, specifically with things. If such a rough distinction may be drawn, Keaton emphasizes the behavioral—the engagement with objects—rather than the psychological, where the category signals interest in the affective and in motivation. Moreover, the terrain of Keaton's activity is less significantly the social or the interpersonal and more importantly, the realm of objects and the physical world . . . Keaton nevertheless is able to create a structurally rich and compelling character, one that calls attention to a dimension of human existence—what I call concrete intelligence—that is rarely explored in art, and even more rarely with the finesse found in Keaton's works.[3]

Figure 10.1 *The General*, Buster Keaton, 1926

Courtesy Everett Collection.

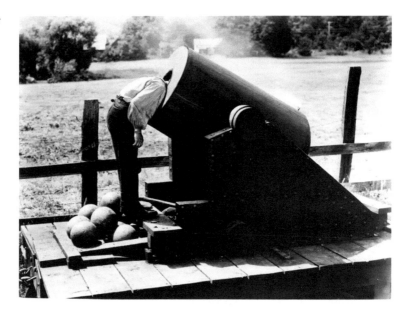

Charlie Chaplin almost always worked with other actors, but he took an eccentric turn in his film *One A.M.* (Mutual, 1916) In that short, he plays a drunk who returns to his home past midnight. His efforts to get from his taxi, through his front door, past his living room, up the stairs and into bed is filled with challenges. His inebriation causes him to do foolish things, get himself entangled with something, and not see the obvious solution to his problems. What should have taken just a minute or two of time is stretched out into 24 minutes of foolishness.

Wile E. Coyote fits the description of an eccentric character. The Road Runner is never really in danger of being caught in the chase. The two don't interact very much at all. Nearly all of the humor is derived from the Coyote's solo efforts with the equipment he has assembled. The Road Runner provides a goal, which keeps the Coyote motivated. But the Coyote is really his own worst enemy.

My Floyd the Android films are built around these ideas. Floyd is a low-wage robot who fools around on the job, or does his work foolishly and gets himself into a difficult situation. I set the challenge for myself that Floyd would get himself into a jam, and not only get himself out of the problem, but be able to continue on with his work when it was sorted out. In *Dim Bulb* (Stupix, 2011) he is changing the lightbulb at the top of a ridiculously tall skyscraper. One thing leads to another and he finds himself plummeting towards the ground riding a 30-foot tall rubber chicken. Not only does he survive, but he gets back to the top of the building and finishes screwing in the light bulb.

Figure 10.2 Floyd the Android, *Dim Bulb*, 2011

© Jonathan Lyons 2011.

Working with props is certainly not limited to solo actors. Laurel and Hardy were usually engaged in labor together. In *The Music Box* (Hal Roach, 1932), directed by James Parrott, they must deliver a crated piano up a ridiculously long flight of steps and into a home. As neither is particularly smarter than the other, they are both involved in the same struggle with the objects, and also have to negotiate with each other. The crated piano was chosen as a prop because it was bulky and delicate at the same time.

The Walt Disney short films commonly had their classic characters indulge in some prop-based comedy. In shorts involving the trio of Mickey, Donald, and Goofy, each of them could break off and work individually for a time. These were essentially theme-based stories, where comedy was found in the equipment and materials used on a job. In *Clock Cleaners* (1937), directed by Ben Sharpsteen, Donald gets caught up in the mainspring of a tower clock, while Goofy has a run in with the mechanical figurines that ring the bell. In *Boat Builders* (1938), directed by Ben Sharpsteen, the three of them are assembling a ship, and each of them takes on a different part of the job. Goofy treats the mermaid figurehead like a real female. In *The Whalers* (1938), directed by David Hand and Dick Huemer, Mickey Mouse tries to throw a bucket of water overboard, only to have the water repeatedly fly back at him. Goofy is put in charge of loading the harpoon gun, and he can't help but set himself on fire.

What follows are some methods to consider when creating gags using props. From simple items to complex elements like machinery or inventions, props play a big role in physical comedy.

Object Use

In his television presentation *Visual Comedy*, Rowan Atkinson describes three ways an object can be funny. These three are built on the actual properties of the objects themselves, and not so much on how they are used.

AN OBJECT CAN BE FUNNY BY BEHAVING IN AN UNEXPECTED WAY

Many practical jokes are built on this: the exploding cigar, the squirting flower, the snake popping out of the can of nuts. In live action films, props can be rigged, or made from unusual materials. Jacques Tati made use of this effect in his film *Mon Oncle* (Specta Films, 1958). His character, Mr. Hulot, visits his sister's modern kitchen. He accidentally knocks a carafe out of the cabinet, and is surprised to find that it is made of a high tech material that doesn't break. It actually bounces. So he has fun with that for a moment, repeatedly dropping it to the floor, and catching it on the rebound. Then he tries another container, assuming it is the same. That one actually is glass, and shatters on the floor.

Figure 10.3 Jacques Tati in *Mon Oncle* (aka *My Uncle*), 1958

Courtesy Everett Collection.

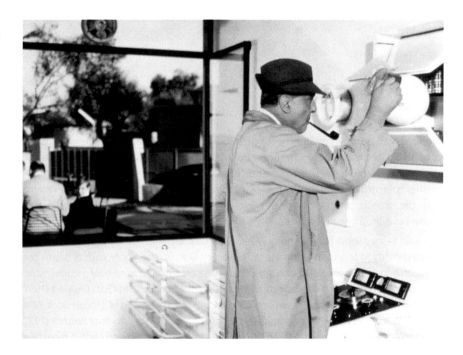

In cartoons, props can be animated to appear as though they have a mind of their own. This was often used by Disney animators, as they would give inanimate objects a personality whenever possible. In the Disney short *Victory Vehicles* (1943), directed by Jack Kinney, Goofy invents a unicycle-like device that has a wheel made of shoes. When he hits a bump, he tumbles forward and winds up face down, with the unicycle kicking him in the pants. Donald Duck in particular needed something to antagonize him. In his interactions with props,

the props seem to go on the offensive. It was all calculated to not only frustrate him and make him look stupid, but whenever possible, put him in danger. In *A Good Time for a Dime* (Disney, 1941), directed by Dick Lundy, Donald is at a penny arcade. He spends five cents to ride in an airplane simulator. When he falls out, he ends up being chased by the small plane which has a spinning propeller threatening to slice him up.

AN OBJECT CAN BE FUNNY BY BEING IN AN UNEXPECTED PLACE

Body parts can become stuck inside odd items. Mr. Bean got his head stuck inside a huge Christmas turkey he was preparing for dinner. Lucille Ball got her head stuck inside a large vase. Curly Howard of the Three Stooges got his hands stuck inside two spittoons.

One unusual use of props is creating a visual double entendre. It was used prominently in the Austin Powers films (New Line Cinema), directed by Jay Roach. Mike Myers and Elizabeth Hurley were honeymooning, and not wearing any clothes. Throughout several different shots, all their "naughty bits" were obscured by props which unmistakably suggested the anatomy that was being hidden.

Figure 10.4 *Austin Powers: International Man of Mystery*, Elizabeth Hurley, Mike Myers, 1997

© New Line Cinema. Courtesy Everett Collection.

The very same gag was used in *Wallace and Gromit: Curse of the Were-Rabbit* (2005). Wallace and Lady Tottington were in her greenhouse having a mildly romantic conversation. At one point, Tottington stands directly behind a pair of melons that line up with her breasts. Speaking of Lord Quartermaine she says "he's never shown any interest in my produce."

In *Kung Fu Panda* (2008), the panda Po uses two bowls to pretend he has big ears like his master. That is mildly funny. When the master enters the scene, he quickly lowers them to his chest, where they stick. When he lets go of the bowls, they take on the appearance of boobs. It is good when one gag leads naturally to a follow up gag.

AN OBJECT CAN BE FUNNY BY BEING THE WRONG SIZE

Perhaps the most common use of this is in costuming. Comedians often wear badly fitted clothes. It creates a constant image of incongruity, making the character simply look funny. Charlie Chaplin's outfit is a mix of a too small jacket, too large pants, and shoes that are too long. It is a very old comedy routine for two men to mix up their hats. One ends up with a hat that looks comically tiny, while the other has the hat fall down over his eyes.

When anything is miniaturized it gains a certain "cute" factor. In his film *Go West* (1925), Buster Keaton finds some cowboy clothes, including a gun belt and holster. But he has no gun. Later, he gets a six shooter, but it is comically small and unthreatening. A normal comedian might be satisfied with simply having a tiny gun. But Keaton looks for more to do with it. When he puts it in his holster, it falls to the bottom out of reach. He has to turn the holster upside down and shake it to get the little gun out. Then he adds a leash so it won't get away from him again. The leash allows him to draw the gun surprisingly fast. By doing all this, his character becomes the entertainment, rather than just having a funny looking prop.

Figure 10.5 Circus clown with prop gun

Photo courtesy State Library and Archives of Florida.

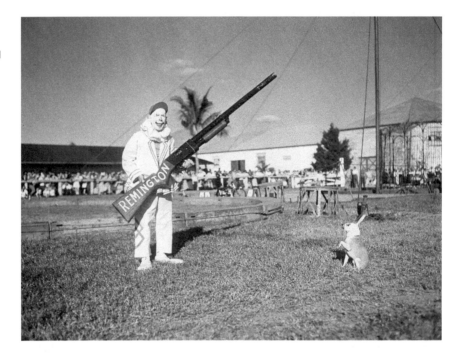

Oversized props are harder to justify. Having a single item be huge is too much of a novelty gag. It is funny for a moment, but strange and unwieldy for the actors. For that reason, it is much more common to shrink the characters. In the Laurel and Hardy film *Brats* (Hal Roach, 1930), directed by James Parrott, the duo play child versions of themselves. They built over-sized sets and props to make themselves look small. The *Cloudy With a Chance of Meatballs*

(2009 and 2013) films are built around the idea of ridiculously huge food. In *A Bug's Life* (1998), Flik visits the "city" where the scale of human objects is huge. A regular-sized can of lard can be an entire restaurant, and a bottle cap can be a table. In that context, the scale of the objects is normal, but still humorous.

In addition to Atkinson's three ways for an object to be funny by itself, I am going to list how objects can become funny for how they are treated.

OBJECTS CAN BE USEFUL IN COMEDY WHEN THEY ARE LOST, STOLEN, OR OTHERWISE ON THE LOOSE

Having a valuable object on the loose can be a good reason for a chase. *The Penguins of Madagascar* (DreamWorks, 2014), directed by Eric Darnell and Simon J. Smith, movie opens in Antarctica, when Skipper, Rico, and Kowalski are very young, and questioning why all the penguins are marching in a line. When a penguin egg gets loose and rolls away, they take it upon themselves to rescue it, which leads to a wildly dangerous and funny chase. When they finally rescue the egg, and it cracks open, they take the little bird as their newest member, Private. In the stop motion film *The Boxtrolls* (2014), the character Archibald Snatcher aspires to belong to the local aristocracy who wear tall white hats. The hat is a prop that represents nobility and privilege. Simply having it elevates the wearer to the elite. The climactic battle includes an exciting pursuit of a loose white hat through the town square.

OBJECTS CAN BE USEFUL IN COMEDY FOR BEING AWKWARD AND BURDENSOME

In the Laurel and Hardy short *A Chump at Oxford* (Hal Roach, 1940), the pair travel to Oxford University. After arriving on campus, some prankish students direct them into the hedge maze, where they will certainly get lost. Being lost in a maze is made much funnier because they have a huge steamer trunk and other luggage with them. Hardy hauls the trunk on his back, not knowing that Stan has also added his own luggage on top of that. Stan is carrying absolutely nothing.

In *Kung Fu Panda*, the overweight panda Po is selected as the dragon warrior and put into a sedan chair carried on poles by four little geese. Po himself becomes the awkward burden, and his butt falls through the bottom of the chair.

OBJECTS CAN HAVE SPECIAL QUALITIES, WHICH CAN BE EXAGGERATED FOR COMEDY

Objects can have certain energy or be naturally problematic. In the Three Stooges short *Hoi Polloi* (Columbia Pictures, 1935), directed by Del Lord, Curly gets a large spring stuck to the back of his jacket, behind his butt. He doesn't know it's there, but when he is pushed to the floor, it allows him to bounce right back up. Those giant U-shaped magnets can have outrageously strong pulling power on metal. In the Disney short *Donald and Pluto* (1936), directed by Ben Sharpsteen, Pluto accidentally swallows a magnet. That, of course causes all kinds of metallic objects to fly through the air and hit him in the butt. Pluto also got into a sticky situation with fly paper in *Playful Pluto* (Disney, 1934), directed by Ben Gillett.

Glue can be applied to nearly any prop to make it a problem. In *The Haunted House* (Metro, 1921), directed by Edward F. Cline, Buster Keaton, working as a bank teller, got glue all over his hands and wound up covered in sticky cash.

OBJECTS CAN ALSO BE MADE FUNNY BY BEING USED IN UNEXPECTED WAYS

This is probably the most important technique to learn. By imaginative use of props, a comedian can improvise whatever he needs. Jackie Chan could seemingly turn any found item into a weapon. When Buster Keaton accidentally drives an old-fashioned convertible car into a lake, and is drifting along, he doesn't panic. He simply raises up the cloth roof and turns it into a sail.

Using the skill of mimicry, an actor can treat objects as though they are something else. The goal is to amuse the audience by showing them similarities they hadn't thought of before. It isn't the prop that is behaving differently, but the comedian seeing a different use for the object, or treating it as though it were something else. Dan Kamin, in his book *Charlie Chaplin's One-Man Show*, expounds on Chaplin's many skills in prop transformations of all sorts. I will use a quote that nicely describes a popular example found in Chaplin's film *The Pawnshop* (1916):

> The film is a virtual catalogue of ways to use one thing as if it is another. The scene in which Charlie dissects an alarm clock, treating it as if it is a heart (listening with a stethoscope), a mouth (pulling a tooth with pliers), a jewel (looking at it through a jewelers loupe which is actually a telephone mouthpiece), a can of sardines (opening it with a can opener and being repelled by the odor), and so on, has often been described and is justly famous.[4]

Figure 10.6 Charlie Chaplin listens to a clock in *The Pawnshop*, 1916

Courtesy Everett Collection.

Donald Duck had some imaginative relatives who could reinterpret objects to suit the situation. In the short *Donald's Nephews* (Disney, 1938), directed by Jack King, Huey is

playing the cello with a bow. He transforms it into a weapon by launching the bow from the cello strings like an arrow. Louie uses a trombone like a pea-shooter to fire a piece of fruit at him. In *Donald's Cousin Gus* (Disney, 1939), directed by Jack King, Donald is visited by his ever-hungry goose cousin Gus. To make sandwiches, Gus takes a loaf of bread and a stack of meat. Treating them like playing cards, he shuffles them together in one quick move, then eats the pile. He transforms spaghetti into yarn by using knitting needles to make a pasta sock, which he also eats.

Creatives in animation have lots of time to figure out ideas for the funny use of props. Find the one that fits in the location, and simply plant it where it will be handy. When your character picks it up and does some extraordinary thing with it, they will appear to be an absolute genius. And so will you.

Machinery

One of the most recognizable musical tracks in animation is the piece called *Powerhouse*, originally composed by Raymond Scott. It was used over 40 times in Warner Brothers cartoons, and has become synonymous with high energy factory situations. Machinery could have fallen under the category of context, but I have elected to place it here because the characters are directly interacting with it, the way they do with props.

The machine age gave us motion pictures, and they were used to express our relationship with the new marvels. The mighty engines of steam and electricity were both liberating and threatening. They were powerful, but needed constant attention lest they get out of control. Vehicles like cars, trains, airplanes, and motorcycles propelled people at speeds unheard of in human history. It amplified the possibilities of human motion, and therefore magnified the comedy potential as well. As technology progressed, rocket engines and other space age inventions came into use. Often, the interaction with machines was based on the fact that the machine, once moving, doesn't want to stop. It is a relentless, uncaring thing. Men who work with machines are expected to keep up and perform as reliably. But we are human, and not machines. The comedian is there to bring humanity into conflict with the machine.

What follows are some examples of comedic interaction with machinery. Each comedian finds a way to fit it into his style.

Charlie Chaplin's tramp found employment in a factory in *Modern Times* (United Artists, 1936). He does his very best to keep up with the assembly line. With a wrench in each hand, his job is to tighten nuts as the parts roll out of the machine. Charlie's character does not like to fail. He artfully goes faster and faster, but when his break comes, he can't stop himself. He staggers off the line and into the street still twisting the wrenches. He has become a machine himself, albeit a comical one. Chaplin found numerous ways to get lost in the machinery, including falling into the gears and traveling through them as though he were food moving through the bowels of the factory. Ultimately, he becomes the master engineer, and dances while doing his duty.

As a contrast to how Chaplin masters the machine, Lucille Ball has a vastly different experience. Lucy and her best friend Ethel, played by Vivian Vance, also work on an assembly line. They sit at a conveyor belt bringing out chocolates for them to wrap with paper wrappers. The gruff supervisor tells them if one candy gets through unwrapped they'll be fired. At first it's easy, but soon the belt starts moving faster, and the candies pour out too fast. The pair resort to eating them, and piling them up on the side. When the supervisor returns they hide the candy by stuffing their cheeks, and filling their hats with it. The supervisor is pleased with what appears to be solid work. Her reaction is to call out to the machine operator and yell "Speed it up!" They don't even bother to show the inevitable failure. Seeing the two get fired would not add to the comedy. It's good to know when to stop.

Factories are dangerous places where safety is a serious issue. But in cartoons, that danger can be exaggerated for humorous effect. Huge machines that pound, chop, grind, twist, burn, and saw can be running at full steam, with no responsible humans to stop them. Roaring furnaces can produce great buckets of molten metal that threaten to pour at just the wrong time. Machines work well because they give the impression of being monstrous. In the Popeye short *Lost and Foundry* (Fleischer Studios, 1937), directed by Dave Fleischer, Swee'Pea wanders off into an unmanned and fully operating factory. Thanks to the absolutely precise timing of animation, Swee'Pea innocently crawls through the gauntlet of terror, coming to no harm. When Popeye tries to save the baby, he gets caught up in the works and suffers considerable physical abuse.

In the Aardman movie *Chicken Run* (2000), directed by Peter Lord and Nick Park, the two chickens Ginger and Rocky find themselves caught in a huge machine that makes chicken pot pies. With their feet stuck in the pie dough they must escape huge rollers, a gravy squirter, and the oven. The adventure is carried out as though it were an Indiana Jones action sequence with narrow escapes, and ultimately the destruction of the machine itself.

Figure 10.8 *Chicken Run*, from left, Ginger, Mr. Tweedy, 2000

© DreamWorks SKG. Courtesy Everett Collection.

In the Disney short *Modern Inventions* (1937), Donald Duck sneaks into a World's Fair exhibition of "Modern Marvels" where he is the only visitor. He first encounters a robot "butler" who insists on taking his hat for him. Donald then pulls out a different hat. This turns into a running gag throughout the film, as the robot butler returns and takes each new hat that Donald produces. The robot cannot be reasoned with. Donald visits a series of silly inventions, all of which have articulated arms, allowing them to become more like characters. The arms empower the machines to grab Donald and do everything wrong, with him caught in the middle. In the automated barber, he finds himself strapped into the barber's chair. But he is upside down. His head is where his feet ought to be, and the machine slathers his head with shoe polish and buffs it to a shine. At the other end, his butt is given a fine grooming as though it was his hair. It is all built to drive Donald mad, which is what he does best.

Jacques Tati acted through his simple everyman Mr. Hulot. In *Mon Oncle* (1958), his brother-in-law gives him a job at the "Plastac" company. He is tasked with keeping watch on a machine producing plastic tubing. He sits at a small desk while the machine slowly cranks out the tubing. It is boring work, and the machine makes a hushed sound that lulls Hulot to sleep. Tati is satirizing the subordination of people to machines. Something goes wrong, and the tubing starts coming out of the machine comically misshapen. A friend wakes him, and together they must try to sneak a hundred yards of ruined tubing out of the factory without the boss knowing about it.

In his feature films, Buster Keaton often found himself dealing with very large machines. In *Steamboat Bill Jr.* (1928), he is the bumbling college boy whose father runs an old steamboat. He has no idea how it works, and is comically out of place working on it. But in the end, he is alone on the ship when a hurricane strikes the town. Desperate to save the girl he likes from danger, he rigs ropes from the engine room to the wheelhouse, where he can operate the entire ship himself. It is as though he has reined in a wild horse, and broken it to his will. He has cleverly mastered the machine.

Ultimately, the soulless machine should reveal the character of the comedian. They can be made a fool of, or they can master it.

Accessories

Actors often have one basic question to ask themselves. What do I do with my hands? It really is a challenge. Comedians have taken the license of making accessories out of one or maybe two props. This would be something they regularly have, and could make use of whenever it suited them. Medieval jesters had a short stick called a marotte. It was typically topped with a small version of the jester's head. Arlecchino carried his slapstick in commedia dell'arte and pantomime. Groucho Marx regularly had a big cigar in his hand, which he waved around to punctuate his jokes.

The most famous comic accessory is certainly Charlie Chaplin's flexy little cane. It is a very delicate thing that bends when he leans on it. It seems to be a wisp of a cane, which he uses as an extension of his character. When he wants to appear elegant and sophisticated, he can swish it about like a gentleman. If he is in a confrontation, he can turn it into a weapon. Chaplin wrote:

> I have developed the cane, until it has almost a comedy sense of its own. Often I find it curling itself around someone's leg, or rapping someone on the shoulder and getting a laugh from the audience almost without my knowing that I was directing its actions.[5]

Many props are simple items a person might have anyway, such as a hat. There is a whole art of hat manipulation. It involves complex tossing and catching of the hat, having it land neatly on the head whenever possible. Laurel and Hardy routinely got their hats confused. Regardless of how hard they tried, getting the right hat on the right head sometimes seemed impossible. Simply having a hat get knocked into a funny position could make someone look silly. And let's not forget how many times Indiana Jones got a laugh by risking his life to save his fedora. Similarly, in *Toy Story* (1995), Woody values his hat just as much.

Rowan Atkinson provided his Mr. Bean with a couple of regular props. One was his little automobile, the yellow-green Mini Cooper. The other was his stuffed bear, Teddy. Mr. Bean's character is still a child at heart, and Teddy is treated as a friend that he cares

about. It softens his character, and gives him an appealing way to interact with something when he is alone at home.

Figure 10.9 Rowan Atkinson on a Mini at Goodwood Circuit in 2009, by Nathan Wong

Licensed under CC BY 2.0 via Wikimedia Commons.

Accessories need to feel natural for the character, and be used with an ease. It can be a versatile tool like Fix-it Felix, Jr.'s little hammer. When Bugs Bunny enters a scene eating a carrot, it is not only to support his rabbit-ness, it expresses his indifference towards whomever he is speaking to. Popeye's pipe was practically part of his body. The accessory can be necessary, like Carl Frederickson needs his cane in Pixar's *Up* (2009).

Inventions

The wacky inventor has been one of the most reliable sources of comedy props since the introduction of film. Inventors are useful characters because they, like artists, must have creative imaginations. If you can think of some funny use of technology, it can be real enough to create laughs. It can be anything from the dawn of the industrial age, to the latest genetic engineering.

To be comic, inventors need at least one or two things. First, a ridiculous or trivial goal. The application of great thought and work towards some small thing seems inherently foolish. Willy Wonka wants to create chocolate and candy. That is a trivial thing, but people can relate to it. If the goal is not trivial but potentially valuable, then they definitely need an unusual method of achieving the goal. It's great if they have both the ridiculous goal and the unusual method.

Figure 10.10 *Willy Wonka & the Chocolate Factory*, 1971

Courtesy Everett Collection.

Figure 10.10 *Willy Wonka & the Chocolate Factory*, 1971

Courtesy Everett Collection.

Ultimately, the invention must work in some way. A successful invention should not be the end of the story, it should only facilitate the character's ability to continue on with what they do. Wallace and Gromit's first film *A Grand Day Out* (Aardman Animations, 1989), directed by Nick Park, establishes Wallace as an inventor. In this short, his goal could hardly be more trivial. He has run out of cheese, and needs some to eat with his crackers. Rather than simply go to the store, he decides to go to the moon, which according to folklore, is made of cheese. In this duo, Wallace is the one with dumb ideas, and Gromit is the actual brains of the two. In comedy, smart characters never get any respect, so it makes sense that Gromit is a dog. With a trivial goal, they really need a ridiculous method. Real science is rarely ever funny, so it must be made funny. In physical comedy, it is best to take it away from the theoretical, and more towards the practical, closer to what regular people can relate to. The easiest way is to give the inventing a clearly homemade quality. Therefore, in the world of Wallace and Gromit, is it is perfectly acceptable that building a rocket ship involves the sawing of wood. After a montage of workshop gags, they are able to actually board a rocket and take off. Achieving the extraordinary goal of reaching the

moon, they exit the space craft and visit the surface of the moon with no more excitement than if they were picnicking at the beach. The underplayed response to their success allows them to continue behaving like they normally would.

If the invention goes bad, through the law of unintended consequences, things should go hilariously wrong. In *Cloudy with a Chance of Meatballs* (2009), Flint Lockwood lives on the island of Swallow Falls, where the only local food source is sardines. He invents his "FLDSMDFR" which stands for Flint Lockwood Diatonic Super Mutating Dynamic Food Replicator. The machine turns plain water into prepared food such as hamburgers and pancakes (not a trivial goal, but ridiculous in concept). Because of an accident, the machine works *too* well. An overcharge of electricity and a huge storm send the machine into the clouds where it creates oversized food and rains it down on the island. The massive food items become comic props themselves. Lockwood has solved one problem, but created another, funnier, one.

Inventing doesn't necessarily mean creating completely new machines to do strange things. In certain contexts, the resources to build proper machines may not exist. Imaginative characters can rebuild known technology using available materials. In the television show *Gilligan's Island*, the castaways were lucky enough to have "the professor" among them. Somehow, using things like bamboo and coconuts, he was able to devise a lie detector, a washing machine, a Geiger counter, and more. The world of *The Flintstones* was filled with machines from the modern age rebuilt with prehistoric materials, and very often powered by dinosaurs. A small, quick chewing creature can be wheeled around the grass to mow the lawn, or a giant brontosaurus can lift rocks like a crane at the quarry.

Sometimes, invention is really small in scale. The inventor may simply concoct an odd way to "improve" a common task through some simple engineering. Buster Keaton occasionally used this technique. In his short film *The Scarecrow* (Metro Pictures, 1920), directed by Edward F. Cline and Buster Keaton, the show opens with him living with a friend in a one room house. Mealtime is a series of quick gags built around the silly idea of making things more efficient. The record player doubles as a stove. The salt and pepper shakers are suspended on strings so they can swing them to each other. The dinner table has a little wagon holding the bread and butter, and can be pulled from one side to the other with a string. All the dishes are permanently attached to the table top. When the meal is over they remove it, hang it up on the wall and just hose off all the dishes at one time. The pair has obviously practiced every move, so their eating is perfectly synchronized.

If the invention is a robot, what is being created is actually a whole new character, rather than a machine or prop. All the comedy elements of characters can be brought into play. Robots are often single minded, and this allows them to have some of the characteristics of the fool. In fact, Henri Bergson's theory of comedy is that people are funny when they act like automatons who have rigid behavior. Robots are a combination of unnatural power and limited thinking.

Finally, I recommend against having the inventor's work being too easy. It should appear to be difficult work in some way. If the inventor is a real genius with a serious laboratory to work in, it diminishes the comedy potential substantially.

Since physical comedy does not work through dialog, the stories are less about thoughts and more about doing things. It finds fun in **action**. Characters might fight, but it is rarely

through fist fights or wrestling. It usually involves silly weapons. There are pies to throw. There are banana peels and rakes to step on. During chases obstacles must be overcome. Vehicles can go out of control. Manual labor means struggling with tools and equipment. Machines can have minds of their own. Magical inventions can be whipped up in the garage. Sports require balls, sticks, and goals. Cooking requires kitchens full of appliances. Hunting and fishing require guns, traps, poles, hooks, and bait. Even taking a trip to the beach can mean wrestling with an uncooperative beach chair. To be effective in creating physical comedy, you must be able to look at everything in a location, and see potential ways to use it for laughs.

Notes

[1] Dale, Alan. *Comedy is a man in trouble* (Minneapolis: University of Minnesota Press, 2000), p. 31.

[2] Towsen, J. *Clowns* (New York: Hawthorn, 1976), p. 348.

[3] Carroll, Noel. "Keaton: Film acting as action." *Making visible the invisible: An anthology of original essays on film acting.* Ed. Carol Zucker (Metuchen, NJ: Scarecrow, 1989), p 198.

[4] Kamin, Dan. *Charlie Chaplin's one-man show* (Metuchen: Scarecrow Press, 1984), p. 38.

[5] Maccann, Richard Dyer. *The Silent Comedians* (Metuchen, NJ: The Scarecrow Press, 1993), p. 96.

CHAPTER 11

Comic Acting

There is a lot of great advice available about acting in animation, but not so much dedicated specifically to making people laugh. It is the same with most acting instruction in general. In the preface to his book *Why is That So Funny?*, John Wright has this to say:

> In most of our drama schools far more attention is paid to making students cry than is ever paid to making them laugh. This is partly due to the legacy of Stanislavski, and the majority of our acting teachers base their approach on some aspect of his teaching.[2]

Constantin Stanislavski is responsible for the widespread use of **the method**. Where comic actors often work through their personal style, dramatic actors are regularly called on to be completely different characters. Method acting allows dramatic actors to quickly immerse themselves into how their individual character thinks, and create more natural interpretations of their behavior. It was a great advance for dramatic actors because it was a powerful response to the long standing use of **figurative** acting. In figurative acting, actors memorize and reuse poses and gestures that have been established for them, and audiences can quickly recognize. It is an old-fashioned way of acting, and has long been considered clichéd.

However, animators still rely on a fair amount of figurative acting, because it has the advantage of clarity. Figurative acting is what we learn when reading Preston Blair's book *Learn How to Draw Animated Cartoons*. The whole idea of **strong poses** is intended to avoid ambiguity in the performance. Character model sheets often include illustrations of typical poses. In addition to giving a character weight and energy that is appropriate for their body type, animators are expected to express recognizable emotions. So how do we escape figurative acting *and* avoid ambiguity in performance? I will start with a

piece of advice I think might help. It is from Jeff Raz, the founder of the Clown Conservatory in San Francisco:

Clowns have to be idiosyncratic. You are more yourself than anyone in the room.[3]

Being yourself means being different. Being different is not easy. It is hard for an actor to step out and be unusual. The initial reaction is often bad. That happened when Johnny Depp first came onto the set of *Pirates of the Caribbean* (Disney, 2003), directed by Gore Verbinski, and unleashed his Captain Jack Sparrow. Some Disney executives balked, but Depp won, and won big. His performance is perhaps the most idiosyncratic in recent memory. Jack Sparrow doesn't care what Disney executives or the other pirates think of him. He is more himself than anyone on the boat.

The Jeff Raz quote suggests a character who **moves like nobody else**. I will describe what I'm writing about by referring to the tool of motion capture. If you were to have motion capture of Cary Grant, Robert De Niro, or Matt Damon, then apply the action to a generic human figure, with no sound, most people would have a hard time identifying them. They would look like normal people. If you had motion capture of Chaplin's Tramp, Groucho Marx, or Curly Howard, and applied the motion to a generic figure, it would likely be recognized by anyone with any level of familiarity with the characters they played. Those actors had idiosyncratic ways of moving. While they may or may not be funny in themselves, the movement establishes the actor as a singular individual. Jerry Lewis, for example, had a peculiar style of running that was one of his signature ways of moving. Dramatic actors are not nearly so individual. Sure, when we see their face and voice, they are unique, but otherwise the differences are small. In animation, we want big differences.

As an example of a good animation that is also idiosyncratic, I would suggest looking at Genndy Tartakovsky's *Hotel Transylvania*. The characters in that film have a wider range of movement styles than in most features. Dracula tends to be more rigid. When walking, he sometimes appears to float along the ground. In contrast, the young human, Jonathan, walks with an extra bounce and hyperactive legs, supporting a vertical body and arms that don't swing at all. Genndy appreciates characters who move funny.

Figure 11.1 *Hotel Transylvania,* from left: Quasimodo (voice: Jon Lovitz), Johnny Stein (voice: Andy Samberg), Dracula (voice: Adam Sandler), 2012

© Columbia Pictures. Courtesy of Everett Collection.

Large-scale animation productions require a certain amount of quality control, and that can reduce the potential for developing a unique expressiveness. Some animation studios have what is called a **house style** of animation. It's very good animation by nearly all standards. It's also very consistent, which is good from a production point of view. The animation varies based on the characters' bodies and emotions, but they may not have a lot of individual style. Many animators want to create **cartoony** acting. Cartoony acting can simply be normal movement that is exaggerated. However, creating unique, idiosyncratic movement is more challenging, and more effective.

Reference

So how does one create idiosyncratic ways of moving? Sometimes animators will collect clips from movies of actors they want to be inspired by. Having a broad range of experience with movies across many genres and through history will provide the largest selection to choose from. It helps if you watch movies with an eye towards those things that set an actor's physical performance apart from others. Actors will do this sort of thing as well. It doesn't have to be another actor they are emulating either. Johnny Depp used the rock star Keith Richards as one of his inspirations for Jack Sparrow.

Many animators will record reference videos of themselves to use when working. Often, the purpose is to work out action specific to a shot. I believe that process can be considerably expanded. Reference could also be made not just for individual shots, but during the development stage for the character. The producers of the *Stuart Little* movie (Columbia Pictures, 1999), directed by Rob Minkoff, took the step of hiring clown and actor Bill Irwin to come in and act out scenes for the artist to use when animating Stuart. To devise an idiosyncratic style of acting, you could possibly do extensive experimentation, consciously trying to do things in new and unusual ways, recording each take and searching for new directions.

There is one additional way which I would like to encourage. That is studying how people move in real life. Animators will often carry sketchbooks to capture impressions of people in life. These sketches tend to be limited to simple poses. I suggest keeping an eye open for interesting motion, and creating notes or video of the subject. Or simply imitate them.

Charlie Chaplin was a keen observer of how people move. His famous walk was inspired by a shuffling old man he had seen as a boy. He maintained this habit of observing real people for his entire career. He said:

> It really is a serious study … although it must not be taken seriously. That sounds like a paradox, but it is not. It is a serious study to learn the characters; it is a hard study. But to make comedy a success there must be an ease, a spontaneity in the acting that cannot be associated with seriousness.

> In fact, naturalness is the greatest requisite of comedy. It must be real and true to life. I believe in realism absolutely. Real things appeal to the people far quicker than the grotesque. My comedy is actual life, with the slightest twist or exaggeration, you might say, to bring out what it might be under certain circumstances.[4]

When Chaplin says **grotesque** he is referring to the overly energetic acting commonly found in silent pictures when he started. That sort of acting is the visual equivalent of a recorded laugh track added to sound. It is intended to *tell* the audience that what just happened is important or funny. If the situation isn't really all that funny, maybe they will laugh at how the actor is jumping around.

Chaplin was almost singlehandedly responsible for shifting the emphasis in comedy to a more restrained and thoughtful style. The more accuracy and detail you can put into a performance, the more successful it will be. When Chaplin planned to play the part of a barber in *The Great Dictator* (United Artists, 1940), he spent a considerable amount of time at a barbershop watching how they worked. From that same interview, Chaplin said:

> I picked out a particularly busy barbershop so that I could sit there a long time before my turn came. I watched all the barber's ways. I studied out exactly what he did, and what he might be expected to do in my photoplays. And I followed him home that night. He was some walker, and it was three miles to his home, but I wanted to know all his little idiosyncrasies.[5]

Everybody is different to some degree. Some do a great job of being normal, others don't realize how unusual they are. First find people who are different in some interesting way, and develop what you find there. Isolate the details and remember them. By collecting enough details, you may be able to assemble them into a unique and interesting individual.

Our Flawed Humanity

Idiosyncratic acting does not conform to standards of beauty. It is unusual. It is weird. Hopefully it is funny. In his book *The Hidden Tools of Comedy*, Steve Kaplan wrote:

> One of the hardest things about comedy for actors is that, as human beings, we all want to be in the right. We all want to look good. We all want to be good. And comedy is the subversion of that. In acting school, actors have learned to be the best of everything. The best walkers. The best talkers. The best fencers. The best poets. The best.
>
> But in comedy, we ask them to not be the best.
>
> Nobody in the world wants to appear like an idiot. But actors in comedy have to. In comedy, you've got to love the pie. You want the pie to land in your face; you want to be the clown. You want your character to accept their own flawed humanity.[6]

Our flawed humanity is what makes people laugh, when the pretensions are dropped and we can see that the actor on the stage is not so different from us. By recognizing the flaws, and learning how to best present them, we may be able to make people laugh at themselves.

Perhaps the most fundamental way to make a character seem real is to have him or her display some of the many issues people have with their bodies. By definition, physical comedy has a lot to do with the human body. Proper ladies and gentlemen don't act like

anything is going on underneath their fancy clothes. The good-looking actor never tugs the back of his pants to pull the fabric out from his butt cheeks. If a lady were to have the sniffles, her nose should be gently dabbed with a hanky, not blown out with a honking horn sound effect. Comedians have no such pretensions. Funny characters don't need to be completely vulgar, but it helps when they honestly exhibit some down to earth qualities.

Early on, Charlie Chaplin's Tramp character seemed to have more than his share of itches that needed scratching. It became one of his little trademark actions, and was recreated by his imitators. Having an itch suggest the possibility of having fleas, or of not taking a bath. It was an action that supported his character as being poor. The Tramp might affect having manners, but he often displayed a lack of them. He also had a funny way of mimicking a burp, which involved a small lurch, a tip of the head, puffing of the cheeks, and topping it off by bumping his fist into his chest. He had obviously observed the small things people do when belching.

Hunger is a regular experience for humans and other animals. Nothing says "I am real" like a character ravenously consuming food. Think of the Muppet Cookie Monster. He shoves cookies in his mouth and crumbs fly everywhere. It's funny. In their movie *Room Service* (RKO, 1983), directed by William A. Seiter, the Marx Brothers spend days hiding out in a hotel room with no food. When a meal finally arrives, they all tear into it. Harpo sets to eating with the efficiency of a machine. The fork hits the plate, quickly moves food to his mouth, then repeats over and over again with the perfect timing of a metronome for what seems like a solid minute. And of course, Po, of *Kung Fu Panda* (2008), was a full on glutton. You never see anyone in a drama talking with their mouth full.

Figure 11.2 *Kung Fu Panda*, Po the Panda (voice: Jack Black), 2008

© DreamWorks Animation. Courtesy Everett Collection.

Mr. Bean did many gags about dealing with his own body, and he built some routines around the topic. In *The Return of Mr. Bean* (ITV, 1990), directed by William Howard Davies, he is a theater employee waiting in line to greet the Queen. While nervously preparing, he discovers his own bad breath, flosses his teeth, and finds he has a rough fingernail. To file down the fingernail, he uses the zipper on his pants. Just as the Queen is approaching, he realizes he has left his zipper down. He struggles to get the zipper up, and ends up with his finger protruding from the fly of his pants looking like you can guess what.

To top things off, or bottom it out, don't forget the potty humor. Pixar hasn't shied away from it. In *Cars 2* (2011), a fluid leak made it look like the tow truck Mater had peed on the floor. In *Finding Nemo* (2003), a little octopus "inks herself" when she get scared. In *Monsters, Inc.* (2001), the Yeti monster has to explain that the yellow snow cones are just lemon flavored.

Emotions

Buster Keaton created one of the most idiosyncratic performance styles ever. He earned the nickname **the great stone face** for his **deadpan** facial acting. As a child in vaudeville, his father would toss him around the stage with reckless abandon. They learned early on that audiences laughed more when the boy didn't show any reaction. In the movies, when the world seemed to be collapsing around him, his expression would only have the very slightest change. He might just pinch his brow ever so slightly, or it could be just one single blink.

Keaton was an extraordinary stunt man, and had a genius for creating clever gags. If one were to imagine him having a typical facial performance, responding as regular people would, he would not have had the same impact. His stolid expression is a very simple gimmick that makes him totally stand out. He appears impervious to fear or panic, as though he were superhuman. At the very least, he is not a regular person.

Keaton's lack of expression is an example of how it can be funny when someone's reaction is out of alignment with normal expectations. Gene Wilder's portrayal of Willy Wonka is another good example. He is clearly a happy, successful, fun loving person. But as the children visiting his factory find themselves in danger, he obviously doesn't care much about them. A normal company owner would be extremely concerned. When things are going terribly wrong, Wonka remains oddly calm. That calmness is actually sort of reassuring. It is the behavior of a successful person, and that is attractive. He is very centered, like the eye of a storm. It is as though everything is going exactly as he imagined it would.

Gromit the dog, from Aardman Animations, has a very Buster Keaton-like facial performance. In fact, a lot of the work from that studio uses a more limited range of expression. The work is still successful because they create exciting, interesting, and funny situations. They don't need the grotesque reactions to sell it as funny.

Now that I have made the point about restrained acting styles, I will explain how the opposite also works. How characters can have huge reactions that are funny in themselves.

It can be funny when someone freaks out over something rather small. It just has to be really significant to them. Perhaps they are overly sensitive on a certain topic. In *Hotel Transylvania*, Dracula is being an overprotective father to Mavis, his "little girl." When Frankenstein yells out to him "she's not so little anymore," Dracula turns quickly and growls, "Yes she is!" and then puts on his most terrifying expression of viciousness. Later on, Jonathan, the human, attempts to remove a contact lens from his eye. The young man's fingers probing his own eyeball to retrieve the lens is an unattractive process, and Dracula is completely disgusted and shows it. It's a normal, though amplified, reaction that seems strange when applied to an abnormal character such as Dracula.

The strong reactions from Dracula come and go very fast. Big reactions can be okay when they are contrasted with other behavior. A quick change of emotion is another

technique of comic acting. Dramatic actors tend to have scenes that allow them to fully explore a single thought or feeling at some length. This is the behavior of an emotionally stable adult. But emotionally stable adults are not comedy material.

Children, in contrast, are comedy material. The younger the child, the more emotionally delicate they are. They can go from joyful to distraught in the blink of an eye, then reverse it again. It is that rapid change of thinking that is displayed by the minions of *Despicable Me* (2010). They have pure emotions, and little control over them. They are also easily distracted. Their thoughts shift quickly. A room full of minions is like a room full of kindergarteners. None of them are above that behavior, so they need their "master" to give their lives some order. That's why they are minions.

As always, generic acting is bad acting, and it is no different for moments of great emotion. Big reactions can be funny when they are done with great style. Curly Howard of the Three Stooges had a variety of trademark behaviors he would use when he got frustrated, or scared, or angry. He might slap his own face repeatedly, or bark and growl like a dog. Donald Duck, of course, regularly gets tipped over the edge and loses his temper. When Donald loses control, he puts his own unique spin on the emotion. He goes through his fist-swinging-ready-to-fight dance, and has that spitting-quacking voice that suggests swearing. Again, it is an idiosyncratic behavior that almost anyone would recognize as Donald. Before long though, both Curly and Donald calm down, and go back to doing whatever it was they were doing before. That sets them up for some new irritation, and the cycle continues.

Acting Normal

As previously mentioned, actors like to look good. The fact is, almost nobody likes to look foolish. That's why we need professionals for the job. Understanding this tidbit of human nature can be very valuable. When people find themselves in a foolish situation, they will very often try to act like nothing is wrong and hope nobody notices. Charlie Chaplin explained his approach this way:

> Even funnier than the man who has been made ridiculous, however, is the man who, having had something funny happen to him, refuses to admit that anything out of the way has happened, and attempts to maintain his dignity.

> That is why, no matter how desperate the predicament is, I am always very much in earnest about clutching my cane, straightening my derby hat, and fixing my tie, even though I have just landed on my head.[7]

Chaplin has described one of the options for a reaction. One of the simplest lessons to learn is that while funny things can happen to a character, the real comedy is found in how they react to it. Taking a pie to the face is only the beginning. The audience wants to see what the character will do next. There are multiple choices, and some are funnier than others. Simply striking a sad face is probably the least funny thing a character can do. Donald Duck might freak out for a moment. Oliver Hardy, of Laurel and Hardy, was famous for his slow burn, which often involved an irritated look directly into the camera. Then he would slowly turn toward Stan Laurel, and glare at him. It was then Stan's turn

to display his guilty face, and possibly even cry. It is crucial that the character doesn't quit. Chaplin's characters succeed because they don't let situations get the best of them. The Tramp will suffer temporary setbacks, but he won't let it stop him. It is the behavior of a winner, and audiences like winners.

If you can get your character into a dilemma, where they have various forces influencing their behavior, it is an opportunity for some extremely comic behavior. In acting there is something called **subtext**. Subtext is the unspoken thoughts and motives of your character, and can be a key ingredient in comedy. John Cleese played Basil Fawlty, the owner of a small English hotel. Each episode put Fawlty into confusing and frustrating situations. He would have to put on a false image of control for the customers he valued. He would fake being cheerful and warm. In an interview about the show, Cleese had this to say:

> Great comedy is always about things happening on different levels. Because people say that comedy is about conflict, and people often think that that means character A has to be head to head with character B. But the interesting conflicts are within people, when something has happened which is absolutely terrible, but they are having to pretend that it's fine. But if you see them just thinking it's terrible it's not funny. It's the fact that they have to keep up the act. So any time that someone is doing something at one level, and something almost contradictory in conflict with it is happening with it at another level, it's funny.[8]

Basil Fawlty is really not a very nice guy. He causes nearly all of his own problems. The audience knows the subtext, and they revel in seeing Fawlty caught in the middle of his powerful emotions, trying to act as though everything is fine. The character of Basil Fawlty, by the way, was inspired by a real-life owner of a hotel where several members of the Monty Python troupe had stayed. He was quite rude to everyone. Some of the members were so exasperated with the owner, they left for other accommodation. John Cleese found him amusing. The characterization is not ridicule or mockery. Children's author Ruth Manning-Sanders wrote:

> An understanding of human nature is not born in a day; it comes of experience, and it comes from a wide and varied contacts. In order to make humanity laugh at a picture of its own folly ... one must know that folly. And not only must one know it, but one must sympathize with it and forgive it—or how should folly laugh without bitterness at its own image?[9]

You can see a very similar situation in Sony's animated film *Hotel Transylvania*. Dracula runs an exclusive hotel for monsters, which is supposed to be human free. The human Jonathan has accidentally wandered into the hotel. Dracula has to cover up his presence, and pretend everything is as it should be. When dealing with his guests, his acting is a combination of real fear and fake confidence. Dracula has a variety of inner conflicts. He doesn't want to kill Jonathan because he is not the vicious killer humans think of him as. He also has the inner conflict of having his daughter Mavis reach maturity, and want to leave home to explore. He is trying to keep Jonathan away from Mavis. The farcical situation causes Dracula to continuously have to lie and have radical changes in behavior based on who is in the room. He goes from being supremely in control, to having everything on the verge of falling apart.

Figure 11.3 *Hotel Transylvania*, from left: Murray the Mummy (voice: Ceelo Green), Frank (voice: Kevin James), Dracula (voice: Adam Sandler), Wayne (voice: Steve Buscemi), Griffin—The Invisible Man (voice: David Spade), 2012

© Columbia Pictures. Courtesy Everett Collection.

Business

Physical comedians can use something called **business**. Business is an action, or series of actions, the actor does simply to get a laugh. They are a kind of gag. They are usually small and unnecessary actions that do nothing relevant to the story. However, they can be very amusing and, therefore, have value. If you are introducing a brand new character, it can be helpful to give them some business that demonstrates their thinking process. It can establish them as a comic character. Comedy groups can have comic business as well. Whenever the Three Stooges stop for some slapping or eye pokes, that is business. When Laurel and Hardy get their hats mixed up, again, that is business. Groups tend to have reliable old bits that always get a laugh. It is their lazzi, as used in the commedia dell'arte.

One form of business is for the actor to have small difficulties or struggles. Actors get what are called stage directions. These are things they need to do as part of the story, things other than talk. For example "open a drawer and take out a gun." Actors rehearse the direction, usually to do it smoothly with no trouble. They may do it calmly, or in a panic, but still the act is accomplished with minimal trouble. For comedy, it can be the opposite. Comedy is about real life. Real life is not rehearsed. There are hitches and mistakes. The stage direction can be carried out in the most awkward way. Fumbling around with something is a good way to make the character sympathetic. It is a matter of finding the funniest hitches and mistakes, and practicing how to make them even worse. Opportunities for business happen whenever a character has stage directions. If an actor had the stage direction of opening a drawer and taking out a gun, it could include:

- Having to open several drawers to find the right one.
- Opening a drawer and having it fall on the floor.
- The drawer is locked, and the key must be pulled out of a pocket, which can lead to more problems.

- The actor has to dig around in the drawer and push other junk out of the way.
- A banana is pulled out instead of a gun. The banana is tossed over the shoulder, which, for unknown reasons, is always the funniest way to discard something.
- A gun is taken from the drawer, but it only squirts water.
- When the gun is finally found, it is fumbled and dropped. It goes off accidentally, hitting an offscreen cat.

Dealing with small problems is the domain of the fool. But tricky characters can engage in business as well. They do it just for fun. In the Warner Brothers short *The Heckling Hare* (1941), directed by Tex Avery, Bugs Bunny is being pursued by a dog. He comes to a pond where he is going to escape by jumping in. But he doesn't just dive into the water. He comes to a complete stop, pulls out a bathing cap, and delicately mimics all the motions a woman might do in putting a cap on to protect her hairdo. He is not the least bit panicked. Sure, it slows the advancement of the story, but it is a great moment that shows Bugs's attitude toward the whole adventure. He takes what could be a small stage direction, "jump into the water" and builds completely new material on top of that. Making choices like that are far more interesting than simply following the "rules" of what a character is supposed to do in a given situation.

Comic business is nothing more than gags, and it has the same issues I brought up in the chapter on gags and comic events. They are only good for quick laughs and are not critical for the story. Another problem with comic business and animation is that animation tends toward efficiency. Every frame costs money and time. It is not common for a character to be allowed to take the time for comic business. But it is not a waste of time, it's time in which the comedian puts the story aside and connects with the audience. Humorous stories have no pretense of importance. They do not take themselves so seriously. In comedy, it is okay to break the illusion, and say "This is all in fun."

Entrances

The audience is gathering an impression of a character from the very first frame, and it's best if the character appears to already be in some state of thought or action. No matter what shot you are doing, the character should already have something on his or her mind, and the body should be supporting the idea.

That little tip is an introduction to the topic of how a character enters a scene. A great entrance will immediately capture an audience's attention. Charlie Chaplin worked at making interesting entrances. Here, Rowan Atkinson explains why:

> Chaplin so took over a picture, he seemed to always be center screen, or entering or exiting in some eye-catching manner. Entrances and exits are a special aspect of physical comedy, worthy of great thought, but Chaplin also did this for a different reason: editing. Sennett would often edit out any material he didn't care for, and this angered Charlie. But Sennett had to leave in the entrances and exits. By embedding good stuff in those moments, Chaplin was assured of quality screen time.[10]

Sennett was editing out what he didn't care for, and audiences will do the same, essentially forgetting those moments. So Chaplin used that knowledge to make sure his time on screen was as effective as possible. If he could make a great entrance, he was primed for a great performance. The entrance sets the tone for the scene, so it should say something about the style of the character.

Consider the character Kramer from the television show *Seinfeld* (West-Shapiro Productions). He had a very idiosyncratic way of entering Jerry's apartment. He never knocked. He would barge in quickly, usually in some state of agitation. From the minute he came in, the storyline had to shift toward him, because he couldn't be ignored. His performance had momentum based on the entrance.

Figure 11.4 *Seinfeld*, Michael Richards, Jerry Seinfeld, "The Shoes" (Season 4, aired February 4, 1993), 1990–98

© Columbia TriStar Television. Courtesy Everett Collection.

Of course, characters can't always explode into the shot. Buster Keaton, for example, would enter the frame quite mildly. His character is thoughtful and serious, so it would be unusual for him to burst in and steal the scene. He tended to do the opposite, but made it work to his advantage. When possible, the space he was entering already had a high energy, such as the trading floor of a stock exchange, an army recruitment center at the outbreak of war, a rowdy casino, or a ranch kitchen filled with hungry cowboys. His

meek attitude was out of place, and he appeared vulnerable. It put him at odds with the situation, and set him up with obstacles to overcome.

Entrances require extra thought when bringing a recurring character into some strange context. They need a reason to be there, even if it is a simple mistake. When a Bugs Bunny short required him to be in some unusual place, they used the gag of him tunneling underground, popping up into the scene, and checking his map. He would sometimes speak one of his famous lines: "I knew I should have taken a left turn at Albequerque."

Voices

Figure 11.5 Pinto Colvig in Walt Disney studios creating sounds for an animated film in the 1930s. The American vaudeville actor became a movie voice actor who worked with the major Hollywood studios

Courtesy Everett Collection.

Even though my emphasis is clearly on wordless comedy, I should give some recognition to the possibilities in voice work. The voice is produced by the body and throws a living vibration into the quality of the words. It can provide a valuable energy to what is said. In the Pixar feature *Up* (2009), I couldn't help but laugh at the menacing Doberman pincher whose voice box had malfunctioned, and had given him a voice with a high-pitched sound as though he had been inhaling helium.

The word **persona** is derived from the Latin words for "through sound." It is through the character's voice that we can discover their personality. Persona was also the word used for the masks in ancient Greek theater. Actors in Greek theater wore masks, but with

open mouths to allow the actor to speak. The mouths could be shaped to work as small megaphones, amplifying the voice.

Character, on the other hand, refers more to the thoughts and beliefs of an individual. Character is how a person makes choices, how they decide what's right and wrong. It is what guides their direction.

Character is interior, personality is exterior.

When creating characters it's useful to understand this difference. We tend to make characters who express their thinking through their personality. The hero has a great personality, the villain is dislikable. But of course, history has many charismatic individuals who have brought great evil. And, the world is filled with misunderstood individuals who care deeply about others, but don't know how to show it.

Wikipedia has this simple description of how character's voice plays into the formula of humor.

> A popular saying, variously quoted but generally attributed to Ed Wynn, is, 'A comic says funny things; a comedian says things funny', which draws a distinction between how much of the comedy can be attributed to verbal content and how much to acting and persona.[11]

Figure 11.6 *The Ed Wynn Show,* Ed Wynn, 1949–50

Courtesy Everett Collection.

One evening I went to the Circus Center in San Francisco, to watch a performance of students in their Clown Conservatory. It is interesting to watch novice comedians, because it is such a contrast to professionals. The pros have done their acts perhaps

thousands of times. They have everything down, and proceed with a natural ease. The students, on the other hand, are clearly working hard. In that regard, none of the students stood out. But one of them did snag my attention. It was because of her voice. Her voice was a little funny. I don't recall what she said, but the unusual quality along with her delivery and timing helped to separate her from the group.

There is also a kind of character I refer to as **sub-verbal**. Basically, these are characters who speak, but they speak in gibberish. To themselves, they are talking, but their words mean nothing to the audience. Though their words mean nothing, they are able to put emotional inflection into the sound. So it is still an expressive form of communication. Historically speaking, this is called **grammelot**. Wikipedia describes it as:

> A style of language in satirical theatre, a gibberish with macaronic and onomatopoeic elements, used in association with mime and mimicry. The format dates back to the 16th century Commedia dell'arte, and some claim grammelot to be a specific universal language (akin to Lingua franca) devised to give performers safety from censorship and appeal whatever the dialect of the audience.[12]

Macaronic, by the way, refers to a jumbled mixture of languages. When theatrical troupes traveled through other lands with unfamiliar languages, they were able to fall back on this sort of talking, and still be entertaining.

"Taz," the Tasmanian Devil (Warner Brothers) is perhaps the most well-known cartoon character to sound this way. He was occasionally able to get out some English, but is generally known for his animal sounds. The minions of *Despicable Me* (Illumination) also use this style of communicating. Another of the great sub-verbal characters is the Muppet "Swedish Chef." Throughout his faux-Swedish, he would also pepper in some understandable English. I believe he now works as a writer for Ikea catalogs.

How does a normal character converse with a subverbal character? There are two ways. The normal character can simply imitate the gibberish, and it magically works. It's then funny to hear two characters using the same odd sounds. The other way is for the normal character to simply carry on one side of the conversation normally. It is implied that he understands the other's strange language, and can be understood in return. The audience can follow the conversation when only hearing one side. That method was used by Soupy Sales to speak with the offscreen character "White Fang."

Cartoon voice work is a great exercise for animators to try out. One time I attended a class in cartoon voiceover. It was tremendous fun, sitting in a room with several strangers, and talking in funny voices. When putting on a voice, I find I must get into the character. I start making faces to match, and posture my body to go with it. I was also involved in the creation of an alien language for a short film. To get random sounds we created a list of various sausages and prepared meats from around the world. The actor simply read the list, with a vocal style inspired by Japanese samurai films. It worked quite well.

For animation students involved in dialog exercises, I would recommend putting some serious thought into the voices. The sound quality of the voice is perhaps even more important than what is being said. Many dialog exercises use clips from movies, featuring regular

actors with regular voices. It is worth finding some voices with real personality. We all have to admit that Mel Blanc was a major contributor to the success of Warner Brothers cartoons. A funny voice is absolutely a contributing factor to the humor.

Any actor will tell you that comedy is hard. This chapter simply lists some suggestions on possible directions to take. What it mostly requires is courage and the willingness to go out and fail.

Jacques LeCoq was a gymnast and physical education teacher before he founded his school of theater in 1956. While not necessarily focused on comedy, his emphasis on movement still influences theater and mime performance today. I found a description of his teaching that is applicable to the work of comic acting. This is by John Wright, in his book *Why Is That So Funny?*:

> LeCoq used to teach from the principle of via negativa (latin for "negative way"). This is a method of teaching that suppresses explanation, example, and instruction. He simply told his students "no, that's not it." Forcing everyone to dig really deep to find out what "it" might be. But LeCoq could skillfully navigate his charges to a point where they were compelled to draw their own conclusions, and to find their own way in the work. He used via negativa to avoid theorising and intellectualising about a process that was primarily empirical and spontaneous.[13]

While it puts a lot of stress on the actor, I can understand this approach. It is the way a performer learns on stage. They do not get any explanation from the audience. When animators shoot reference, too many of them chose to go into a room alone, and do only enough takes to work out the actions they need. If your goal is to make people laugh, how do you know if your acting choices will work? You know by having people there, and seeing if they laugh. My advice is to work on these sorts of scenes with people you trust. Invite them in and insist that they give honest reactions. If what you're doing isn't working, try other things, very different things. Chaplin did many different takes to get to those he liked. By applying via negativa to his own work, he was able to find those magical things that don't come quickly and easily. The people in your reference shoot don't have to explain why they don't laugh. They don't have to analyze. Animators tend to like **principles** they can follow. Comedy cannot be created by following rules. What you are searching for is a spontaneous magic. It should be hard work, but it should also be fun. Wright continues to say:

> If I start to theorise, or try to give detailed instructions, or if I try to direct you in a more conventional way, you'll start to think and to analyze what you're doing, and then all your playfulness and comedy will quite simply evaporate.[14]

Notes

[1] Skredvedt, Randy. *Laurel and Hardy: The magic behind the movies* (Beverly Hills: Moonstone, 1987), p. 389.

[2] Wright, John. *Why is that so funny?* (New York: Limelight Editions, 2007), p. xiv.

[3] Raz, Jeff. "Clowning and its philosophy." San Francisco: Commonwealth Club, 4 June 2008.

4 Hayes, Kevin J. (ed.). *Charlie Chaplin Interviews*. (Jackson, MS: University of Mississippi Press, 2005), pp. 4–5.

5 Ibid., p. 5.

6 Kaplan, Steve. *The hidden tools of comedy* (Studio City: Michael Weise Productions, 2013), p. 154.

7 Maccann, Richard Dyer. *The silent comedians* (Metuchen, NJ: The Scarecrow Press, 1993), p. 95.

8 Cleese, John. "Extended Interviews." *Fawlty Towers: The Complete Remastered Collection*. BBC Video, 2009. DVD.

9 Cline, Paul. *Fools, Clowns, & Jesters* (San Diego: Green Tiger Press, 1983), p. 46.

10 Atkinson, Rowan, David Hinton and Robin Driscoll, "Visual Comedy." *Funny Business*. 22 November 1992.

11 Wikipedia: Comedian: <http://en.wikipedia.org/wiki/Comedian>.

12 Wikipedia: Grammelot: <http://en.wikipedia.org/wiki/Grammelot>.

13 Wright, op. cit., p. 186.

14 Ibid., p. 187.

CHAPTER 12

The Impossible

All the previous chapters were based on what we can learn from the history of live comedy. This one chapter is devoted to giving your animated characters cartoon powers. It should be obvious how important it is to lay the groundwork in reality. Comedy is about understanding human nature, and having fun with it. If you start and finish with that in mind, you can then do anything you can imagine to make it cartoony. You can place your order with the Acme company for anvils and dynamite. Your characters can fly, fall, or move at the speed of light. They can manipulate matter as well as the minds of their opponents. They can do the things real people could only dream of. Actors, however, do their best to achieve what they can. The poet Theodore De Banville wrote of the English pantomime actor John Rich:

> Between the adjective "possible" and the adjective "impossible" the English
> Pantomimist has made his choice: he has chosen the adjective "impossible." He
> hides where it is impossible to hide, he passes through openings that are smaller
> than his body, he stands on supports that are too weak to support his weight; while
> being closely observed, he executes movements that are absolutely undetectable, he
> balances on an umbrella, he curls up inside a guitar case and throughout, he flees,
> he escapes, he leaps. And what drives him on? The remembrance of being a bird, the
> regret of no longer being one, the will to become one again.[1]

That nicely describes the acrobatic comedian's ability to entertain with virtuoso physical performances. Such actors have to be very talented, and practice extraordinarily hard. They take tremendous risks each time they put on a show. It is truly amazing to watch people on stage do things that appear impossible.

When the movies began, however, there was a small problem.

The motion picture camera was invented to record actual events. It was soon discovered that the camera could play tricks. Through clever composition and editing, it can be used to fool people. For example, by stopping the camera, an actor dressed in a devil's costume could walk into the shot. Then the camera is started again. In the resulting film it would appear that Lucifer magically appeared in the scene. While it was great fun at first, audiences soon caught on, and it was much less effective. Even subtle editing can leave doubts in the actuality of the performance. For example, if you want to show someone jumping off a

building, you could film the whole event in one shot. Or, you could do it in two separate shots. First you see them jump off, then cut to them landing on the ground. What happened in between the cuts is suggested, but not shown, and viewers will suspect that it was fake.

Buster Keaton avoided what are called **impossible gags**. It refers to a gag that the audience recognizes as being beyond any acceptable reality. For example, in the Jerry Lewis film *Artists and Models* (Paramount, 1955), directed by animator Frank Tashlin, Jerry undergoes a massage that is painful to watch. Using a pair of obviously fake legs, his body is bent and twisted into excruciatingly odd positions. All the while Jerry is making his outrageous facial expressions. It is undeniably fake, and a bit out of place with the rest of the picture. The Three Stooges had only slightly more license to get away with that sort of thing. When Curly gets a shot of "vitamin p.d.q.," his legs grow twice their normal length, so he's about ten-feet tall. Moe solves the problem by bonking his head with a hammer, and driving him back down to his normal height. These effects draw too much attention to themselves, and are only funny for being so bad. Modern use of computer graphics to create cartoon effects with real people are only a marginal improvement.

Where such effects fail for humans, they work great for cartoon characters. Much of the value in animation is that it can deliver what live action cannot. A duck can take a shotgun blast to the face, and all that is damaged is his dignity. This is the chapter where reality can be ignored to create a **super reality**. This is where characters can defy the laws of physics. This is where magic can happen.

Magic

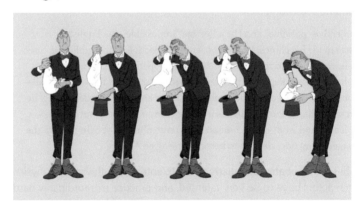

There is a response people invariably have to a seemingly impossible magic trick—they laugh. There is nothing really funny about the trick. ... It is a laughter of delight which stems from the surprise of having one's perceptions about reality playfully contradicted.[2]

Dan Kamin

There is a close relationship between comedy and magic, and especially so in animation. Stage magicians and wizards provide a convenient route for me to describe how cartoons can enter into the realm of magic. From Mickey Mouse as the Sorcerer's Apprentice in Disney's

Fantasia (1940), to Goofy getting caught up in moving a magician's trunk in *Baggage Buster* (Disney, 1941), directed by Jack Kinney, to Presto Digitione in Pixar's *Presto* (2008), directed by Doug Sweetland, such films directly use the conjurer for the fun effects they are expected to deliver. But cartoons don't need the presence of those characters to make the impossible happen. As a way of organizing what seems like an unlimited number of potential effects, I will use the nine categories of stage magicians' effects. The categories are; **production**, **vanishing**, **transformation**, **penetration**, **restoration**, **escape**, **teleportation**, **levitation**, and **prediction**.

Production

Production is making something magically appear. The quintessential production trick for a magician is pulling a rabbit out of a hat. Production can be made funny either by producing funny things, or by producing things in a funny way. There was a vaudeville star named Adolf Proper who played a character called "The Banana Man." That name came from an act where he pulled 300 bananas from out of the inside of his large overcoat. The huge number of bananas was impressive enough to call it magic. Harpo Marx also seemed to have these **infinite pockets** inside his large trench coat. When a hobo asks him for a dime to buy a coffee, Harpo pulls out a steaming cup of coffee and hands it to him. Currently, the same effect is used by the Penguins of Madagascar. The penguin Rico seems to be able to regurgitate any needed item from his belly.

When discussing magical production in animation, the website TVtropes.org offers a term that I like very much: **Hammerspace**. Here is their definition:

> Hammerspace is the notional place that things come from when they are needed, and where they go back to when not. The term was fan coined as the place cartoon characters and anime/manga characters would store the overly-large hammers and assorted weaponry they had a propensity for hitting each other with, especially for comedic effect.[3]

The effective use of hammerspace requires creativity. In the Tex Avery short *What's Buzzin' Buzzard* (MGM, 1943), a starving vulture decides to eat his friend. A comedian can't just attack and eat his prey. It must be funny. Since the act of eating can be prefaced with cooking, that is the route that Avery took. In order to properly prepare his friend for dinner, he needs the correct props. In the middle of the desert, the buzzard is able to conjure up, one gag at a time, an entire kitchen of heavy duty appliances from out of nowhere.

Vanishing

Where a stage magician makes items disappear through vanishing tricks, I will focus on characters being invisible. Being invisible is the ultimate trickster's tool. As discussed in Chapter 9 on gags and comic events, comedy can be found in manipulating what a characters sees and doesn't see. When one character is invisible, the other characters are automatically set up to look like fools. Invisibility can make a character bolder than they would have been, and sometimes they become irresponsible because they feel completely anonymous. Invisibility is a super power.

All you need for this effect is a way of making a character invisible. Perhaps it is some high technology, or a magic potion. Decades ago, there was a ladies' cosmetic called vanishing cream. Essentially, it covered up facial blemishes. In the hands of animators though, vanishing cream can be rubbed on, and it can actually make a character become invisible. It allowed Jerry the mouse to torment Tom the cat with impunity. The method of becoming invisible is not as important as how it is used to generate comic situations.

To keep the comedy and conflict alive though, it is good to counterbalance the invisibility by giving the other character a chance. Invisible characters can unintentionally reveal themselves, such as by walking through soft material and leaving footprints. Also, invisibility is never permanent, so eventually it wears off. That's an opportunity for a reversal. The character can be suddenly revealed, and yet doesn't realize it. They carry on with confidence while the audience knows the danger they are in.

Transformation

For a transformation trick, a magician presents an object, covers it up briefly, then reveals it to be changed into something else. I will apply transformation to the character himself. As cartoon characters are infinitely malleable, their bodies can be transformed in multiple different ways.

First let's consider magic potions. When Robert Louis Stevenson wrote *The Strange Case of Dr. Jekyll and Mr. Hyde* he probably never considered how many adaptations and comedies would come out of it. The sudden and extreme change of a character, revealing some hidden animal within, is something we believe is not too far off from reality. At Warner Brothers, Friz Freleng directed a few variations on the story. In *Hyde and Go Tweet* (1960), Sylvester the cat pursues Tweety bird, until Tweety drinks the terrible formula and transforms into a monster. In *Hyde and Hare* (1955), Bugs Bunny was adopted and taken home by Dr. Jekyll himself.

Figure 12.2 *Dr. Jekyll and Mr. Mouse*, top right: Jerry, bottom: Tom, 1947

Courtesy Everett Collection.

Such potions are valuable in cartoons because of how ridiculously fast they work. The same kind of idea also drove the story in *King Size Canary* (MGM, 1947), where a bottle of Jumbo Gro plant formula triggers massive growth among a bird, a cat, a mouse and a dog.

The **quick change** of costume has a history on stage. Some stage magicians will demonstrate quick change by using their lovely lady assistants. The woman will be hidden for a very brief moment, then revealed to be in a completely new costume. I have seen Bill Irwin use quick change in a show. He ran behind a wall, and exited the other side with a new costume. It was so fast, it was hard to imagine him breaking stride to change anything. In addition to the new costume, he exited with a very different walk. He didn't just change clothes, he changed character.

Quick change is what Bugs Bunny does whenever he suddenly appears in female clothes to fool his adversary. The Bugs Bunny film *Hare Conditioned* (Warner Brothers, 1945), directed by Chuck Jones, is a quick change extravaganza. The cartoon takes place in a department store, where a manager is chasing Bugs, hoping to stuff him for the taxidermy department. During the chase, the pair run into and out of several different departments, each time exiting in some new get up. The outfits include ski wear, rain gear, children's clothes, lingerie, a pantomime horse costume, and when exiting the Turkish bath, they are wrapped in towels. It all happens in a rapid fire progression. In this case the comedy is all based on surprise. Otherwise, the new costumes are intended to fool the opponent. Bugs also takes turns dressed as an elevator operator, and a female customer looking to buy shoes. In those cases, the manager doesn't see through the disguise. Bugs is simply having fun with the situation.

Hypnotism, while not on the list of stage magic, can also be responsible for character's behavior transforming. In *The Hare Brained Hypnotist* (Warner Brothers, 1942), directed by Friz Freleng, Elmer Fudd reads a book on hypnotism. His plan is to capture animals with his eyes, rather than hunt them with a gun. When he finds Bugs in the forest, he gives it a try. Of course Bugs won't fall for it, and he takes control and he hypnotizes Elmer into thinking he is a rabbit. Once Elmer starts behaving like a bunny, their whole relationship reverses. Elmer becomes the clever one, and in a satisfying twist on the theme, he irritates Bugs. The trickster can sometimes not see the unintended consequences.

Penetration and Restoration

For animation, it works to combine penetration and restoration into one effect. On stage, penetration is having solid objects apparently pass through another solid object or a person. Putting a human subject into a box, then skewering the box from all directions with swords is a good example. Restoration typically involves borrowing something of value from an audience member, covering it up, then smashing it with a hammer. It must be a convincing destruction. Then, through some sort of production trick, the original is returned to its owner unharmed. These are the two effects demonstrated by cartoon characters every time they get blasted, sliced, shattered, mangled, pierced, shaved, or rearranged, and then return in the next shot none the worse for wear. Comedy relies on the understanding with the audience that the character won't be permanently injured.

It's not what happens to the character that is funny, but how the character reacts to it. When the character undergoes the misfortune, that is the opportunity to have a funny

response. They can be embarrassed, angered, or act like nothing has gone wrong. In some cases, they aren't aware of what happened, and simply fall to pieces on the floor, then the camera cuts away or goes black. Usually it's good to end with at least the eyes showing some surprise at that point. Maybe they have to pull themselves back together. When Daffy Duck takes a shotgun blast to the face, his bill gets moved to another position, and he has to pull it back into place. Daffy's understated reaction is half the comedy. Expressing pain is not out of the question, it just needs to be handled humorously. Excessive screaming in pain is not inherently funny. That often happens during "The Itchy & Scratchy Show" on *The Simpsons*. What is funny is how Bart and Lisa laugh at it. Which suggests that how other characters react to an event is also part of the humor.

A powerful impact can cause serious body deformation. For instance, getting run over by a steamroller, leaving a character flattened. In the Oswald the Lucky Rabbit film *Bright Lights* (Walt Disney Studios, 1928), directed by Walt Disney, Oswald is stomped on by a security guard, and he splits into six smaller Oswalds who all run around for a moment, before running back together and reforming into the full-size rabbit. The exact same effect was created in a circus with a gag called the "Adam Smasher," where clowns dressed as scientists put a tall clown into a box, leaving his head exposed. They drop a pile driver on him, knocking him inside. The doors then pop open and a handful of diminutive clowns dressed identically to the tall clown come running out.

In the Disney film *Wreck-It Ralph* (2012), Fix-it Felix has a unique method of self-restoration. He and Sergeant Calhoun are trapped in the Nestle Quicksand, and they need to reach the Laffy Taff vines. If they can make the taffy laugh, they will drop down closer. The vines find it funny when Felix gets hit in the face, so he makes Sergeant Calhoun repeatedly punch him. He uses his fixing hammer to repair his face each time Sergeant Calhoun strikes him.

Characters do not always have to be completely restored. In the Tom and Jerry short *Mouse Trouble* (MGM, 1944), directed by William Hanna and Joseph Barbera, Tom blows the hair off the top of his own head with a shotgun. He covers up the hairless patch with a funny looking toupee, and wears it for the remainder of the film. It might be funny to see a character have to keep patching himself up, and by the end of the story he is a disheveled mess. The audience will be confident they will return to normal for the next show.

Escape

Escape artistry is a specialty among magicians. Typically, they use handcuffs, rope ties, chains, locks, and locked boxes. What makes an escape stunt great is a time limit, where the magician's life is on the line, such as having to hold his breath underwater. Animated characters need to be threatened in some way to make the escape necessary. When a character is cornered and there seems to be no chance, a clever escape is one of the funniest things you can do.

Escapes are a big part of the game in chase stories. In the most slapstick chase cartoons, characters have enormous capacity to dish out and take violence. So a well-placed blow against the chaser can facilitate an escape by the chasee. However, endless pounding would quickly get tiresome, so clever ideas are much more interesting. In the cowboy

themed short *Texas Tom* (MGM, 1950), directed by William Hanna and Joseph Barbera, Tom the cat has Jerry tightly held in his fist, and a six-gun in his face. All Jerry has to do is blow hard into the barrel of the gun, and it causes the bullets to pop out of the back into Tom's mouth. Tom is surprised, the gun flies up and he lets go of the mouse. Jerry jumps onto Tom's head, catches the gun and whacks him in the back of the head with it, causing all six bullets to fire and shoot out of Tom's mouth. We get an escape, and Jerry delivers a topper of a blow.

Figure 12.3 *Texas Tom*, poster art for MGM Tom and Jerry animated short, 1950

Courtesy Everett Collection.

Where the fool must suffer through damage and restoration, the trickster's quick thinking allows him to escape. Bugs Bunny has escaped many predicaments simply with his wits. For instance, Bugs has found himself facing Elmer Fudd's shotgun many times, but he senses that Elmer Fudd is not a vicious killer. So sometimes he plays on his sensitive side and puts on a very dramatic "death." Elmer then has terrible regrets for his actions, and becomes the fool. That strategy probably wouldn't work with Yosemite Sam. Bugs customizes his response to play off the weaknesses of his opponents.

Feature film stories will put their protagonists into danger that is to be taken seriously. The solutions can't be cartoonish or light hearted. Often such stories are solved by what I call the **missing element**. This is someone who was in the story not that long before, and wandered off at some point, and the audience has forgotten about them. Then they can suddenly return at just the right moment to solve the problem. For instance, in the climax of *Toy Story 3* (Pixar, 2010), directed by Lee Unkrich, when the toys are nearing death in the mouth of the trash grinder, they are rescued by the toy aliens operating their beloved "Claw." The aliens had run off earlier in the sequence.

Characters can also be saved by pure luck, which I describe later in this chapter.

Teleportation

To achieve the effect of teleportation, magicians must use secret doors to make quick exits, appearing to vanish, only to reappear somewhere else. Teleportation is no challenge for cartoon characters. The most famous example is Droopy Dog in his chase films with the Wolf. The Wolf could travel to the other side of the Earth, using multiple forms of transportation, only to find Droopy already there, patiently waiting for him.

Teleportation as a gag relies heavily on the element of surprise. When and how the character appears is the opportunity to make it really funny. One of my favorite examples is in the Looney Tunes short *The Stupid Cupid* (Warner Brothers, 1944), directed by Frank Tashlin. Daffy Duck has been struck by Cupid's arrow, and has fallen in love with a chicken. He goes full Pepé Le Pew on the poor girl. She is running from him, and at one point, wants to hide inside a barrel. She lifts the barrel off the floor, only to find Daffy is already there. He has a romantic table set, is chilling a bottle of champagne in ice by rolling it between his hands, and he has a big smile. His character and intentions are unmistakable.

Teleportation can be played out in various ways. A unique version of teleportation was done by Buster Keaton in his film *Sherlock Jr.* (1924). In that film, he is a movie projectionist who falls asleep on the job. In his dream he steps into the movie on the screen. As the film cuts to different locations, he stays in the same spot in the frame. He finds himself suddenly in different places. It is teleportation from his point of view, and it surprises him each time it happens. It was an extraordinary effect for its time, and is still an impressive sequence.

In cartoons, a door isn't necessarily anchored between two rooms. It can keep working as a portal regardless of where it is. The hero can remove a door from a wall, place it on the floor, and open it to reveal a flight of stairs going down. In Pixar's *Monsters, Inc.* (2001), the closet doors that led to children's bedrooms retained that power regardless of where they were. That was the key element in the fantastic chase sequence at the end of the film. The monsters were able to jump into and out of the scream factory by going through the doors.

The closet doors in *Monsters, Inc.* are an example of what could be called the **goes in here—comes out there effect**. It isn't necessary for the character's entire body to go through either, they can simply reach through. This sort of thing happens when someone answers a telephone and gets punched in the face by whoever is on the other end of the line. In the Friz Freleng-directed short *A Star is Bored* (Warner Brothers, 1956), Bugs Bunny has hidden inside a tree. Elmer Fudd points his gun inside the tree, but the barrel comes out of a hole in the ground behind him, pointing right at his own rear. It kind of looks like it could be a different gun, so when Elmer notices the barrel, he moves his gun in and out to test out his suspicions. The movements match, so we are convinced it is the same gun. Jones plays with the effect even more when Daffy Duck steps into the shot and takes over the gun, hoping to shoot Bugs himself. Daffy ties a red ribbon onto the barrel and puts it in the tree. It comes out of the hole with a polka dot ribbon, which for Daffy is enough to disprove the theory. Of course, when Daffy pulls the trigger he shoots himself.

A close relative of teleportation is the super-fast character. Of course, Speedy Gonzalez and the Road Runner are two of the most famous. Extreme speed is a characteristic of the tricky character, but the fool trying to capture them is given much more screen time, as they are really the funnier of the two. However, the super-fast character can be very funny when we see events through their eyes. In the DreamWorks feature animated film *Over the Hedge*

(2006), directed by Karey Kirkpatrick, the squirrel Hammy is hyperactive to begin with. During the climax, he is given a human energy drink which stimulates him to move at the speed of light. From his point of view, the world is practically frozen in time. He can casually walk through the scene, undo all the traps set for the animals, and save the day.

Levitation

On stage levitation tricks are often done on "hypnotized" subjects, and rely on hidden supports. Animators can suspend the law of gravity anytime they like, so levitation by itself doesn't mean very much. However, the ability to hang temporarily in the air is valuable in timing. First, when a character is momentarily hovering, he or she can have extra time for expression. A frightened character can spin his feet a while so the audience can appreciate his terrified expression before he bolts off. When Wile E. Coyote has just stepped off the cliff, he is given a beat or two to look plaintively at the camera. It's simply a way to help the audience experience the moment, and anticipate what's about to happen.

Sometimes when a trickster character is falling, he has the ability to stop in mid-air. This happened in *A Star is Bored,* when Bugs Bunny is on set shooting a movie. He is flying a jet fighter plane directly toward the ground. Just as he is about to hit, the director yells "cut!" The plane stops inches short of crashing and just hangs there. Bugs gets out of the plane so his stunt double, Daffy Duck, can step in and take over for the crash.

We can include various unorthodox methods of flight under the heading of levitation. The Coyote concocted numerous ways to take to the air. In story development, you can assemble some ridiculous pieces of equipment that could conceivably lift or power someone through the air. Figuring out what can go wrong is probably not that difficult.

Figure 12.4 *Chaser on the Rocks*, from left: Wile E. Coyote, Road runner, 1965

Courtesy Everett Collection.

Prediction

Prediction is a form of mentalism, where the magician can predict some secret piece of information provided by an audience member. For action comedy, a character can seem to be one step ahead of his opponent. One character simply knows what another will do. One is the fool, the other is the trickster who is ready to lay the trap. Droopy Dog can predict exactly where the Wolf is headed, and get there before him. Many gags suggest the prankster has foreknowledge of what the victim will do, and prepares for it. There doesn't need to be a logical reason for the trickster to be able to do that.

Characters can be inexplicably endowed with very specific skills, simply to drive a story. In *14 Carot Rabbit* (Warner Brothers, 1952), directed by Friz Freleng, Bugs Bunny is caught up in the American gold rush. He has the uncanny ability to find gold. All he has to do is walk around in the hills and if he passes over buried gold his body starts to shake and dance. This talent attracts the attention of Yosemite Sam, who wants to profit from it. Bugs acts as though it is no big deal, so he lets Sam take advantage of him. Sam's greed and impatience, however, are his undoing. Each time he digs for gold, something unexpected happens and it is always bad for him.

Surrealism

> The links between comedy and dreams are very specific, especially in the mechanism of free association, by which the dreamer and the comic hero jump from point to point by intuitive leaps and without any necessary logical connection.[4]
>
> Maurice Charney

Of all the art movements in history, the one that animators should know best is **surrealism**. Surrealism was founded in the 1920s. Encompassing visual art, writing, music, and film, it was influenced by Sigmund Freud's study of the subconscious, using free association and dream analysis. I might define surrealist visual art as **the juxtaposition of unexpected elements, resulting in a dreamlike image**. Surrealists felt that art could be free of aesthetic and moral preoccupations. In other words, it doesn't have to "mean" something. Like unfocused thought, it can just play. Literary examples of this predate the surrealist movement, for instance Edward Lear's *Book of Nonsense,* and Lewis Carroll's *Alice's Adventures in Wonderland.* Children love the strange characters and bizarre events that Alice experiences, because they were created only to be fun and exciting. Prior to Lewis Carroll, most children's literature consisted of stories intended to teach moral lessons. It was serious, dreary stuff.

Wikipedia says this about surrealism:

> Surrealism as a visual movement had found a method: to expose psychological truth by stripping ordinary objects of their normal significance, in order to create a compelling image that was beyond ordinary formal organization, in order to evoke empathy from the viewer.[5]

Surrealism can be a challenging art form. Many people want art that is just plain beautiful, or at least makes "sense." None of this means that surrealism is random or

haphazard. The art comes from the selection and treatment of the elements. The work should follow most of the rules of good art and composition. Just adding one thing out of place may be all that it takes. At the very least, I would say a "compelling image" lures the viewer in and invites him or her to ask themselves: **What's going on here?** Hayao Miyazaki movies occasionally make use of surreal situations and images.

Figure 12.5 *Spirited Away*, 2001

Courtesy of Everett Collection.

Surrealism isn't necessarily bizarre. It can definitely be funny. The original surrealists were fans of silent comedy, particularly Buster Keaton. While Keaton avoided impossible gags, he often worked to achieve things that were highly improbable. Keaton devised an imaginative comedy that found ways to make crazy things happen, but that still fell just inside the realm of possibility. For example, during the cyclone sequence of *Steamboat Bill Jr.* (1928), Keaton is in a bed inside a hospital. The cyclone lifts the walls and roof off the building, leaving Keaton in bed, but outside. He jumps out of bed, things get worse around him, so he jumps back into bed and pulls the covers over his head. The strong wind causes the bed, which is on wheels, to roll down the street and into a stable filled with horses. When Keaton pulls the covers off his head, he is in a completely different place. Keaton's mild responses to these incredible events suggest that he is trying to figure out what happened. The audience, in turn, follows his lead and understands his confusion. It is easy to see this as some strange dream he is experiencing. Robert Knopf emphasizes Keaton's use of classical composition in his shots when describing Keaton's surreal moments:

> As Keaton places improbable gags such as these in more and more realistic environments, he produces moments that straddle the line between dream and reality, the line that surrealists call the marvelous.[6]

The **marvelous** is the term used by the surrealists to distinguish their art from that which is considered fantasy. Knopf also writes:

> The fantastic is the product of pure fantasy, and escapism, while the marvelous is based in part on everyday reality.[7]

So that is the distinction between fantasy and surreality. Fantasies are consciously constructed alternate worlds and are completely imaginary. People will use the word surreal to describe events they actually experienced but that were very strange. Creating surreal art should try to emulate that sort of experience.

Sometimes, simply starting in a "normal" world, then moving into a strange one can constitute surrealism. One of the most surrealist inspired cartoons is *Porky in Wackyland* (Warner Brothers, 1938), directed by Bob Clampett. In that film, Porky is hunting a rare Do-Do bird for a huge reward. He flies his plane to darkest Africa, and lands in Wackyland. The landscape and creatures there are clearly inspired by the surrealist painter Salvador Dali.

A good example of surrealism in modern mainstream animation is in Sony Pictures Animation's *Cloudy With a Chance of Meatballs*. The story begins on the island of Swallow Falls. At that point, the context is essentially a real place. It is a cartoon, sure, but there is nothing remarkable about the island. Flint Lockwood invents a machine that produces food. Through an unlikely accident, the machine is launched into the sky, where it causes meals of epic proportions to rain down onto the island. Through these events, the island has stepped over from being realistic, to being surreal.

Figure 12.6 *Cloudy with a Chance of Meatballs*, 2009

© Sony Pictures. Courtesy Everett Collection.

Luck

Back in the early days of theater, there was something called **deus ex machina**, which translates into "God from the machine." The original Latin term referred to the use of machinery, such as a crane, that could fly an actor playing a god onto the stage to resolve a problem. In the ancient times, gods were considered to be in control of everything anyway, so it was acceptable then. In modern usage, it refers to a **plot device** where a character gets into significant trouble, but is saved by a previously unmentioned fact or character. It is simply an easy way out for the writer, and is generally considered bad writing. Now, we like to see people solve their own problems. In my college

screenwriting class, I learned that you can get a character into trouble through bad luck, but you can't get him out of it with good luck.

However, comedy often breaks the rules. Consider Captain Jack Sparrow. I remember when I was working on the first *Pirates of the Caribbean* film and I saw the footage of Jack standing atop the mast of a ship as it pulls into port. The camera pulls back to reveal it is just a little boat that is beginning to sink. At what seems like the last possible moment, he steps from the mast to the dock, as though it were a completely normal way to return. He had no lack of confidence. That is exactly the sort of ridiculous luck that Buster Keaton would have had. Lucky people are beloved by the gods, and by audiences as well. The luck cannot be small. It must be astonishing.

In cartoons, the director is god. In *Barbary-Coast Bunny* (Warner Brothers, 1956), directed by Chuck Jones, Bugs Bunny gets revenge on a bandit who stole his gold by gambling with him. Bugs places his wager on a number, and the bandit spins the roulette wheel. No matter what the bandit does to fix the game, the little ball will always land on the number Bugs has picked. His luck is absolutely magical. Tex Avery took full advantage of his position as director and god. Anything could happen to his characters, and some of them had all kinds of strange powers. In *Bad Luck Blackie* (MGM, 1949), a black cat was truly bad luck. By intentionally crossing someone's path, he could create any manner of catastrophe in the blink of an eye. Anvils and anchors could drop out of a clear blue sky.

Figure 12.7 Tex Avery cartoon, *Bad Luck Blackie*, 1949

Courtesy Everett Collection.

Scott Curtis wrote:

> Some have argued that there are no consistent laws of physics for an Avery cartoon, nothing defining the difference between real and unreal; the laws seem to be different for hunter and hunted, rascal and victim. But that is precisely the point: the laws are different for each character. What we might call good luck

or good karma or good timing in the real world is codified in comedy according to character. Buster Keaton gags, for example, often revolve around Keaton's uncanny ability to escape harm: recall the famous *Steamboat Bill, Jr.* (1928) gag in which a falling facade of a house appears about to crush him; only he occupies the one spot where an open window allows him to stand unscathed. Nature works differently for some. The same principle applies in animation, except that there are two distinct laws of physics at play and some characters have access to both.[8]

So there you have it. Some characters can manipulate reality, some cannot. The director chooses the luck, bestows it upon anyone he wants to have it, and withholds it from others. The universe is completely against Wile E. Coyote. Luck is on his side only momentarily, so that he can get himself up in the air, or moving at high speed, then it abandons him at the worst moment. For him, there will be a huge rock in exactly the wrong place. Something will break, or flip, or collapse, at exactly the wrong time. Luck, both good and bad, becomes a character attribute.

Once you understand the foundation of comedy that actors have delivered successfully for millennia, you can more effectively move into the impossible world of cartoons. Everything begins, and ends, with character. Magical effects on their own mean nothing in animation. They must exist only to amplify the energy of the characters. Also, they must be intrinsic to the universe presented. The players must accept it as part of their world. If characters have the ability to do extraordinary things, or survive terrible events, they should make use of it with a certain amount of regularity. Those powers must be considered in the equation at all times, and balanced out with maintaining the integrity of the characters. They must still express themselves through their behavior. If they are funny characters at heart, properly used effects will serve to make them larger than life, and audiences will love them even more because of that.

Notes

[1] Staveacre, Tony. *Slapstick: The illustrated story* (London: Angus & Robertson, 1987), p. 53.

[2] Kamin, Dan. *Charlie Chaplin's one-man show* (Metuchen: Scarecrow Press, 1984), p. 37.

[3] TVTropes: <http://www.tvtropes.org>.

[4] Charney, Maurice. *Comedy high and low: An introduction to the experience of comedy* (New York: Peter Lang Publishing, 1987), p. 154.

[5] Wikipedia: Surrealism: <http://en.wikipedia.org/wiki/Surrealism>.

[6] Knopf, Robert. *The theater and cinema of Buster Keaton* (Princeton: Princeton University Press, 1999), p. 124.

[7] Ibid., p. 122.

[8] Curtis, Scott. "Tex Avery's Prison House of Animation, or Humor and Boredom in Studio Cartoons." *Funny pictures*. Ed. Daniel Goldmark and Richard Keil (Berkeley: University of California Press, 2011), p. 220.

Bibliography

Adamson, Joe. *Tex Avery: King of cartoons*. New York: Popular Library, 1975.

Atkinson, Rowan. *The Story of Bean*. July 31, 1997. Television.

Atkinson, Rowan, David Hinton and Robin Driscoll. "Visual Comedy." *Funny Business*. 22 November 1992.

Balducci, Anthony. *The funny parts: A history of film comedy routines and gags*. Jefferson: McFarland & Company, 2012.

Barr, Charles. *Laurel & Hardy*. Berkeley: University of California Press, 1968.

Barrier, Michael. *Hollywood cartoons: American animation in its golden age*. New York: Oxford University Press, 1999.

Berle, Milton. http://www.cmgww.com/stars/berle/about/quotes.html

Bishop, George Victor. *The world of clowns*. Los Angeles: Brooke House, 1976.

Canemaker, John. *Felix: The twisted tale of the world's most famous cat*. New York: Pantheon Books, 1991.

Carroll, Noel. "Keaton: Film acting as action." *Making visible the invisible: An anthology of original essays on film acting*. Ed. Carol Zucker. Metuchen, NJ: Scarecrow, 1989, pp. 198–223.

Chaplin, Charles. *My autobiography*. New York: Simon and Schuster, 1964.

Charney, Maurice. *Comedy high and low: An introduction to the experience of comedy*. New York: Peter Lang Publishing, 1987.

Cleese, John. "Extended Interviews." *Fawlty Towers: The Complete Remastered Collection*. BBC Video, 2009. DVD.

Cline, Paul. *Fools, Clowns, & Jesters*. San Diego: Green Tiger Press, 1983.

Curtis, Scott. "Tex Avery's Prison House of Animation, or Humor and Boredom in Studio Cartoons." *Funny Pictures*. Ed. Daniel Goldmark and Richard Keil. Berkeley: University of California Press, 2011, pp. 211–27.

Dale, Alan. *Comedy is a man in trouble*. Minneapolis: University of Minnesota Press, 2000.

Dardis, Tom. *Harold Lloyd*. New York: Viking Press, 1983.

Disher, M. Wilson. *Clowns and pantomimes*. Bronx: Benjamin Blom, 1968.

Epstein, Lawrence J. *Mixed nuts: The story of comedy teams in America*. New York: PublicAffairs, 2004.

Etaix, Pierre. *Pierre Etaix: The Criterion Collection*. 2013. DVD.

Fowler, Gene. *Father goose*. New York: Covide Feide, 1934.

Furniss, Maureen, (ed.). *Chuck Jones: Conversations*. Jackson: University Press of Mississippi, 2005.

Gilbert, Douglas. *American vaudeville: Its life and times*. New York: Dover, 1968.

Gordon, Mel. *Lazzi: The comic routines of the commedia dell'arte*. New York: Performing Art Journal Publications, 1983.

Gunning, Tom. "The cinema of attraction: Early film, its spectator, and the avant-garde." *Film and theory: An anthology*. Eds. Robert Stam and Toby Miller. Malden: Blackwell, 2000, pp. 229–35.

Harness, Kyp. *The Art of Charlie Chaplin*. Jefferson: McFarland & Company, 2008.

—. *The Art of Laurel & Hardy*. Jefferson: McFarland & Company, 2006.

Hayes, Kevin J. (ed.). *Charlie Chaplin interviews*. Jackson: University of Mississippi Press, 2005.

Jenkins, Henry. *What made pistachio nuts?* New York: Columbia University Press, 1992.

Kamin, Dan. *Charlie Chaplin's one-man show*. Metuchen: Scarecrow Press, 1984.

Kaplan, Steve. *The hidden tools of comedy*. Studio City: Michael Weise Productions, 2013.

Kerr, Walter. *The silent clowns*. New York: Knopf, 1975.

King, Rob. *The fun factory*. Berkeley: University of California Press, 2009.

Knopf, Robert. *The theater and cinema of Buster Keaton*. Princeton: Princeton University Press, 1999.

Maccann, Richard Dyer. *The silent comedians*. Metuchen, NJ: The Scarecrow Press, 1993.

Mast, Gerald. *The comic mind*. Chicago: University of Chicago Press, 1979.

Neale, Steve and Frank Krutnik. *Popular film and television comedy*. New York: Routledge, 1990.

Newell, J. Philip. *Shakespeare and the human mystery*. New York: Paulist Press, 2003.

Nicoll, A. *The world of Harlequin*. Cambridge: Cambridge University Press, 1963.

Nollen, Scott Allen. *The boys: The cinematic world of Laurel & Hardy*. Jefferson: McFarland & Company, 1989.

Raz, Jeff. "Clowning and its philosophy." San Francisco: Commonwealth Club, 4 June 2008.

Robinson, David. *Chaplin: his life and art*. New York: McGraw Hill, 1985.

Schickel, Richard. *The essential Chaplin*. Chicago: Ivan R. Dee, 2006.

Sennett, Mack. *King of comedy*. Garden City: Doubleday and Company, 1954.

Skredvedt, Randy. *Laurel and Hardy: The magic behind the movies*. Beverly Hills: Moonstone, 1987.

Staveacre, Tony. *Slapstick: The illustrated story*. London: Angus & Robertson, 1987.

Sweeny, Kevin W. *Buster Keaton interviews*. Jackson: University Press of Mississippi, 2007.

Swortzell, Lowell. *Here come the clowns*. New York: Viking Press, 1978.

Thomas, Frank and Ollie Johnston. *Too funny for words!* New York: Abbeville Press, 1987.

Towsen, J. *Clowns*. New York: Hawthorn, 1976.

Trav S.D. *No applause please, just throw money*. New York: Faber and Faber, 2005.

TVTropes: <http://www.tvtropes.org>.

Ward, Richard Lewis. *A history of the Hal Roach studios*. Carbondale: Southern Illinois University Press, 2006.

Wattach, Adrien. *Life's a lark*. New York: Benjamin Blom, 1969.

Weissman, Stephen. *Chaplin: A life*. New York: Arcade Publishing, 2008.

Wikipedia. Comedian: <http://en.wikipedia.org/wiki/Comedian>.

—. Grammelot: <http://en.wikipedia.org/wiki/Grammelot>.

—. Surrealism: <http://en.wikipedia.org/wiki/Surrealism>.

Wright, John. *Why is that so funny?* New York: Limelight Editions, 2007.

T - #0760 - 101024 - C212 - 235/191/10 [12] - CB - 9781138777231 - Gloss Lamination